ATOMIC COMICS

BOOKS BY FERENC MORTON SZASZ

The Divided Mind of Protestant America, 1880–1930 (1982)

The Day the Sun Rose Twice:
The Story of the Trinity Site Nuclear Explosion, July 16, 1945 (1984)

The Protestant Clergy in the Great Plains and Mountain West,
1865–1915 (1988)

British Scientists and the Manhattan Project:
The Los Alamos Years (1992)

Scots in the North American West, 1790–1917 (2000)

Religion in the Modern American West (2002)

Larger Than Life: New Mexico in the Twentieth Century (2008)

Abraham Lincoln and Robert Burns:
Connected Lives and Legends (2008)

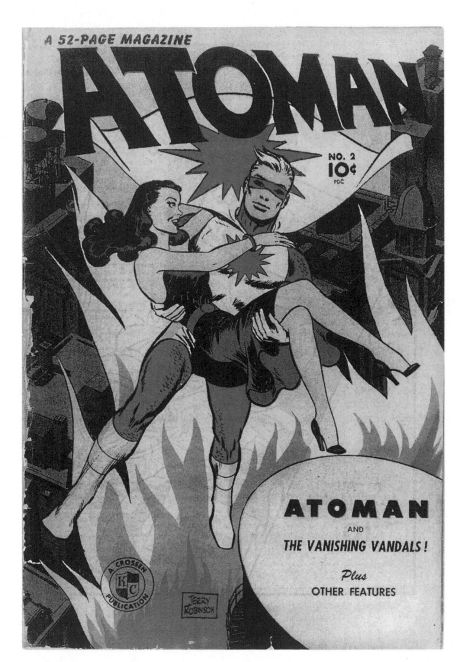

Cartoonists Confront
the Nuclear World

ATOMIC COMICS

Ferenc Morton Szasz

UNIVERSITY OF NEVADA PRESS
RENO & LAS VEGAS

University of Nevada Press, Reno, Nevada 89557 USA
www.unpress.nevada.edu
Copyright © 2012 by University of Nevada Press
All rights reserved
Manufactured in the United States of America
Design by Kathleen Szawiola

Library of Congress Cataloging-in-Publication Data

Szasz, Ferenc Morton, 1940–2010.
Atomic comics : cartoonists confront the nuclear world
/ Ferenc Morton Szasz.
p. cm.
Includes bibliographical references and index.
ISBN 978-0-87417-874-6 (cloth : alk. paper)
ISBN 978-0-87417-879-1 (e-book)
1. Comic books, strips, etc.—History and criticism
2. Atomic bomb in literature. 3. Cartoonists. I. Title.
PN6714.S97 2012
741.5'358–dc23 2011043536

The paper used in this book meets the requirements
of American National Standard for Information
Sciences—Permanence of Paper for Printed Library
Materials, ANSI/NISO Z39.48-1992 (R2002).
Binding materials were selected for strength and durability.

University of Nevada Press Paperback Edition, 2013
ISBN 978-0-87417-918-7 (pbk.: alk. paper)

This book has been reproduced as a digital reprint.

Frontispiece: Cover of *Atoman* #2 (Spark, April 1946)

TO THE FAMILY

Margaret; Eric; Chris and Scott;
Maria and Jonathan; and Tyler, Sean, and Matthew
—all of whom have their own favorite cartoonists.

CONTENTS

ILLUSTRATIONS

PREFACE

s atomic-themed comic books are a somewhat unusual theme
for academic analysis, I should probably start with a word of
explanation. I came of reading age in the late 1940s, a period
when comic books were still at the height of their popularity. We lived
in Minneapolis at the time, and a thick stack of comics provided many
a welcome winter evening's entertainment. My mother, who was a
high school English teacher, despaired at my choice of reading mate-
rial. In every way imaginable, she tried to entice me into the likes of
Little Lord Fauntleroy and *Wuthering Heights*. But nothing worked. How
could the story of *Little Lord Fauntleroy* (who was a complete prig)
match the adventures of Batman, Green Arrow, Sub-Mariner, or Uncle
Scrooge and his nephews? Eventually my mother threw in the towel,
but with a final plea that I at least add classics comics to my growing
obsession (which eventually I did).

My interest in graphic art continued when we moved to Ohio, and
in 1953 I purchased my first *Mad* magazine from the newsstand. This
turned out to be (I think) issue number four, but I soon traded with
friends to complete the collection. Even though *Mad*'s humor has fol-
lowed national trends toward banality and vulgarity, I continue to sub-
scribe in hopes of catching an occasional glimpse of the hilarious satire
provided by artists Harvey Kurtzman, Will Elder, Wally Wood, and Jack
Davis in the 1950s.

My interests in comics faded with college, graduate school, and
eventual employment in the Department of History at the University
of New Mexico. Because of Albuquerque's proximity to Los Alamos,
however, I soon found myself enticed into the history of the early
Manhattan Project. The opportunity to interview many project veter-

ans eventually led me to write two books on atomic history, as well as a number of shorter essays. Somewhere along the line, my earlier interest in comics was reawakened, and around 1995 I decided to compile a collection of every comic book I could find that treated atomic themes. After more than a decade, I have assembled what I believe to be one of the nation's larger private collections of nuclear-themed comics. This rather unusual interest once caught the attention of Hedy Dunn, director of the Los Alamos Historical Society, and she asked if she could borrow the books for a museum display. The exhibit, "Zap! Zing!! Zowie!!! Six Decades of Atomic Comics," remained at the Los Alamos Historical Society Museum for more than a year and drew hundreds of youthful visitors. An abbreviated version later moved to the National Atomic Museum in Albuquerque for eight months, and a few covers still grace its various displays. Professor William Cronon of the University of Wisconsin–Madison toured the National Atomic Museum exhibit of atomic comics with his family and correctly guessed its origins. Later he encouraged me to write a book on the theme. Finally, after far too many twists and turns, here is the final result.[1]

Atomic Comics marks the final volume in what has evolved into my personal atomic trilogy. *The Day the Sun Rose Twice: The Story of the Trinity Site Nuclear Explosion, July 16, 1945* (1984; pbk. 1995) began the process. It was followed by *British Scientists and the Manhattan Project: The Los Alamos Years* (1992), in which I explored the relatively unknown saga of the approximately two dozen British scientists who served at site Y (as Los Alamos was then termed) during the Second World War. Both were based on extensive interviews. *Atomic Comics,* the final volume, analyzes how comic strips, comic books, and assorted newspaper cartoonists have influenced the popular understanding of the fissioned atom. Overall, it has been a fascinating journey.

Many people have aided me in this work. My colleague Paul Hutton regularly astounded me with his encyclopedic knowledge of Western comics. Graduate students Shawn Wiemann, Meg Frisbee, and Jason Strykowski also shared their expertise. Former graduate student Issei Takechi, now pursuing a doctoral degree in Japan, did yeoman work on our joint atomic comics essay, which is excerpted in chapter 5. Futoshi Saito also aided me with translations from Japanese. Cartoon-

ist Leonard Rifas graciously shared his knowledge of early comic art, and Robert Del Tredici his expertise on the Canadian nuclear world. Local retailer Scott Micheel, manager of Comic Warehouse; former student Jeff Brofsky, owner of Tall Tales Comics; and Don Pierce of Don's Book Store have been very helpful as well. And I owe much to Nebraska comics dealer Robert Beerbohm for sharing his extensive compilation of comics that treated nuclear themes. Christine Desai of the Zimmerman Library at the University of New Mexico proved a master in locating electronic cartoon resources. Special thanks also to the staff at Whole Foods and to Elizabeth Robertson, owner of the Napoli Coffee House in Albuquerque, for allowing me to work so many hours there on a single cup of half-caf cappuccino.

And finally, special kudos to my family. My wife, Margaret Connell-Szasz, has served as a sounding board for years on these matters. So too have Eric and Maria. Chris G. Bradley deserves especially high marks for deciphering my handwriting as she performed (once again) absolute magic in turning the scratches on long yellow pads into a readable text. My thanks to all.

ACKNOWLEDGMENTS

MARGARET CONNELL-SZASZ

In the fall of 2010, several months after my husband, Ferenc Morton Szasz, lost his struggle with leukemia, I met with Matt Becker, acquisitions editor for the University of Nevada Press, to discuss the manuscript of "Atomic Comics" that Ferenc had submitted earlier that year. The theme of this study had long been one of his keen interests, and he was eager to have it in print. The professional expertise of the University of Nevada Press staff has made this possible, and I would like to thank Matt Becker, Barbara Berlin, and Kathleen Szawiola, as well as Kimberly Glyder, who created the cover for the book. I am also indebted to Chris Garretson Bradley, who typed the original manuscript, acquired the illustration permissions, and shared with me the responsibility for responding to queries from copy editor John Mulvihill. The staff of the University of New Mexico Department of History contributed in many ways throughout the process, and I am indebted to Dana Ellison, Yolanda Martinez, Barbara Wafer, and Helen Ferguson. I owe further thanks to John Byram, director of the University of New Mexico Press, for responding quickly to a last-minute request. Eric Garretson and Maria Szasz are always there when I need them.

During the BBC radio coverage of the tenth anniversary of 9/11, one person observed: "We all live in the shadow of apocalyptic nuclear things." By deploying a unique approach to this issue, atomic comics have boosted our understanding of the omnipresent nuclear shadow. Ferenc Szasz brings this concept to the foreground in his groundbreaking assessment of the role of atomic comics in the nuclear age.

ATOMIC COMICS

INTRODUCTION

At 10:45 a.m. on August 6, 1945, President Harry S Truman revealed to the world that the Allies had dropped a new type of weapon on the Japanese city of Hiroshima. "It is an atomic bomb," the president said. "It is the harnessing of the basic power of the universe." Within three weeks, the editors of Pocket Books had compiled and published a slim volume that reflected the nation's shocked response, and *The Atomic Age Opens* quickly disappeared from bookstore shelves. As Pocket Books had guessed, the public desperately wanted to comprehend the meaning of the fissioned atom. Atomic energy is so powerful, the editors said, that it could never be left solely to scientific experts or private development by American corporations. Instead, "It belongs to the people. The people must understand it."[1]

From August 6, 1945, to the present day, "the people"—the ultimate source of authority under the American political experiment—have struggled mightily to comprehend the meaning of Harry Truman's announcement. As writer Laura Fermi observed twelve years later, nuclear weapons and nuclear energy were introduced to the world on the very same day, and for the majority of citizens, the two remained synonymous.[2] For the next seven decades, voices from every walk of life tried to untangle this nuclear weapons/nuclear energy overlap. Scientists, politicians, newspaper columnists, science writers, poets, artists, filmmakers, physicians, photographers, sculptors, psychologists, musicians (from country-and-western singers to opera librettists), just to name a few, have all had their say. Each, in his or her own way, has tried to enlighten the American people as to the long-term significance of the fissioned atom. Although the literature on this subject is enormous, historians have generally overlooked another important

medium that helped translate the atomic world for "the people": cartoons, especially newspaper comic strips and the lowly comic book. With circulation figures reaching into the millions, cartoonists played a major role in forging the nation's atomic awareness for over three generations.

Noted cartoon expert Bill Blackbeard has defined the comic strip as "a serially published, episodic, open-ended dramatic narrative or a series of linked anecdotes about recurrent, identified characters, told in successive drawings regularly enclosing ballooned dialogue or its equivalent and minimized text." Although Blackbeard's definition covers the waterfront, it somehow slights the overall *power* of the comics medium. This power reaches well beyond realistic art (Mickey Mouse looks nothing like a real mouse) to somehow capture the imagination of the viewer. Famed comix artist Robert Crumb once gently derided his craft as "only lines on paper," but in the hands of skilled cartoonists, this magic blend of picture-and-text can speak to untold audiences. "Comics are to art what Yiddish is to language," cartoonist Art Spiegelman once observed: "it is the vernacular language of a certain kind."[3] From the beginning, the classic newspaper comic strips commanded a fiercely loyal following. When President Woodrow Wilson opened his newspaper in 1915, he turned first to *Krazy Kat;* in the 1940s, poet Dorothy Parker did the same for *Barnaby;* so, too, did thousands of Americans start the day with *Calvin and Hobbes* during the 1990s. This loyalty and affection, when combined with massive circulation figures, allowed the comics to shape public opinion in ways that can hardly be imagined.[4]

There is no comparable definition of the comic *book* that I am aware of—outside of a general classification as "sequential art"—but if there were, it would have to emphasize the "collective nature" of the genre. This fact means that the creation of comic *books* would be vastly different from newspaper comic *strips,* which are usually produced by one or two individuals. (Charles Schultz, for example, wrote every single newspaper *Peanuts* strip by himself.) Comic books, on the other hand, became a communal enterprise, involving editors, writers, pencillers, inkers, letterers, and colorists. A number of early comic book stories emerged from semianonymous industry "bullpens," or from such venues as the famed Eisner/Iger comic studio in New York

City. In a sense, putting together a successful comic book resembles the creation of a musical: both rely on the talents of many people.

From their beginnings in the 1930s to today, comic books have reached a wide, albeit hard-to-nail-down audience. A post–World War II survey found that 95 percent of children and 65 percent of youth read them regularly. DC Corporation cofounder Jack Liebowitz realized from the onset that because they fell between literature and cinema, comics held great potential for storytelling; a few years later a New York University sociologist agreed, noting that comics could "talk to everybody." By 1949 the organizations that had drawn on nonfiction comics to promote their causes included the US Navy, the US Army, the State Department, the United Nations, the CIO, the National TB Association, and the National Lutheran Council. In a few years General Electric, Westinghouse, General Dynamics, the CIA, and the US Civil Defense program would all follow suit.[5] Still, the majority of educators and virtually all "proper" society looked down on the comic strips and comic books. In *Science in Our Lives,* journalist Ritchie Calder blamed comic strips for the nation's failure to comprehend authentic science. A decade later educator Robert Hutchins denounced vapid television offerings by comparing them to "moveable type [that] had been devoted exclusively since Gutenberg's time to the publication of comic books."[6]

But this sentiment began to change in 1977 when the Smithsonian Institution published a hefty compilation of classic newspaper strips, ranging from *Krazy Kat* to *Barnaby* to the *Adventures of Dick Tracy.* In 1981, the Smithsonian followed with another compilation of classic comic books. With the publication of *The Comic Strip Century* (1995) and *100 Years of American Newspaper Comics* (1996), critics reluctantly acknowledged the comic strip as a distinctive American art form. The special Pulitzer Prize given in 1992 to Art Spiegelman's *Maus*—a two-volume graphic novel of the Holocaust—turned the tide for comic books as well. By the 1980s, at the latest, comics had emerged as "the world's most popular art form." As Japanese cartoon giant Osamu Tezuka once noted, "Comics are an international language. They can cross boundaries and generations. Comics are a bridge between all cultures."[7] And, as Tezuka might well have added, they can also serve as a powerful force to shape public opinion on a variety of complex topics,

such as atomic energy and atomic weapons. And that, of course, is the subject of this book.

As science writers and cartoonists soon discovered, explaining the power of the atom to the ordinary citizen was no easy task. People had to master an entirely new vocabulary: atoms, electrons, protons, neutrons, alpha, beta, and gamma rays, fission, and fusion, just to list the basic terms. In addition, they had to adopt a completely different way of comprehending the universe. As Isaac Asimov once noted, the discovery of the existence of a subatomic world inflamed the imagination, for now there could be worlds within worlds, ad infinitum.[8] Yet this very complexity provided cartoonists with a perfect opportunity. All cartoonists share one thing in common: with a few strokes of the pen, they can simplify complex issues for the average reader. And this gift, for better or worse, has helped shape the American comprehension of the atomic age.

I have divided *Atomic Comics* into three overlapping chronological sections, consisting of two chapters each. Part I treats the comics before Hiroshima. In chapter 1, I explore how the popular newspaper adventure strips *Buck Rogers* and *Flash Gordon* made the world of "atomic power" accessible to a general audience—likely with broader success than the far more accurate books and essays penned by science writers. Chapter 2 carries the story from the mid-1930s through the splitting of the U-235 nucleus in 1938 to August 1945. From 1938 to 1941, the nation heard an enormous amount of speculation regarding the possibility of cheap and inexhaustible energy, all of which abruptly ceased in early 1942 because of wartime security regulations. Then came Hiroshima and Nagasaki, and suddenly the world knew. In part II, chapters 3 and 4 examine the nation's initial reaction to the atomic age, which I date from August 6, 1945, to somewhere in the early 1960s. At first comic artists took credit for predicting the arrival of atomic power. Afterward they constructed a series of superheroes who boasted "atomic" origins, although none of them lasted. Even the established superhero icons, such as Superman and Captain Marvel, had their problems confronting a nuclear force that equaled (if not surpassed) their own powers. Superman needed all his strength, and a good deal of luck besides, to defeat the "Atom Man" in 1946. Lacking the Man of

Steel's near invulnerability, "ordinary" comic book heroes faced even greater challenges as they attempted to defuse various nuclear weapons or prevent the nation's atomic secrets from being "stolen." During this era, corporations such as General Electric Company also produced a number of nonfiction comic books that urged Americans to wholeheartedly adopt nuclear power. The federal government also drew on cartoonists to support their civil defense measures. Simultaneously, Superman's major rival Captain Marvel provided a multifaceted cartoon critique of all aspects of the fissioned atom. For about six years, Captain Marvel stories served as picture-and-text parables of the dangers that might flow from the release of atomic energy.

The two chapters of part III discuss the longer-range impact, which I date from roughly the mid-1950s to the present. Chapter 5 examines the vigorous antinuclear efforts of counterculture "comix" artists and newspaper cartoonists, as well as the far more nuanced responses from key Japanese cartoonists. Chapter 6 briefly highlights the major atomic-themed adventure tales that continue to this day. It also discusses the origins of nuclear superheroes, such as Spider-Man, Captain Atom, Solar, and Firestorm, as well as their nuclear opponents, such as Dr. Octopus and the Atomic Skull. Many modern nuclear-themed adventure tales treat the story of the fissioned atom with such disdain, cynicism, or parody that they have helped create a pervasive gray atmosphere I term "atomic banality." In an ironic twist, the mixture of awe, terror, and fingers-crossed optimism that dominated the early comic book treatment of the atomic age has migrated to the opposite end of the arts and entertainment spectrum: opera. The 2005 production of the opera *Doctor Atomic,* with music by John Adams and libretto by Peter Sellars, stands out as one of the few venues where one can still encounter the measured, ambiguous artistic response to the nuclear age, a response that once dominated the far more democratic art form of comic books.[9]

PART I

BEFORE HIROSHIMA

COMIC STRIPS CONFRONT
THE SUBATOMIC WORLD

THE TURN OF THE CENTURY TO THE EARLY 1930S

In 1895, German scientist William Roentgen shocked the world by his announcement of the discovery of X-rays ("X" for unknown) that could penetrate solid matter. News of the "Roentgen rays" reverberated throughout Europe and America, much as Charles Darwin's theories of evolution had done a generation earlier. When Roentgen displayed the X-ray photograph of his wife's hand, with her ring clearly visible, at the Wurzberg Physical Medical Society, he disclosed to the public the existence of a subatomic world, a world that seemed to run by its own laws.

The medical applications of this new "photography," as it was first termed, were obvious to all, and it took only a month before doctors began locating bullets in the arms of wounded soldiers. But the mysterious rays also served as a form of entertainment. It was not long before an "X-Ray Studio" opened on East 26th Street in New York City where patrons could pay to observe their own bones. However, it was also not long before experimenters developed reddened skin and mysterious burns, a clear sign of the dangers that lay behind this new phenomenon. Thomas Edison began experimenting with X-rays the day he first heard about them, and his assistant, Clarence Dolly, has the dubious distinction of being the first known person to die from X-ray-induced cancer. By 1906, experimenters were strongly cautioned to wear protective clothing. It took almost two decades for scientists to determine that X-rays were actually a form of gamma radiation.[1] The cartoonists' response to this scientific breakthrough seems minimal, but the press did print a variety of doggerel that spoofed "the wonderful new electric rays." The most popular ditty appeared in the *Electrical Review* in 1896:

X-exactly So!
The Roentgen Ray, The Roentgen Rays,
What is this craze?
The town's ablaze
With the new phase
Of X-ray's ways.
I'm full of daze,
Shock and amaze;
For nowadays
I hear they'll gaze
Thro' cloak and gown—and even stays,
These naughty, naughty Roentgen Rays.[2]

But Roentgen's announcement proved only the beginning. In the years to follow, the popular press treated the emerging discoveries of this subatomic world with wide-eyed astonishment. French scientist Henri Bequerel identified uranium rays in 1896, and two years later Pierre and Marie Curie isolated radium. English physicist J. J. Thomson postulated the existence of the electron in 1897, and in 1905 Albert Einstein set forth his famous theory that mass and energy were equivalent. In 1919 British scientist Ernest Rutherford demonstrated artificial nuclear disintegration. In 1932, English physicist James Chadwick discovered the neutron, and the next year Irene Curie (the Curies' daughter) and her husband Frédéric Joliot announced that they had created artificial activity. The culmination came in 1938 when German physical chemists Otto Hahn and Fritz Strassmann split the uranium atom, correctly interpreted by Austrian physicist Lise Meintner and her nephew Otto Frisch. All these breakthroughs received their share of "gee whiz" media coverage. For example, when the *New York Times* reported on Rutherford's experiments, they suggested that the energy contained in the nucleus of the atom could either bring forth "an almost illimitable supply of power" or (if it could not be controlled) "spell the end of all things." As Princeton physicist Henry DeWolf Smyth noted in his famous postwar report, by 1940 "all prerequisites to a serious attack on the problem of producing atomic bombs and controlling atomic power were at hand."[3]

During the same era, newspaper and magazine circulation increased

dramatically, and by the early 1920s the nation's reporters had begun to specialize. Talented wordsmiths such as Ring Lardner and Heywood Broun helped raise 1920s sports reporting to the level of high art. Although the science writers of the era were less well known, they did the same for their subdiscipline, aided by the new Science Service Organization (founded 1921) based in Washington, DC. Of the roughly two dozen science reporters, the three most famous in the interwar years were probably prolific writer Edwin E. Slosson, David Henry Dietz of the Scripps-Howard chain, and William L. Laurence of the *New York Times*. All wrote extensively about the various subatomic breakthroughs. Trained in both chemistry and literature, Slosson lectured and wrote endlessly on the importance of science until his death in 1929. A frequent contributor to the popular magazine *The Independent*, Slosson's *Easy Lessons in Einstein* (1920) inaugurated the age of popular science writing in America. Published on the verge of Albert Einstein's first visit to the United States in 1921, the book professed to explain theories that Einstein himself despaired could ever be widely comprehended. Slosson's book appeared at the right time to catch the "Einstein fever" that swept the nation from 1921 to 1923. The scientist received a ticker-tape parade, and the New York Public Library made all his books available on a long table; every chair was filled for weeks. Crowds in New York and Washington jostled to catch a glimpse of him, and hundreds crowded his lectures (delivered largely in German) at a variety of venues. He even had an official visit with President Warren G. Harding, which produced the headline: "Einstein Idea Puzzles Harding." After this visit, Americans viewed the genial German physicist as an authentic wizard, whose magic lay well beyond the comprehension of ordinary mortals.[4]

The scientist's genial demeanor, openness, and largely unkempt appearance met with widespread US approval. The oft-reprinted 1921 photograph of Einstein visiting Hopi House near the Grand Canyon (wearing a Plains Indian headdress) only cemented this view. It was not long before the term "Einstein" entered American English as a synonym for "genius." *Easy Lessons in Einstein* began the nation's atomic awareness. The year 1919, Slosson suggested, would eventually be remembered less for the overthrow of the German Empire than for the overthrow of Sir Isaac Newton's law of gravitation. Sooner or later, he

predicted, "the Einstein physics cannot fail to influence every intelligent man." But Americans should not worry, he assured readers, for scientific revolutions "do not destroy; they extend."[5]

Slosson's contemporary David Dietz continued along similar lines. A native of Cleveland, in 1921 Dietz became the nation's first "science editor" for the Scripps–Howard newspapers. From 1923 forward he wrote a daily syndicated column, and over the course of a lengthy career penned scores of books and millions of words in an attempt to explain science to the average person. In 1934, he helped create what became the National Association of Science Writers and also served as its first president. For almost four decades, Scripps–Howard supported his travels to various science conferences and research laboratories, where he interviewed many of the pioneers of atomic energy, including Einstein himself. From 1923 through the 1950s, Dietz was widely syndicated. In fact, the day after Hiroshima he essentially told the nation: "I told you so but no one believed me for twenty years." After the war Dietz covered the 1946 US atomic test at Bikini Atoll for both newspapers and radio. He also published two popular introductions to the subatomic world: the hastily compiled *Atomic Energy in the Coming Era* (1945) and the more thoughtful *Atomic Science, Bombs, and Power* (1954), which argued that wise decisions could only be made by a scientifically informed public.[6]

Lithuanian immigrant William L. Laurence is probably the only interwar science writer still recalled today. A former aviation editor for the *New York World*, Laurence moved to the *New York Times* in the early 1930s. A skilled interpreter, he introduced the fissioning of U-235 to American readers in a May 5, 1939, front-page story in the *New York Times*. He also penned an essay for the *Saturday Evening Post* on the same theme (September 7, 1940). Laurence boasted such a stellar reputation that Manhattan Project head Major General Leslie R. Groves tapped him in July 1945 to serve as the official reportorial witness to both the Trinity atomic test in New Mexico (July 16, 1945) and the atomic bombings of Hiroshima (August 6, 1945) and Nagasaki (August 9, 1945). He also wrote most of the official press releases for these events, which earned him the local nickname of "Atomic Bill." In addition to his newspaper and magazine essays, Laurence also wrote

several popular science books. *The Hell Bomb* (1951) warned of the dangers of the cobalt bomb, while *Men and Atoms: The Discoveries, the Uses, and the Future of Atomic Energy* (1959) predicted a rosy atomic future. In fact, Laurence argued that the development of the hydrogen bomb in the early 1950s had made peace "inevitable." His firsthand account of his experiences with the Manhattan Project, *Dawn over Zero* (1946), earned him a Pulitzer Prize, and the book ranks as a model of popular science writing yet today.[7]

As Slosson, Dietz, Laurence, and others discovered, however, it was no easy task to make subatomic physics clear to the general American public. As early as 1921, Mississippi senator John Sharp Williams publicly doubted that even his colleague from Massachusetts, Henry Cabot Lodge (who had a PhD from Harvard), could comprehend Einstein's theory of relativity. A Yale economics professor sadly agreed: "Astronomers and physicists must fight it out and the rest of us must wait." As British mathematician Bertrand Russell noted in his *The ABC of Relativity* (1925), "Everybody knows that Einstein did something astonishing, but very few people know exactly what it was that he did." This befuddled understanding of Einsteinian physics took on more serious overtones in 1938–39 with the discovery that the U-235 atom could be fissioned to release enormous quantities of energy. With this, scientists and science writers began an active search for striking metaphors that the public could comprehend. For example, French Nobel laureate Frédéric Joliot-Curie spoke of his hope that a pound of uranium would produce as much energy as 1,250 tons of coal. Another science writer suggested that the energy from a pound of uranium might equal five million pounds of coal or three million pounds of gasoline. But numbers like these rarely stuck in the memory—gasoline, for example, is seldom measured in pounds—and as a result, the most common comparisons involved far more dramatic analogies. The best were: If tapped, the energy in a gram of water could raise a million tons to the top of a six-mile mountain; a puff of air could power a plane for an entire year; a fistful of snow could heat an apartment complex for a year; the energy in a railway ticket could run a passenger train several times around the globe; and so on. In time, however, the two most common popular catchphrases became: With atomic power, energy

would become so cheap that it would no longer be necessary to read meters; and, once tapped, the energy contained in a glass of water could power an ocean liner across the Atlantic.[8]

The role of the science writers in the interwar era has never been properly appreciated. To begin with, they introduced the nation to regular scientific newspaper columns; indeed, after 1928 the *New York Tribune* inaugurated a popular "Science for the People" series. Science Service also sponsored a variety of regular radio programs that summarized the "Scientific News of the Week." But the collapse of capitalism during the Great Depression meant that science writers had to fight for space with the social scientists (economists especially) and with the politicians.[9] They never reached the audience they thought they deserved.

The scientists and science writers of the day, however, had a distinct rival in their efforts to make subatomic physics comprehensible to the wider public: the humble newspaper comic strip. *New York World* artist Richard F. Outcault, who, incidentally, began his career as a technical illustrator for Thomas Edison, is credited with creating the nation's first cartoon character—Mickey Dugan, the "Yellow Kid"—in 1895. Although the "Yellow Kid" lent his name to the reckless journalism of the 1890s, he did not survive as a cartoon figure. (The first successful six-day-a-week comic *strip* was *Mutt and Jeff,* created by Harry "Bud" Fisher for the *San Francisco Chronicle* in the fall of 1907.) Still it was not long before the newspaper comic strip achieved a life of its own as the Yellow Kid's successors garnered a cadre of faithful followers. Humorous comics, such as Fisher's *Mutt and Jeff,* George Herriman's *Krazy Kat,* Chic Young's *Blondie,* Rudolph Dirk's *Katzenjammer Kids,* Winsor McCay's *Little Nemo,* and Cliff Sterrett's *Polly and Her Pals,* all saw wide syndication. As publisher William Randolph Hearst III later noted, newspaper readers can skip over editorial writers they dislike, but few can avoid cartoon images, for they, much like public art, virtually "force" people to look at them.[10]

Because people usually purchased a newspaper on a daily basis, cartoonists could create long-running adventure strips that relied on regular readership to follow the story line (something that is no longer possible). Thus the late 1920s/1930s emerged as the heyday of popu-

lar newspaper adventure comics, such as Roy Crane's *Wash Tubbs* and *Captain Easy*, Chester Gould's *Dick Tracy*, and Milton Canniff's *Terry and the Pirates*, just to name a few. Occasional nuclear references aside, the daily adventure newspaper strips began to seriously overlap with the subatomic world in the late 1920s/early 1930s with the arrival of two of the most famous cartoon characters of the day: Buck Rogers and Flash Gordon. More than any other popular medium, these two comics strips helped convey "atomic" ideas to literally millions of American readers.

In August 1928, the relatively obscure writer Philip F. Nowlan published "Armageddon—2419 A.D." in the science-fiction pulp monthly *Amazing Stories*, which introduced the adventures of "Anthony Rogers" to American audiences. *Amazing Stories* editor Hugo Gernsback realized the appeal of Nowlan's character and informed readers in a sidebar that the tale "holds a number of interesting prophecies, of which no doubt, many will come true." He also urged the author to pen a sequel. Nowlan did, indeed, pen a sequel, "The Airlords of Han," which Gernsback published in the March 1929 *Amazing Stories*. But Rogers did not reach a mass audience until January 7, 1929, when the slightly renamed *Buck Rogers in the 25th Century A.D.* began as a syndicated newspaper feature, the nation's first daily scientific adventure comic strip. The appeal was such that a Sunday color feature—with a separate story line—began in March 1930. Nowlan retained total control over his characters. He provided the story lines for both the daily and Sunday strips until his death in 1940. A number of artists, including Dick Calkins, who later drew the aviation adventure strip *Skyhawks*, and Zack Mosley, who in 1934 would begin his own adventure strip, *Smilin' Jack*, also worked on *Buck Rogers*. Indeed, the strip became so popular that *Famous Funnies* (usually considered the first authentic comic book) began by reprinting several weeks of the *Buck Rogers* Sunday episodes. They continued to do so until 1965.[11] In 1940–42, Buck Rogers also briefly starred in a separate comic book title of his own.

Even after seven decades, the Buck Rogers stories have lost little of their appeal. A veteran of the Air Service in the Great War, recently discharged Buck Rogers was hired by the American Radioactive Gas Corporation as a mine inspector. While investigating a mine in the Wyoming Valley of Pennsylvania near Scranton, he was suddenly over-

futuristic creatures, such as snowbirds that could haul chariots over ice flows or the deadly flying serpents that inhabited the planet Mongo. In addition, while few today could name "Killer Kane" as Buck Rogers's deadly foe, Flash Gordon's enemy, "Ming the Merciless," has entered the language as the most infamous villain between Simon Legree and Darth Vader. Indeed, the *Flash Gordon* strips provided the initial inspiration for director George Lucas's popular *Star Wars* film series. From a purely artistic perspective, this critique of the two strips is accurate; but it fails to reflect the genuine impact that *Buck Rogers* had on the popular mindset of the 1930s and early 1940s. Crudely drawn and simplistic through it may have been, being first has its advantages, not least of which is that "Buck Rogers" entered the language of the day. A contemporary dictionary definition of "Buck Rogers" read (slight paraphrase): "of or pertaining to all things scientific or futuristic."[20]

The Science-Fiction Novelists

Although Buck Rogers and Flash Gordon reached mammoth newspaper audiences with their atomic-themed adventures, European and British science-fiction novelists had their own following as well. Czechoslovakian playwright Karel Èapek not only invented the term "robot," his *An Atomic Phantasy* (1924) discussed both atomic power and the collapse of humanity. His *The Absolute at Large* (1922) also treated atomic weapons. For American readers, however, British writer H. G. Wells must be acknowledged as probably the most important contributor to the pre-1945 popular understanding of the atomic era. In a number of futuristic works, Wells similarly pointed to the emergence of atomic power. His book *The Shape of Things to Come* (1933) even forecast the arrival of atomic weapons. Wells has also been acknowledged as the first person to use the phrase "atomic bomb." In an earlier futuristic novel, *The World Set Free* (1914)—set in "the 1950s"—Wells penned a story of endless destruction from aircraft-delivered atomic weapons, as well as the dangers of lingering radioactivity—"inconvenient rays," he termed them—that could never be entirely eliminated. As critic Paul Brians has shown in his classic *Nuclear Holocausts: Atomic War in Fiction,* during the interwar era, scores of popular fiction writers—ranging from Upton Sinclair to Edgar Rice Burroughs to long-forgotten hacks— also drew on similar, atomic-themed tales.[21]

But here one must look at circulation figures. Neither *The World Set Free* nor *The Shape of Things to Come* ranks among Wells's best-selling novels. Although science-fiction readers formed the first authentic "fan clubs," editors of the various sci-fi pulp magazines were happy if they sold sixty thousand copies a month. On the other hand, by the early 1930s the King Features syndicate had emerged as the largest national distributor of comic strips. By 1935, the country boasted about 135 other syndicates as well. Together these syndicates provided six hundred features to fourteen thousand daily and Sunday papers.[22] One can never completely separate the various ways by which the pre-Hiroshima American public learned about the subatomic world, of course, but a good case can be made that (in reverse order) the science-fiction pulp magazines; the novels and stories of H. G. Wells and lesser-known authors; the professional science writers; and (especially) the *Buck Rogers/Flash Gordon* phenomena provided the basic framework of popular understanding of the probable wonders of a nuclear-powered future. In this world, one might acknowledge the dangers inherent in the splitting of the atom, but, overall, the weapons could be controlled, and the promised energy seemed potentially limitless. In other words, the "atomic future" would surely, somehow, work out for the best.

picture-and-text story from the former and the last-second surprise endings from the latter. In addition, comic artists all acknowledged the power of the pulp magazine covers, for they realized that striking cover art often determined which of the approximately 125 monthly comic book titles would leave the newsstand shelves in exchange for a dime.[6]

Historians agree that the fledgling comic book industry of the mid-1930s only limped along until two Cleveland teenagers, Jerry Siegel and Joe Shuster, created Superman. After Superman appeared on the cover of the first issue of *Action Comics* in 1938, the comic book world would never again be the same. The idea of an invulnerable superbeing who arrived from another planet captivated American audiences of the late 1930s. Not only did Superman echo widely held Judeo-Christian beliefs (his father, Jor-El, sent him as a child to Earth to work for justice), Superman also arrived in the midst of both a national depression and a collapsing European political situation. In simple, colorful images, the comics medium proved an ideal form to present the adventures of the "Man of Steel" against a host of villains in a classic retelling of the battle between Good and Evil.

By 1941, Superman comic books, newspaper strips, radio programs, and toys had mushroomed into a multimillion-dollar enterprise. "Superman literally *created* the industry," recalled later DC Comics president Carmine Infantino. "He's invulnerable, he's immortal," another editor exclaimed. "Even bad scripts can't hurt him."[7]

Mass-market publishing of the day proved a cutthroat industry, and it was not long before other editors brought forth similar costumed superheroes. One industry legend claims that accountant Victor Fox saw the sales figures for *Action Comics* #1 at 10:00 a.m., quit his job at 11:00, and began interviewing comic artists to draw other superheroes that same afternoon.[8]

Thus, hard on the heels of Superman came Batman (second only to Superman in popularity), the Flash, Hawkman, Captain Marvel, Plastic Man, Sub-Mariner, and a host of lesser figures, such as the Spectre, Spy Smasher, Green Lama, and Golden Arrow. Teenager Archie Andrews, caught in an eternal love triangle with Betty and Veronica, was created in 1941 as an anti-Superman figure. The first popular female superhero, Wonder Woman, appeared in 1941. She was created by Harvard psychologist William Moulton Marston to entice girl readers into

comics. The subsequent additions of Mary Marvel (1942) and Super-girl (1959) had the same goal. In spite of these efforts, however, comic books remained largely a young male pastime.

From the onset, parents and educators scoffed at this new medium. With an eye firmly cast on the potential school market, industry leaders tried to deflect criticism by producing factual or educational comics. In April 1941, *Parents' Magazine* began *True Comics,* a juvenile version of *Life* magazine. EC Comics followed with *Picture Stories from the Bible* (Old Testament) and *Picture Stories of the New Testament,* profits from which went to various religious organizations.

In 1941 Gilberton Company inaugurated its famed *Classic Comics,* one of the longest running of all comic books series. While urging young buyers to be certain to visit their local library and read the originals, *Classic* also conveniently encapsulated the world's greatest works of literature into about fifty pages.

Simultaneously, industry artists tried to elevate the status of the comics. They termed their final product "illustrated stories" rather than "comic books," but this term never really caught on. Still, the young artists of the 1930s and early 1940s were well aware that they were on the cusp of a new art form. Based in New York City, the industry drew on the skills of a talented generation of Italian and Jewish immigrant children. The major city advertising agencies all had "Jewish quotas" for hiring, but the comic book business remained open to talent. "The comics were still viewed as trash," famed creator of *The Spirit* Will Eisner once remarked, "so they were an easier business to enter, the way peddling or the rag trade had been." The early superheroes all had Jewish roots.[9] In fact, Rabbi Simcha Weinstein has recently argued that the greatest of the superheroes, Superman, Batman, Captain America, and Spider-Man, all could trace their origins to the rich legacy of Jewish-American culture.

Since the fledgling comics industry of the late 1930s was based in New York City and heavily staffed by young Jewish writers, artists, and publishers, it is not surprising that comic book heroes began fighting Fascism almost two years before the American government. One scholar has counted sixty-one patriotic/symbolic comic book heroes of the World War II era who battled Fascist villains. They bore such names as the Flag, the Shield, Minuteman, the Spirit of Old Glory (the

Depression-era schooling had left a number of young people with marginal reading skills, and comic books proved an irresistible genre for these GIs.

Comic books proved the ideal medium to reach this group, and the industry tripled its production from 1940 to 1945. By late 1942, one-third of the magazines sent to military bases consisted of comic books. *Superman* comics sales alone approached 10 million dollars a year during the war. By 1943, DC was mailing 35,000 copies of *Superman* monthly to American troops all over the globe. The Nazi propaganda organ, *Das Swartz,* took notice of this, and in one issue branded Superman as "a Jew." A midwar survey by *Newsweek*—the first of its kind—revealed the extent of the readership: 95 percent of people in the 8–11 age group read comics; 84 percent in the 12–17 age range; and 35 percent of those 18–30. Some estimates put annual sales at a billion copies. With the possible exception of film, never had a mass medium grown so rapidly. "We do not altogether know what gives comics such universal appeal," confessed educational expert Josette Frank in 1949.[13]

Respected comic book dealer Robert Beerbohm has compiled a list of all books that contained atomic stories from 1939 to 1998. He discovered about forty such tales published between 1939 and 1945, with about twenty falling in the 1940–45 era. Just a few examples will have to suffice. In 1940, *Wow Comics* introduced "Atom Blake the Boy Wizard," whose father conducted nuclear experiments and used their "mysterious rays" to turn young Atom into "a super-human being capable of absorbing this magical power." The father died but left the boy with a magical ring containing the "rays of sun energy" to grant his every wish. So, too, the superhero Starman possessed a gravity rod that transformed starlight into endless energy. In a sense, the short-lived Atom Blake represented, in story form, many of the *New York Times*'s energy predictions of 1939–40. Similarly, the initial issue of *Police Comics* (August 1941) featured Roy Linson, whose misadventure with the explosive 27-QRK—powerful enough to "blow New York off the face of the earth"—caused him to become the Human Bomb. Likewise, in *Keen Detective Funnies* (1940) G-Man Todd mixed TNT with a "magnetic X-19," which turns him into "TNT Todd." As short-lived as Atom Blake, TNT Todd could fly, shoot lightning from his fingertips,

and intercept enemy bombs in midair. Basil Wolverton's Spacehawk in *Blue Bolt* comics (1940) could fly at the speed of a million miles an hour because he had tapped the secret of "applying atomic power." In *The Bouncer* (1944) Rocket Kelly visited the "Atom World" of Selura and forced the rulers to make atomic power available for everyone's benefit. *All Winners* #2 (1941) told of the Destroyer, a masked hero who saved England from wholesale destruction from a flying Plague Bomb. One wartime Spymaster adventure actually had the hero fight "the Atom," who turned out to be a foreign spy. The list goes on. In *All Winners* #4 (1941) the Human Torch destroyed an "atom gun," but not before it demolished an island, a building, and the Statue of Liberty with a single burst of power. The first issue of *Blue Bolt* (June 1940) introduced Sub-Zero Man, who sported an atomic pistol and drove an atomic ship.[14] And so on.

The dreams of atomic aircraft—although not precisely portrayed as such—could easily be extrapolated from Airboy's famed airplane "Birdie," which first appeared in November 1942. An orphan raised by Catholic monks in California, one of whom just happened to be an expert designer of experimental aircraft, Airboy not only battled a vast array of villains, he also convinced the beautiful Nazi female pilot Valkyrie, as well as her formidable flock of Airmaidens, to join the Allied cause. Dashing though Airboy might have been, the star of the stories remained his plane, Birdie. Unlike other aircraft of the day, Birdie flapped her wings and possessed a set of grappling hooks under the landing gear that allowed her to grip onto enemy aircraft in flight. Even more enticing, Birdie contained a sophisticated electronics system that allowed her to come when called. Airboy always spoke to her as if she were alive. Even Batman's famed Batmobile and Batplane paled beside Birdie. If ever an atomic aircraft were produced, surely it would have nothing on Airboy's Birdie.[15]

Security

These wartime atomic-related comic book stories generally flew under the radar of the newly created federal security system. Up to 1939, news of the advances of nuclear science functioned essentially in an "open world," as scientists traveled from nation to nation to freely discuss their theories and discoveries. During the "golden age" of the

interwar era, nuclear physics was viewed as simply "international gossip." With the potential for a nuclear weapon at hand, however, the scientists argued that all information regarding fission should be restricted until the political situation in Europe changed. Since American scientists had had little experience with governmental use of their discoveries, the foreign-born émigrés usually led the way in this regard. In the spring of 1939, a group of physicists, sparked by Hungarians Leo Szilard, Eugene Wigner, and Edward Teller, and Italian Enrico Fermi, enlisted the aid of Danish physicist Niels Bohr to voluntarily stop publication regarding uranium research in the major scientific journals until the political situation improved. This voluntary restraint always proved leaky, however, as Joliot-Curie initially proved reluctant to cooperate. It was not until April of 1940 that the British, French, and American scientists succeeded in imposing a voluntary censorship on nuclear articles in the major academic journals of the day. Several of these periodicals contained helpful "author indexes," and their 1940–45 issues clearly reflect the disappearances of articles by any well-known nuclear scientists. It was this absence—"the dogs that do not bark"—that led a Russian lieutenant to inform Soviet premier Josef Stalin that he was positive that the Americans and British had a secret atomic bomb program under way. In early 1940, when the first funds were transferred from the US Army and Navy departments to purchase materials for possible construction of a nuclear weapon, atomic-related news stories began to disappear from the national press. As scientist Gordon Dean later observed, "Thus, the atom, in the month that Norway was invaded [April 1940] vanished behind a banner of secrecy from which it has never wholly emerged."[16]

Although the movement began by quietly silencing the technological and professional science journals, the situation changed dramatically after Pearl Harbor. In December 1941, Byron Price, the executive director of the Associated Press, moved to Washington, DC, to establish the US Office of Censorship, which would eventually employ ten thousand people. At his urging, the nation's major editors, syndicated news services, and radio leaders agreed to a voluntary honor system regarding all potentially sensitive matters. In June 1943, essentially the same month that Los Alamos began operation, the Office of Censorship asked the press and radio to not even *mention* any wartime experi-

ments involving atoms. Among the forbidden subjects were the terms "atomic power," "cyclotrons," betatrons," "atomic fission," "atom smashing," and any reference to basic atomic research. Overnight, the science writers who had been covering U-235 and U-238 switched to other topics. "At first," noted science-fiction editor John W. Campbell in 1947, "the secrecy was such that the very secrecy was kept secret."[17]

The driving force behind this popular press atomic silence, as security official John Lansdale Jr. later recalled, was to distract the Germans (and the Russians) from the seriousness of the American effort. Both the scientists and the government argued that if the Germans ever realized that the Americans were genuinely serious about nuclear fission, they might redouble their own efforts.[18]

Thus, from early 1942 (at the latest) to August 6, 1945, the mainstream press adopted a policy of almost total silence on atomic matters. The coverage provided by the *New York Times* during those years serves as a classic example of this restraint. The *Times* mentioned atomic-related issues, sometimes without using the actual term, only when they absolutely had to. In April 1943, they described the destruction of the electrochemical plant at Rjukan, Norway, which produced the "queer chemical known as 'heavy water,'" which can be used in the manufacture of high explosives." A few months later, they reviewed a new textbook on nuclear physics, but pointed to the authors' reluctance to discuss the possibilities of an atomic bomb in any detail: "If the reader wakes some morning to read in his newspaper that half the United States was blown into the sea overnight, he can rest assured that someone, somewhere succeeded."[19]

In the spring of 1944, the *Times* reintroduced discussion of the atomic bomb, but only as a response to a recent Hitler speech that had threatened the Allies with a new "secret weapon." Since Allied intelligence could neither confirm nor deny the truth of Hitler's boast, speculation included the possibility that a V3 rocket might carry some form of atomic bomb in the "Amerika bomber." As a Nazi journalist bragged from neutral Sweden, "America will soon know what war is."[20]

The secrecy surrounding the Manhattan Project meant that no one outside of his or her immediate region knew of the instant cities of Oak Ridge, Tennessee, or Hanford, Washington; similarly, the existence of the secret community of Los Alamos never reached the pages

of the nearby *Santa Fe New Mexican*. Even the field test of the world's first atomic device at Trinity Site, east of Socorro, New Mexico, on July 16, 1945, received only minimal local newspaper coverage. Although the blast wave was felt in three states and the flash might well have been visible from the moon, area newspapers dutifully buried on page five the official notice that an ammunition dump on the Alamogordo Bombing Range had accidentally ignited. Only the *El Paso Herald Post* broke ranks to make the Trinity blast a headline story: "Army Ammunition Explosion Rocks Southwest Area."[21] From 1942 to August 6, 1945, the atomic silence of the American mainstream media proved deafening.

Science-Fiction Speculation Proves Close to the Mark

Excluding the voluntary censorship of the professional scientific journals—which might well have had a real impact—the three-year silence imposed on the mainstream radio/press media proved ineffective. The reason is simple. Both before and during the war, the popular culture of the era had produced scores of atomic-related stories in science-fiction magazines, comic books, and newspaper comic strips, and a number of these tales set forth the parameters of atomic power with uncanny precision.

At their height of popularity in the Depression decade, the pulp magazines created an enormous market for short stories, and the cadre of science-fiction pulps developed a loyal readership that staged the first annual fan conventions. In *Astounding Science Fiction* (May 1941) Robert A. Heinlein (under the pseudonym Anson MacDonald) published the tale "Solution Unsatisfactory," in which a nation created an atomic weapon (in this case "radioactive poisons" rather than bombs). Said one character: "It's like this: Once the secret is out—and it will be out if we ever use the stuff—the world will be comparable to a room full of men, each armed with a loaded .45 . . . all offence and no defense." In 1941 Heinlein also published a novelette that sketched the American effort to produce an atomic weapon to end a war. The same year Isaac Asimov wrote a short story describing the impact of the fissioning of uranium. In March 1944, author Steve Cartmill published in *Astounding Science Fiction* a story in which the hero disarmed an enemy's atomic weapon. The description proved so close to the

actual weapon being constructed in Los Alamos that military intelligence soon arrived in *Astounding*'s offices to inquire where Cartmill had obtained his information. As it turned out, he had derived everything from the open literature. "If a science-fiction author can outline the structure of an atomic bomb accurately enough to worry military intelligence," wrote editor John Campbell after the war, "it may fairly well be assumed that the scientists of many nations can do at least as well." When military intelligence warned Campbell to cease publishing stories on atomic bombs, Campbell protested. He argued that the sudden disappearance of the atomic genre would send a clear signal that the United States had a secret project under way.[22]

In 1944, the pulp magazine *Startling Stories* carried Malcolm Jameson's novelette *The Giant Atom*, which described a steadily expanding "atomic fire" that spewed out lethal rays. In the wake of Hiroshima, Jameson's heirs rushed the story into paperback under the title *Atomic Bomb*, rewriting specific sections to suggest that the late author had been a "startlingly accurate prophet" whose work "might well be considered a blueprint of the now post-war world."[23] Ultimately, however, Jameson's dreadful prose and hackneyed characters doomed the novel to well-deserved obscurity.

But the atomic theme extended well beyond the limited circulation of the science-fiction magazines. In the late 1930s/early 1940s, one of the most popular of all cartoon figures, Walt Disney's Mickey Mouse, also confronted the dilemmas of nuclear power. In a widely distributed newspaper strip adventure by famed cartoonist Floyd Gottfredson, *Mickey Mouse on Sky Island* (1936–37)—later reprinted in book form—the heroic mouse-everyman faced the dilemma of misused atomic power. Mickey and Goofy unexpectedly meet the slightly daffy scientist Dr. Einmug, who has learned how to live on a cloud. Assisted by Captain Doberman, Mickey realizes that Dr. Einmug has "discovered a way to extract the power from radium, all at once instead of gradually." The scientist has also learned how to line up atoms in an "atomizer" so that they all point in the same direction (a proto-laser?). Our hero also battles with the villain Black Pete, who is out to capture the secret. After noting that Dr. Einmug's "new power is absolutely unlimited an' we've got to stop him," Mickey and Goofy learn that Dr. Einmug has actually discovered a way to tap the energy in a glass of water.

But he is afraid to tell anyone else for fear they might use his invention for killing rather than for helping people.

In the climax scenes, Mickey foils Pete's efforts to steal the atomic plans, and Dr. Einmug decides to keep his formula secret. The world is not ready, he sadly concludes, and his discoveries "would only bring sorrow." In the closing panels, he flies off to another planet, whereupon Mickey and Captain Doberman decide to tell no one of their success: they had "one of the most amazing adventures in history—an' no one'll ever know."[24]

The nation's second most widely recognized cartoon figure, Superman, also wrestled with atomic dangers. In *Action Comics* #21 (February 1940), for example, Clark Kent meets a scientist who has been experimenting with an "atomic disintegrator"—a weapon "that could destroy any matter it was leveled at." A female villain tortures the scientist into revealing the secret and then destroys the Wentworth Tower to prove her point. Superman finally disables the disintegrator and warns the scientist to "forget you ever succeeded in disrupting the atom. Farewell."[25]

Superman's equally popular radio show, which began in the winter of 1940, drew on an identical story line. In three early 1940 episodes, Dr. Sven Dahlgren invents an "atomic beam" machine that vibrates buildings to destruction. Unfortunately, a traitor steals the atomic fuel cylinders (as well as kidnaps Lois Lane) in an effort to destroy the *Daily Planet* newspaper, where Clark Kent works. Only Superman's last-second heroics rescue the building from the atomic beam.[26]

Once the nation had entered the war, the editors at DC Comics feared that Superman's popularity was such that he would be expected to end the conflict overnight. So, they cleverly had Clark Kent fail the eye exam (he mistakenly read the eye chart in the next room). Even so, in 1943 *Look* magazine asked Siegel and Shuster to draw a two-page scenario on "What If Superman Ended the War." (He would take Hitler and Stalin to the League of Nations and have them tried for "modern history's greatest crime—unprovoked aggression against defenseless countries.")[27] Although the government usually left popular culture authors alone, the mass popularity of the Superman tales led the security apparatus to twice censor his wartime atomic adventures. In the first, security officers asked that a story entitled "Battle of the Atoms"

in *Superman* comics not be printed in 1944 as scheduled. In this tale, villain Lex Luthor's atomic bomb—"The most potent weapon ever invented"—was drawn as roughly the size of a softball (only slightly smaller than the actual Fat Man plutonium core). In the climax scene, Luthor throws the bomb at Superman's chest, gloating that "nothing can survive the blast of this atomic bomb." The indestructible hero does, of course, and sends the villain to jail for twenty years. This story, with full explanation, did not actually appear until the January/ February 1946 issue of *Superman*.

The second attempt to censor Superman's atomic adventures involved his even more popular newspaper comic strip. In April 1945, the Superman artist drew a futuristic "cyclotron" that was prepared to bombard the hero with three million electron volts at the speed of 1,000,000,000 per hour. "Withdraw Superman!" a bystander warns. "You'll be blasted to pieces." Superman, of course, survives, and the quirky scientist Professor Duste eventually concludes that his "atom smasher" is out of order. The censors asked the McClure Syndicate to refrain from any further atomic-related stories in the newspapers, and they complied. The story line immediately cut to Superman playing all nine positions of a baseball game by himself.

After Hiroshima, the government censorship apparatus met considerable ridicule over its attempts to shut the atomic barn door after the horse had been stolen. Government censors had even asked librarians to turn in names of those requesting the September 7 issue of the *Saturday Evening Post*, which contained Laurence's "The Atom Gives Up" essay. When a house organ of a construction firm published photos of the ongoing building at Hanford, every issue was confiscated and destroyed. Science-fiction writer Philip Leslie was actually held at gun point by security officials for penning a story about a "Nazi Uranium237" atomic weapon.[28]

The loudest scoffing, however, revolved around the attempts to stifle Superman's newspaper comic strip atomic tales. As Lt. Col. John Lansdale Jr. wrote to the War Department in the midst of the second Superman flap, the Office of Censorship simply did not have the personnel to police the nation's newspaper cartoon strips. Moreover, any efforts to do so would simply call unwarranted attention to the subject matter under discussion. In addition, Lansdale argued, having

comic strips treat nuclear themes might not be entirely bad. The odd funny page characterization of a cyclotron would simply serve to "de-emphasize" any serious consideration of the actual device.[29]

President Harry S Truman's August 6, 1945, announcement that the Allies had dropped an atomic bomb on Hiroshima has to rank as the most far-reaching news release in the nation's history. As *The Atomic Age Opens* (1945) phrased it, "The whole world gasped."[30]

This response may be partially traced to the fact that for the previous three years, the mainstream national media had hardly mentioned the concept of atomic power, let alone the possibility of an atomic bomb. Once the cat was out of the bag, however, the media could speak of little else. "[No] single development of this generation . . . has so stirred the imagination of men," remarked an NBC radio news commentator on August 7. "All the leading editorials of the world are playing upon this theme today." The opening of the popular University of Chicago Roundtable radio program for August 12 put it succinctly. Said Chancellor Robert Maynard Hutchins to his panel of distinguished guests, "Gentlemen, is the atomic bomb good or bad for the world?"[31]

The formal University of Chicago Roundtable discussion was replayed in countless informal conversations across the land. As historian Paul Boyer has shown in his classic study *By the Bomb's Early Light* (1985), once the initial shock had faded, the American people instantly comprehended the basic outlines of the new atomic age. *The Atomic Age Opens* contains many examples of this instant comprehension. The bomb changed warfare forever, said one newspaper. There could be no defense against it. A Brooklyn taxi driver prayed that the discovery not fall into the wrong hands. Our government should forever keep the secret, said an enlisted man. The People's Lobby Inc. called for a ban on any further use. Many observers compared the suffering caused by the bomb to the Nazi concentration camps. But all was not despair. The *Berkshire County Eagle* (Pittsfield, Mass.) predicted that cheap power lay right around the corner. A Wyoming senator argued that any such power would surely have countless peaceful uses. As Don Goddard of NBC News said in his broadcast of August 7: "all shades of opinion are expressed and all manner of predictions made."[32] As the 1945 news releases on Hiroshima and Nagasaki regarding uranium and plutonium

showed, all the pre-Hiroshima comic book/comic-strip/science-fiction writers were well off-target with their scientific details. Buck Rogers never precisely explained how the "disintegrator beam" worked. H. G. Wells's atomic bombs were composed of "lumps of pure Carolinum, painted on the outside with unoxidised cydonator inductive enclosed hermetically in a cased membranium." Steve Cartmill's atomic bomb contained a can of "cadmium alloy" with a "speck of radium in a Beryllium holder." The "atomic beam" utilized by the evil Yellow Mask in a 1940 *Superman* radio show caused buildings to "vibrate" themselves to destruction, while Jameson's "giant atom" derived its relentless power from interaction with everything it touched.

But that was not the point. Askew though they might have been regarding scientific details, the popular culture authors had correctly introduced the basic outlines of the atomic era: if a proper atom could be split, it would provide a weapon of unlimited power that could destroy cities in an instant; poisonous rays would soon follow; and grave danger existed that such horrific devices might fall into the wrong hands, for there could be no defense against a surprise attack. As author James Gunn noted in 1975, after Hiroshima people realized that they were all "living in a science fiction world."[33]

Following Truman's announcement on Hiroshima, both science-fiction writers and the nation's cartoonists were quick to point out how accurate they had been. "I saw the headline, brought on the bus by a stranger," recalled famed author Ray Bradbury, "and thought: Yes, of course, so it's here! I knew it would come, for I had read about it and thought about it for years."[34] Indeed, in the aftermath of the war, science fiction achieved an instant level of respectability, one that it has sustained until the present.

A number of newspaper cartoonists took a similar tack. Indeed, several actually claimed credit for predicting the discovery of atomic bombs. For example, in April 1945, three and a half months before Truman's announcement, about 120 American newspapers carried the single-panel cartoon *Private Breger* (in US Army publications termed "G.I. Joe"). Here a round-faced, often befuddled enlisted man holds up a large sign—its back to the viewing audience—that informs two stunned officers precisely how the war would end. Over his shoulder, Private Breger says, "Sorry folks, we can't show it yet." As the epon-

ymous cartoonist Lt. Dave Breger later told *Time*—with tongue only partially in cheek—his cartoon character had "almost exactly" foretold the precise end of the conflict. In August 1945, the *New York Herald Tribune* grimly observed that Truman's press release of the destruction of Hiroshima by "a single small bomb" was "as if the gruesome fantasies of the 'comic' strips were actually coming true."[35]

In October 1945, newspaper cartoonist Harold Gray had his heroine Orphan Annie confess that her protector Daddy Warbucks had long been aware of "this atomic stuff," but that he had kept quiet about it since he wanted to save it for the benefit of the nation. About the same time, Zack Mosley, who had earlier worked on Buck Rogers before creating his own strip, *Smilin' Jack*, portrayed an attractive blonde who stated in no uncertain terms: "What a world! Just think—jet planes, rocket ships, helicopters, radar, atom bombs etc., an actual fact today!" Prominently displaying a blouse covered by the names of twenty-five contemporary American cartoonists, she continued: "And only a few years ago people thought that cartoonists who drew such impossible things in comic strips were batty!"[36]

This opinion was widely shared. In a January 10, 1946, speech, General Leslie R. Groves jested that thanks to Superman and the comic strips, "The children of this country were not surprised about the atomic bomb. They all went home—they were perfectly familiar with it—and said, 'there's nothing to that. We knew it was feasible!' It was the grownups who were surprised."[37]

Groves's off-the-cuff comment may have been more accurate than historians have realized. Scientific details aside, the fact that the American public instantly grasped the basic outlines of the atomic age almost surely had its roots in the larger-than-life adventures of Superman, Buck Rogers, Flash Gordon, and Mickey Mouse, as well as other long-forgotten characters from that "loose and baggy creature" of American popular culture. References to "Buck Rogers" proved widespread all through the Second World War era. In 1940, reporters covered a widely publicized Cal Tech seminar that suggested that Buck Rogers rocket ships lay "just around the corner." In a thoughtful 1944 essay, "How Long Will the War Last?" *New York Times* military correspondent Hanson W. Baldwin noted just after D-day, "The use of atomic energy seems a Buck Rogers idea, but this is a Buck Rogers war,

and no one who has seen the flying bomb is likely to scoff at the possibility of other and more terrible weapons." It is perhaps no accident that Robert Lewis, the copilot of the *Enola Gay*, the plane that carried the bomb, remarked just after the August 6 drop on Hiroshima that "we were struck dumb at the sight. It far exceeded all our expectations. Even though we expected something terrific, the actual sight caused all of us to feel that we were Buck Rogers 25th Century Warriors." Similarly, when Army Air Force General H. H. Arnold predicted on August 17 that electronically controlled atomic missiles were on the horizon, he added: "These Buck Rogers things I'm talking about are not as Buck Rogerish as you might think." Add missiles to atomic weapons, he solemnly stated, and "a Buck Rogers conception of war . . . is right on our threshold." In February 1946, Vice Admiral William H. P. Blandy was termed "the Buck Rogers of the Navy." Shortly afterward, mathematician John von Neumann jested that the US Army was about to join "this Buck Rogers universe." In 1947, a spokesman at an Atomic Energy Commission hearing warned of the dangers that lay with a simplistic public "comic page" and "Buck Rogers" comprehension of atomic energy. He probably never realized the accuracy of his warning. Buck Rogers had emerged as almost a category of thought, and to a somewhat lesser extent, so too had Flash Gordon. In the 1946 MGM film version of the Manhattan Project—*The Beginning or the End!*—scientist Matt Cochrane meets Lt. Col. Jeff Nixon. The dialogue goes as follows: "Hi. My name's Matt Cochrane." "Hi yourself. I'm Jeff Nixon. Give me a fill-in on all this Flash Gordon business." Matt grinned. "Compared to what we're trying to do, Flash Gordon is a kid from the Stone Age."[38]

Since the mainstream press and radio had hardly mentioned atomic themes for over three years, it seems fair to ask: from whence did the average American derive his or her instant level of atomic comprehension? The most likely answer lies in the amorphous realm of American popular culture: science fiction, newspaper comic strips, and comic books. These aspects of American life, which had numerous overlaps with radio, film, and other forms of mass marketing, had conveyed "atomic" themes to American readers for over fifteen years. The numbers speak for themselves. In December 1944, *Time* magazine

estimated that 20 percent of adults read comics avidly; comics sold better on military bases at a 10–1 margin than any other magazine. A year later, social critic Walter Ong estimated that the cartoon industry produced twenty-five million comic books and perhaps six billion newspaper comic strips every month.[39] Scientifically inaccurate though they may have been, these comic books and comic strips frequently discussed the basic framework of: unlimited power sources, horrific weapons, and "poison rays," all utilized by an assortment of loathsome villains. Forged largely by the popular culture of the interwar era, this basic framework of understanding almost surely provided the matrix through which the majority of the American people first tried to comprehend the implications of President Truman's momentous pronouncement.

PART II

THE INITIAL

REACTION:

1945–EARLY 1960S

COMING TO GRIPS
WITH THE ATOM

EARLY ATOMIC SUPERHEROES

n 1940 the American Physical Society, the main US professional physics organization, contained 3,751 members. Assuming that slightly over half had some interest in the subatomic world, this meant that in August 1945 only about two thousand people really comprehended the scientific implications of the fissioned atom. In 1945, this group faced an enormous task, for virtually every intelligent citizen wanted to understand precisely what had occurred at Los Alamos, Hanford, Oak Ridge, Hiroshima, and Nagasaki. The atom, as Hans Bethe told a nationwide radio audience on December 2, 1945, had become "the hero of the day." But, as then twenty-two-year-old Cleveland resident Molly Roth later recalled, "you almost did not know how you should feel."[1]

The scientists were quick to respond. Within a year, Robert Marshack, Eldred C. Nelson, and Leonard I. Schiff—all identified as from "the Los Alamos Atomic Bomb Laboratory"—published *Our Atomic World* (1946). Simultaneously, Dexter Masters and Katherine Way edited *Our World or None*, subtitled "A Report to the Public on the Full Meaning of the Atomic Bomb." This slim volume contained essays by J. Robert Oppenheimer, Albert Einstein, Leo Szilard, and others. Oak Ridge physicist Russell R. Williams wrote "The Meaning of Atomic Power" for the *Saturday Review* and so on. In addition, science writers David Dietz and John W. Campbell added their explanations in, respectively, *Atomic Energy in the Coming Era* (1945) and *The Atomic Story* (1949). In 1946, Harvard president James Bryant Conant claimed that the future of the nation depended on its ability to educate its citizens in the field of science. The next year a special committee of the Federation of Atomic Scientists began a campaign to raise a mil-

lion dollars to inform Americans about the vast implications of atomic energy.[2]

These hastily compiled scientific introductions shared many similarities. Cautioning that there was no single "atomic secret," the scientists predicted that any nation (read the Soviet Union) could create a similar nuclear weapon within five years. Testifying at a Senate committee hearing, General Leslie R. Groves demurred. For engineering reasons alone, he predicted that the Soviet Union would need twenty to sixty years to produce a similar bomb. But everyone agreed that atomic weapons had forever altered the face of warfare. "It is most effective as a surprise weapon," General Groves told a group at the Industrial College on January 10, 1946. "The bombs will never again, as in Japan, come in ones or twos," cautioned scientist Philip Morrison. "They will come in hundreds, even in thousands." "There is no defense," concluded radar specialist Louis N. Ridenour. The only defense against an atomic bomb, said General Groves, is not to be there when it is dropped. The power of fissioned uranium atom was such, the scientists insisted, that it created "the absolute necessity of international control of atomic energy and atomic bombs if the people of all nations are to live in a stable, peaceful world." Any nuclear arms race had to be stopped at the onset, they insisted. The world had to devise a precise solution, and it had to do so immediately. The sense of urgency was palpable. "Gentlemen, you are mad," said social critic Lewis Mumford. "Let us say no to the atomic bomb rather than say no to life itself."[3]

Catapulted into the spotlight—really for the first time—American scientists devoted countless hours to spreading the message. Los Alamos veterans spoke to numerous regional service clubs, such as Rotary, and to an equal number of civic and women's organizations. No cocktail party was complete unless it had a scientist to explain the meaning of the new era. In a particularly creative effort, British Mission veteran Joseph Rotblat—who had departed Los Alamos for London after learning that the Germans had surrendered—helped establish an Atom Train Exhibition. Essentially a traveling museum housed in several railway cars, the Atom Train toured all through the British Isles. The elaborate displays did an excellent job in explaining atoms, radioactivity, nuclear weapons, and the practical applications of the fissioned atom. Juxtaposing a map of what would occur "If a bomb fell

on London" with the probable atomic breakthroughs in agriculture, industry, energy, and medicine, the Atom Train maintained that the opening of the atomic age held great possibilities for both good and evil. As it solemnly concluded: "Which is it to be?"[4]

The scientists' overall message juxtaposed grave warnings with earnest pleas for UN control. But they did not stop there. As will be shown in the next chapter, they also hoped that the fissioned atom would somehow revolutionize the world's energy situation. Admitting that they could see no further than the faintest shadow of the nuclear future, many crossed their fingers that atomic energy could be put to work for the benefit of humankind.[5]

In their earnest efforts to convey the message to the nation, the scientists did not limit themselves to radio, public performances, or the world of print. In fall 1945, Dr. Edward Tompkins of Oak Ridge contacted Donna Reed, a former student who had established connections with Hollywood, to suggest that the story of the atomic bomb might be made into a movie. Reed gave his letter to MGM, and soon director Sam Marx inaugurated production of the first "atomic film." The title was derived from a phrase by Harry Truman, "the beginning or the end." Directed by Norman Tauroy from a screenplay by Lt. Com. Frank Wead, the film starred Brian Donlevy as Maj. Gen. Leslie R. Groves, Audrey Totter as Groves's secretary Jean O'Leary, and Hume Cronyn as J. R. Oppenheimer. Marx also drew upon several military and technical advisors—including Tompkins, who had written the initial letter—and even had two consultations with President Truman. To ensure fairness, Marx allowed the marines, navy, army, and merchant marine to help select actors for the Hiroshima sequence. Although the studio had access to several feet of actual atomic bomb footage, MGM technicians decided not to utilize the Signal Corps films. Instead, their special-effects experts labored for seven weeks to produce a depiction of the detonation. They "bombed Hiroshima" twenty-five times before they were satisfied with the results.[6]

A flop with both the critics and at the box office, *The Beginning or the End* mixed fact and fiction in an awkward retelling of the Manhattan Project story. Although the director persuaded Albert Einstein to reenact his famous letter to Roosevelt, he also introduced a fictional Lt. Col. Jeff Nixon, who watched in horror as his fictional colleague Matt

Cochrane died in a radiation accident. Jeff had the equally unpleasant task of delivering Matt's last letter to his pregnant wife, Anne. After Jeff handed over the letter, symbolically, under the shadow of the Lincoln Memorial, Anne painfully read it aloud:

> God has not shown us [with Hiroshima] a new way to destroy ourselves. Atomic energy is the hand he has extended to lift us from the ruins of war and lighten the burdens of peace.
>
> You and the boy will see the way when the atoms in a cup of water will heat and light our home . . . when the power in a pasteboard railroad ticket will drive trains across great continents . . . when the energy in a blade of grass will send planes to distant lands and let the people know one another . . .
>
> You, the giver of a new life, must know that what we have unleashed is not the end. With all my love, I tell you this, my dear: men will learn to use this new knowledge well. They won't fail. They cannot fail! For this is the moment that gives all of us a chance to prove that human beings are indeed made in the image and likeness of God.[7]

Graphic illustrations also played a vital role in explaining the atom's power to the astonished world. Two months after the Japanese surrender, *Life* magazine published General H. H. Arnold's grim prediction that any future atomic war might incinerate over ten million Americans. In several shocking drawings, *Life* artists created the nation's first graphic images of the probable destruction of Washington, DC, as well as bewildered radiation monitors standing in front of the ruins of New York City's public library. A few months later cartoonist David Low and scientist Albert Einstein added their contribution. Low sketched a fiery white horse labeled "atomic energy" that had eluded the grasp of two amateur cowboys marked "politics" and "science." This cartoon introduced the *New York Times* essay by Einstein, who argued that humankind had to devise a new type of thinking if it hoped to survive, because "the real problem is in the hearts of men." Although the US Atomic Energy Commission needed to begin the process of control, Einstein said, their decisions depended ultimately on those made in the public square. "To the village square we must carry the facts of atomic energy," he noted. "From there must come America's voice."[8]

Comic Books

The Beginning or the End, *Life* magazine, and the *New York Times* were not the only mass culture avenues by which the implications of the atomic age reached the American public in the immediate years after the end of the war. In the fall of 1945, the comic book companies found themselves especially well poised to deliver their own versions of the atomic message. Circulation had never been higher. In spite of War Production Board restrictions on paper, ink, and electricity, plus the drafting of numerous cartoonists, the industry sold between forty and sixty million comics every month as servicemen "developed an insatiable appetite for comic books." Although circulation fell to twenty-seven million a month by 1946, that still represented a massive social force. From the fall of 1945 to about 1960, the comic book industry treated the onset of the atomic age in three distinct phases. First, the various "educational" comics tried to simplify nuclear history for their readers, along with stern advice to young people on how they should utilize this newfound power. Second, artists hastily cobbled together a cadre of "atomic superheroes," none of whom survived for very long. Finally, writers engaged their established costumed superheroes in confrontations with a variety of atomic threats, after which the hero often didactically warned readers of the potential dangers of the fissioned atom.[9]

Since the comic book industry operated on a lead time of several months, the abrupt end of the war in August 1945 caught them by surprise. For the most part, it was early 1946 before writers were able to come out with any atomic-themed comic stories. In January 1946, *Real Life Comics* placed the atomic bomb on its cover, but the issue lacked any interior story. An unnamed editor, however, wrote a lengthy introduction that set the tone for the next decade:

> Most of today's leaders are already old. They will soon have to pass their leadership to younger hands. And when they pass it on it will be squarely up to the boys and girls now growing to manhood and womanhood in the postwar world to see that the tremendous force of the atom is used for the good of mankind.
>
> Youth, especially American youth, has been given the philosopher's stone

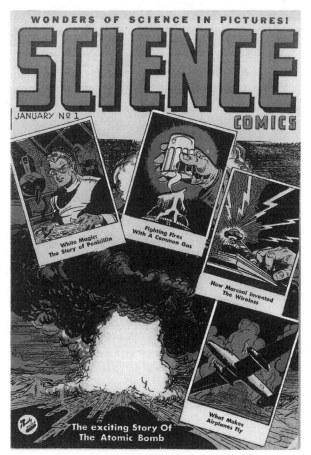

Cover of *Science Comics* #1 (Humor, January 1946). "The Bomb That Won the War," the lead story of this issue, offers a simplified version of atomic history and an optimistic forecast for atomic energy.

for which the wise men of the Middle Ages searched so long in vain. It will be the responsibility of the younger generation to employ it wisely!

Boys and girls of America, the future is in *your* hands.[10]

The January 1946 *Science Comics* similarly featured "The Bomb That Won the War" on the cover and followed with a lead story that presented early atomic history, as well as an account of the destruction of Hiroshima. The tale closed with the hope that "In the hands of the

peace-loving nations of the earth, atomic energy will help build a new world far more wonderful than man ever dreamed a few brief years ago!"[11]

In like fashion, *True Comics* presented the story of "atoms unleashed" for its March 1946 issue. Slightly confused as to the details of atomic history, the creators nevertheless expressed their hope that atomic energy might help cure cancer and "bring about a new era of enlightenment and progress." *Air Ace* (February/March 1946) provided a full-color picturization of the atom and its probable future. The initial publication of *Picture News* (January 1946) opened with the question: "Will the atom blow the world apart?" The February 1946 *Picture News* portrayed J. Robert Oppenheimer warning a US Senate committee that "no nation could successfully defend itself against an atomic attack." Here illustrators juxtaposed the graphic destruction of London, New York, and Moscow against the peace and prosperity provided by universal, cheap energy. The only way to control the atom, they suggested, lay with United Nations' supervision.[12]

Virtually every nonfiction comic book of the late 1940s produced a variation of these themes. *Jim Ray's Aviation Sketchbook* (March/April 1946) and *Future World* (Summer 1946) are representative examples. Both mixed easy-to-comprehend pictorial portrayals of nuclear fission with hopes of endless atomic power for cars, trains, and ships. As *Aviation Sketchbook* concluded, "In evil hands it could destroy the world. Let's make it work for peace." Two other similar offerings, *Picture News* and *Air Ace,* depicted America's spring 1946 test explosion of atomic weapons at Bikini in the Marshall Islands. *Air Ace* reporter Al Klein described the last-minute evacuation of natives from the Eniwetok Atoll because of radiation dangers. Klein frankly admitted his fears. After watching the detonation of the atomic weapons "ABLE" and "BAKER," he wrote that it seemed like the end of the world. *Picture News* featured atomic bomb stories in six of its first ten issues. In 1947, Street and Smith publishers brought out what they termed an "American first"—a 160-page "inspirational textbook" entitled *Science Is in the Air,* told primarily through illustrations. This book detailed the forthcoming wonders of science in general and atomic wonders in particular. David A. Lilienthal, chairman of the US Atomic Energy Commission, added an essay on "Peacetime Uses of Atomic Energy,"

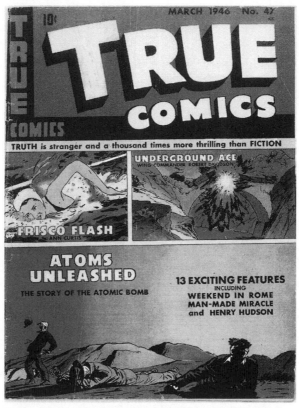

Cover of *True Comics* #47 (True Comics, March 1946). The story "Atoms Unleashed" in this issue suggests atomic energy might help cure cancer, providing advice to young people on how they should utilize the newfound power of atomic energy.

while artists set forth the first pictorial representation of "Atomic Peace." A quirky one-shot issue of *The Secret Voice* (1945) relayed the tale of Cosmo, a cartoon bug, who had helped the scientists discover the secret of atomic weapons and now hoped to produce "a post war beam for a better world."[13]

From 1945 to the late 1950s the comic book editors and artists seized on the ambiguity of atomic power and urged young people to use it with caution. Thus, the initial comic book response to the onset of the atomic age proved far more perceptive than one might have imagined.

Probably the foremost attempt to educate American youth in this fashion came with the publication of *Dagwood Splits the Atom* (1949). In this work, King Features lent its familiar cartoon characters for a challenging assignment. Blondie and Dagwood shrank to atom size to explain nuclear fission through a combination of illustration and rather dense text, as Mandrake the Magician, Popeye, and Jiggs all marveled at their adventures. Newsman Bob Considine wrote the introduction, while none other than former Manhattan Project chief General Leslie R. Groves (now retired) wrote the foreword. Considine praised *Dagwood Splits the Atom* as the clearest explanation of atomic energy he had ever seen. He also encouraged young people to choose atomic energy for their careers, predicting that the atom would eventually power trains, cars, and aircraft. General Groves echoed this sentiment. "No effort is too great for us to make in imparting the facts about atomic energy to the greatest number of our people," he said. King Features artist Joe Musial dedicated the comic to the nation's young people. It was up to them to assume the responsibility of directing atomic energy for useful purposes, he said. Musial also warned that the knowledge of how to split the atom would never disappear. Since this publication was "no ordinary comic book," he urged people to read *Dagwood Splits the Atom* several times. This comic propelled Musial to a national reputation.[14]

Although comic books had long been proud of their "nonfiction" titles, the educational wing of the industry never turned much of a profit. After only ten issues, *Picture News* died in 1947. *Air Ace* succumbed the same year. *True Comics* did not last beyond 1948. *Real Fact* expired in 1949. Although *Classic Comics* continues today, industry leaders quickly realized that the comic book functioned far better as a source of entertainment than as a means of instruction.

Thus, the ultimate power of the comic book presentation of the early atomic age probably lay less with the factual publications than with its skill at storytelling. And, as we are just now beginning to realize, whoever tells the stories controls the culture. *Dagwood Splits the Atom* to the contrary, comic book writers and artists had far more influence when they wove the atomic messages into thrilling tales of adventure.

New Atomic Superheroes

Since the words "atom" and "atomic" were on everybody's lips, publishers hurried to tap this universal interest. A two-page bare-chested "Atomic Man" emerged in December 1945 with the promise: "I will dedicate my life to spread happiness throughout the world by means of atomic energy!" but, alas, he never appeared again. In early 1946, two separate companies came out with identically titled *Atomic Comics*. Like the pulps, they featured striking, even lurid covers. The first *Atomic Comics* (January 1946) depicted the villain Fang Gow counting his riches. In spite of their primary titles, however, none of the interior stories dealt with nuclear themes. Eventually one title featured "Lucky Wings, the Atomic Blondshell," but neither version of *Atomic Comics* lasted long. Since the larger-than-life hero lay at the core of 1940s comic book popularity, it took only a short while before a new wave of atomic-themed superheroes reached the newsstands. In late fall 1945, Jay Burtis Publications placed a caped, shirtless, masked hero wearing bathing trunks on the cover of its *Atomic Bomb* comic book. Although he dominated the cover, Mr. "Atomic Bomb" did not appear inside. There was no second issue.[15]

After this false start, three other companies similarly attempted to market their own version of the "atomic superhero." In the November/December 1945 *Headline Comics*, Adam Mann accidentally drinks a glass of heavy water into which some U-235 crystals had fallen. Then he stumbles into a high-voltage machine. This "incredible chemical accident" turns Adam Mann into a human atomic bomb, with the new power concentrated exclusively in his right hand. (He had to wear a lead glove to stop the radioactivity from leaking away.) Donning a red cape, a kilt, and a Roman legionnaire's helmet, "Atomic Man" spent his efforts righting various wrongs, such as thwarting a deranged scientist who planned to take over the world. After dispatching the villain, Atomic Man berated him for "using [his] scientific knowledge for destructive purposes." The dialogue smelled of the lamp. In one installment, the hero says, "Allow me to introduce myself—"I'm Atomic man! I'm going to vaporize you—unless you surrender!" During the course of his career in *Headline*, Atomic Man discovered that "[I] could use my power to crush every evil influence in the world."[16]

Cover of *Atomic Comics* #1 (Daniels, January 1946 [Canadian]).
This short-lived title represents the hasty efforts of comic book
companies to cobble together a cadre of atomic superheroes.

Unfortunately, Atomic Man could use this power for only six issues; he
expired in September 1946.

Other atomic heroes suffered similar fates. Regor Company's *Atomic
Thunderbolt* hit the newsstands in February 1946. It tells of William
Burns, former merchant mariner who had degenerated into "Willy the
Wharf Rat" after suffering shell shock from a near-miss Nazi torpedo.
A fiendish scientist entices Willy into his laboratory for an experiment
but mistakenly pulls the wrong lever. The ensuing blast kills the sci-
entist but leaves Willy with an indestructible body and the ability to
fly. Garbed in white costume and red gloves with a sun symbol embla-

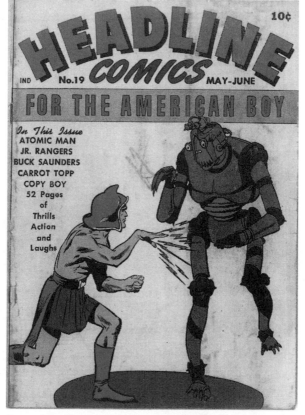

Cover of *Headline Comics* #19 (Prize, May/June 1946). Despite the promise to use his atomic power to "crush every evil influence in the world," Atomic Man lasted for only a half-dozen issues.

zoned on his chest, the Atomic Thunderbolt resolves to "devote my life to save mankind from itself." Achieving this goal proved difficult, however, as the Atomic Thunderbolt did not survive for a second issue.[17]

His successor, Atoman, fared only slightly better. Spark Publications prefaced its 1946 comic with two pages of actual nuclear history, which reminded readers that atomic power could be used for both good and evil. The artists then unveiled a marked, yellow-caped hero whose story "comes right out of the headlines." Scientist Barry Dale worked at the Atomic Institute studying "the secret atomic formula." In a man-

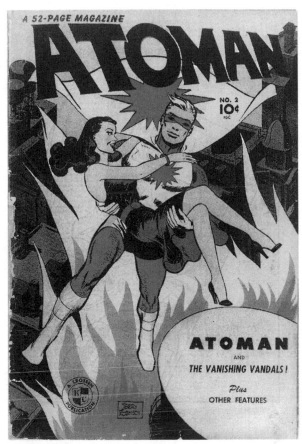

Cover of *Atoman* #2 (Spark, April 1946). Perhaps because of its main character's incomplete backstory, the *Atoman* series collapsed after the second issue from lack of sales.

ner never fully explained, he becomes radioactive and acquires new strength as Atoman, a person "whose body generates atomic power." The tale concludes with a soliloquy: "Atomic power cannot belong to one man . . . group of men . . . or even one nation! It belongs to the whole world! My own power must be used to help all people . . . regardless of race or creed or nationality."[18] *Atoman* survived for a second (April 1946) issue, but even though artist Jerry Robinson had a third story almost completed, the series collapsed for lack of sales.

Atom Wizard (1947) represented the final early American attempt to create an atomic hero. In two completely disconnected story lines, Victory magazine artists introduced a young man who eventually donned a cape, blue mask, and red leotard with the atomic symbol emblazoned on his chest. The origin story proved as complex as his costume. The hero, Drew Lane, had a scientist father who fortunately sprayed him with a "neutron-resistant" solution that protected him against atomic explosions. Forced by Nazis to duplicate his father's discoveries, the young hero detonates an atomic weapon to destroy them but (thanks to the spray) survives intact. Pondering the danger of atomic energy in the wrong hands, the Atom Wizard solemnly resolves that "from now on I dedicate my life to the protection of the world."[19] Unfortunately, he had only two issues to so do.

The much smaller British comics industry introduced its own version of atomic heroes around the same time. The *Atomic Age Comic* (1947) featured "Atomic Tommy, the Bullet Proof Spy Smasher." This was soon followed by *Atomic Comic* and the weekly adventures of Marvelman, whose alter ego had only to say "Kimota" before a lightning flash of atomic power turned him into mighty Marvelman. The British superhero was no fool. When faced with a villain firing an atomic bazooka, he astutely observed, "Now that's a nasty weapon." Simultaneously, the *Adventures of Captain Atom* (1950) boasted that its stories were based on "scientific facts and theories."[20]

No "atomic superhero" succeeded with the public until Spider-Man in the early 1960s. Perhaps the ambiguity that dominated the late 1940s/1950s—where grave warnings of destruction were interlaced with dreams of endless energy—proved too complex to be expressed in the restricted form of a costumed, comic book superhero.

Superheroes and the Early Atomic Age

Writers in the late 1940s to early 1950s soon discovered that they faced major dilemmas when they pitted their established heroes against atomic bombs. Even with all their respective powers, the superheroes seemed dwarfed by the reality of Hiroshima and Nagasaki. It took only a few months for a standard plot line to emerge: a villain tries to steal an atomic device only to be thwarted at the last moment. The adventure comics of the era abounded with variations of this story line. For

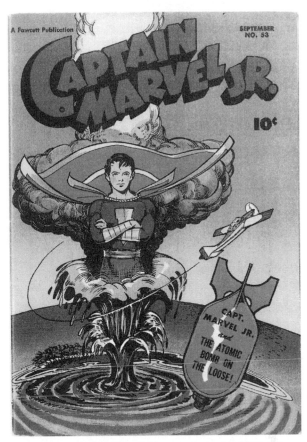

Cover of *Captain Marvel Jr.* #53 (Fawcett, September 1947). This issue illustrates what emerged in the late 1940s and 1950s as a standard plotline in atomic-themed comics: an established super-hero thwarts a villain's attempt to steal or use an atomic device.

example, in 1947, Fawcett's Captain Marvel Jr. battled a villain who had stolen an atomic bomb (depicted as roughly the size of a shoe-box). The terrorist threatened to drop the weapon on a city unless he received ten million dollars. Captain Marvel Jr., however, steered the villain's aircraft into a fog and tricked him into dropping the bomb into the ocean. Although artists depicted a gigantic mushroom cloud, the world remained safe for another issue. Similarly, Captain America and Bucky saved the nation's atomic secrets from falling into the hands

of "The Executioner." In 1954, government agent T-Man defused a hydrogen bomb that had been placed in a statue in the main plaza of an unnamed European city.[21] Such last-minute resolutions borrowed heavily from the world of pulp fiction.

At times, however, the comic book hero also voiced a distinct message for the reader. In October/November 1950, the Durango Kid, along with sidekick Muley, confronted an evil scientist who had invented an "atomic gun." After dispatching the villain, the Durango Kid heaved the weapon into quicksand, noting, "Mankind is not yet ready for a force of such terrible destructive power." In the last panel, he turns to his companion and says, "And let's pray, Muley, that no one ever invents anything like it." Similarly, in 1950 Wonder Woman foiled a villain who had planned to establish an assembly line of atomic weapons. After capturing him, she warned that those who lived by violence were likely to meet a similar end.[22] Rarely had comic book heroes been so didactic in conveying their message to readers.

The universal popularity of the term "atom" allowed DC editors to resurrect a second-level figure from their prewar pantheon and repackage him as a revived "The Atom." When he was first created in 1940, the Atom was so termed simply because he was small. In the 1948 resurrection, however, the Atom was given new powers—plus a new costume. He remains a secondary figure to this day.[23]

The most popular superheroes, such as Superman, and the Marvel family all discovered that the atomic bomb matched even their powers. This made for some rather awkward storytelling. In an October 1946 *Action* #101 story, Superman has been forced to swallow a drug that makes him temporarily insane. (He did this only to save Lois Lane's life.) In this befuddled state, he mistakenly flies into the Bikini atomic blast, which, fortunately, clears his mind. In gratitude, Superman borrows a camera to photograph the mushroom cloud from above. He does so as "a warning to men who talk against peace."[24]

Some of Superman's most exciting postwar atomic adventures can be found in the thirty-six-episode cliffhanger *Superman vs. the Atom Man*, which aired on radio in 1946. Although the dangers of kryptonite (a fragment from the Man of Steel's home planet that alone could destroy him) were first introduced in a 1943 radio show, kryptonite did not gain widespread popularity until this particular story. After Hiroshima,

Cover of *Durango Kid* #7 (Magazine Enterprise, October/November 1950). After he destroyed a villain's "atomic gun," the Durango Kid didactically warned readers that "Mankind is not yet ready for a force of such terrible destructive power."

Superman writers turned kryptonite into a highly radioactive element that emitted powerful gamma rays, much stronger than ordinary uranium. In this radio saga, an ex-Nazi scientist named Der Teufel ("the Devil" in German) injects a German youth with crushed kryptonite to turn him into Atom Man. Atom Man, who can shoot lightning bolts from his fingers, plans to destroy the main reservoir above Metropolis and thus drown the city. In the climax scene, a much-weakened Superman grabs Atom Man from behind and carries him to ten thousand feet, where—enervated by the effects from the kryptonite—he passes

out and the pair both plummet to the earth. (Only one survives.) In 1950 Columbia Pictures reworked this story so that it is Superman's arch enemy, Lex Luthor, who turns into Atom Man.[25] In these characterizations, "the atom" was by no means an entirely positive contribution to the health of the world.

Captain Marvel

The second most popular superhero of the day, Captain Marvel, faced a similar dilemma, but with one exception: he had better writers. *The Adventures of Captain Marvel* and *Whiz Comics* provided the most imaginative comic book treatment of atomic themes for the entire postwar era. Many of the approximately five hundred Captain Marvel stories were written by former pulp fiction writer Otto Binder and usually drawn by master artist C. C. Beck. They combined their talents to create a kindly, often obtuse, even whimsical superhero whose sales eventually topped those of Superman in the late 1940s. (His enemies called him "the Big Red Cheese.")

Binder and Beck crafted a number of immensely clever Captain Marvel "atomic parables." In the October 1946 issue, Captain Marvel confronted the onset of atomic war. The cover depicts him vainly attempting to halt an incoming atomic bomb. In the story, Beck drew the destruction of Chicago and the death of a mother and child whom Captain Marvel had just rescued from a burning house. "Everyone died in this atomic war!" the hero despairs. "I'm . . . I'm, the only man left alive." The story proves to be only a television dramatization. In the last panel, the children watching the show realize, "I guess we'd all better learn to live and get along together . . . one nation with all other nations . . . and one person with all other persons so that the terrible Atomic War will never occur!"[26]

In 1951, Captain Marvel battled an "atomic fire" that could not be extinguished on earth. He solved the problem by cutting out a one-hundred-mile flaming circle of soil and flinging it into the sun. In the last panel, the indestructible hero nearly collapses at the realization that if he had failed, it would have meant the end of the world.[27]

In yet another story, Captain Marvel resolves a conflict between quarrelsome ants and wasps, who were on the verge of an atomic war to decide which species would dominate the globe. (Because of their

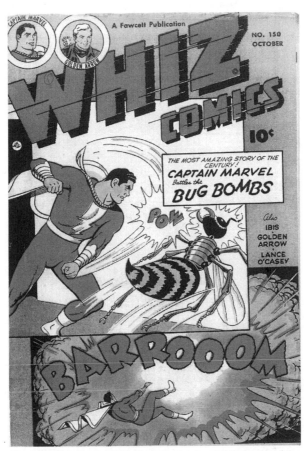

Cover of *Whiz Comics* #150 (Fawcett, October 1952). In one of the
"atomic parables" featuring Captain Marvel in the late 1940s and
early 1950s, the superhero brings peace to insects on the verge of
atomic war through the creation of an organization similar to the
United Nations.

size, ants had slipped through the US defense plants to steal atomic
secrets. In turn the wasps had stolen the secrets from the ants.) In solv-
ing this dispute, Captain Marvel helped the ants and wasps form the
"UI"—a United Insects organization: "Like our United Nations, it will
promote peace here in your insect civilization!"[28]

Captain Marvel also confronted the dilemmas of nuclear energy.
In "Captain Marvel and the Atomic Shop" (1947) a well-meaning pro-

fessor named Adam Atomme sells atomic energy—"the most power-
ful force in the world today"—to all interested passersby; one could
purchase it as an atomic cereal, atomic pain reliever, or atomic acid.
Captain Marvel has to stop Professor Atomme's wayward nephew from
robbing a bank with the atomic acid, and in the last panel he con-
vinces the professor to do additional research before marketing any
more atomic products. In *Captain Marvel Adventures* #107 (April 1950),
the World's Mightiest Mortal confronts a space alien who derives his
strength from consuming cans of "condensed atomic power." Since the
two protagonists find their strength precisely equal, they pummel each
other from China to South America to the North Pole. Finally, Captain
Marvel forces the alien to consume his atomic food all at once, where-
upon he detonates like an atomic bomb. But he survives. The reason:
"I thrive on atomic energy: It can't hurt me." In the last panels, the
hero forces the alien to flee earth, never to return, thus ending "The
world's mightiest battle." In still another adventure, Captain Marvel
tricks "Mr. Atom," an atomic robot who hopes to rule mankind, into
entering a lead-lined prison. Since Mr. Atom can break out momen-
tarily, Billy Batson (Captain Marvel's alter ego) warns readers that "Mr.
Atom is a menace that the world cannot safely ignore!" In 1951, radio
station WHIZ (where Billy Batson works) obtained "atomic power."
This power begins harmlessly enough, but as in the *Sorcerer's Apprentice*
it soon threatens to run amok and destroy everything. Although Cap-
tain Marvel safely brings atomic power under control, the reader is left
with a decidedly unsettled feeling about the whole affair.[29]

Binder and Beck's clever atomic allegories came to an abrupt end in
1953. Shortly after Beck had helped create Captain Marvel, DC Comics
sued Fawcett for breach of copyright, claiming that the Big Red Cheese
borrowed too many characteristics from the Man of Steel. After sev-
eral years in court, combined with sagging sales, Fawcett withdrew the
character in 1953. Ironically, twenty years later, DC purchased rights to
all the Marvel figures and reintroduced them under the title *Shazam*.
The new stories, however, never had the whimsy of those from the
Binder-Beck team. When Captain Marvel disappeared in 1953, so did
the most imaginative comic book allegories of the atomic age.

Atomic Animals

From the onset of the atomic era, cartoonists had difficulty extracting humor from the situation. The first to try was George McManus, creator of the popular newspaper strip *Bringing Up Father*, which detailed the misadventures of newly rich Irishman Jiggs and his social-climbing wife Maggie. In 1948, McManus edited a slim volume *Fun for All* that bore the subtitle "A Lighthearted Reflection of These First Years of the Atomic Era." The compilation, however, contained only one feeble attempt at authentic "nuclear humor": A postwar inspection team at Hiroshima discovers an anomaly—a house with upper windows intact while the lower ones are shattered. Asking the woman of the house about the lower windows, they inquire, "Atomic bomb?" She shakes her head and replies, "Small boy." Extracting humor from the early atomic age proved more challenging than McManus had realized. Cartoonist Robert Osborn's grim *War Is No Damn Good* (1946) contains no light moments. I could find only three *New Yorker* cartoons from 1945 to 1957 and only one *Beetle Bailey* strip from 1950 to 1952 that contain "atomic humor."[30]

Perhaps the closest that cartoonists came to producing genuine atomic humor lay with the mildly madcap adventures of a cadre of atomic animals. Ever since the 1930s, talking animals had filled an important niche in the comic book world. By the late 1940s, Walt Disney's Mickey Mouse and Donald Duck had achieved worldwide recognition. So, too, had Warner Brothers' Bugs Bunny, Walter Lantz's Andy Panda, and MGM's Tom and Jerry. Their success produced a lengthy list of secondary and tertiary animal characters, such as Petunia Pig, Gladstone Gander, Super Rabbit, Krazy Krow, Buggy Bear, and Dodo and the Frog. Charlie Carrot served as one of the few vegetable heroes. (His lady friend was a hot tomato.)[31]

Overall a gentle satire infused the world of these comic book animals. For example, *Red Rabbit* parodied the popular western newspaper strip *Red Ryder;* Super Mouse (the Mouse of Stainless Steel) and Mighty Mouse did the same for Superman. In Hoppy the Marvel Bunny, Fawcett artists created an animal parody of Captain Marvel, who, like his hero, had only to say "Shazam" to assume super-animal powers.[32]

During the war, the American "funny animals" had donned a num-

ber of hats. In 1943, *Animal Comics* showed characters in a carnival scene heaving balls at a portrait of Hitler, and a short-lived character Bee-29 earnestly urged the nation to meet its "honey production goal."

After 1945 every major comic publisher of any size tried to grab a share of this popular market. The titles reflected their similarity: National Periodical's *Animal Antics*, Fawcett's *Animal Fair*, Advanced Global Connection's (ACG) *Funny Films*, Red Top Comics' *Funny Fables*, Holiday Comics' *Animals on Parade*, Walter Lantz's *New Funnies*, Fawcett's *Funny Animals*, Carleton's *Frisky Fables*, Harvey's *Funny 3-D*, DC Comics' *Funny Stuff*, and Parents' Magazine Press's *Funny Book*. The list could easily be extended. Although the majority of these stories proved eminently forgettable, their popularity persisted among young readers for decades.

Thus, in the immediate postwar years, the funny animals formed an important subset of American comic book offerings. In 1952, for example, six of DC Comics' thirty-nine books were of this ilk, starring long-forgotten characters such as Doodles Duck, Ozzie Owl, and Nutsy Squirrel.[33] Around the same time, the far more popular *Looney Tunes*, featuring Bugs Bunny, sold an enormous three million copies every month.

Given their widespread appeal, it was not long before the talking animals ventured into the atomic age. Disney artist Carl Barks created one of the first stories, "Donald Duck's Atom Bomb," for a 1948 Cheerios "giveaway." By mixing "mashed meteors, brimstone, and a lightning bolt," Donald created an atomic bomb in his kitchen. A villain stole the formula—only to discover that Donald's "atomic bomb" simply caused people's hair to fall out. (Today Disney executives try their best to prevent reprints of this tale.) Three years earlier, *All Humor Comics* had introduced "Atomic Tot," an elflike newsboy who becomes a defender of justice because: "his size and ragged clothes/conceal the fact that through his veins/Atomic energy flows."[34] *Toytown Comics* (March 1947) created an oddly drawn urchin named Upan Atom, who wore a derby hat, still used a high chair, and drank carrot juice to turn into "the Mighty Atomic Destroyer." Although he bested such rascals as the Brain and the Freezer, dreadful story lines assured that Upan Atom's career was not a long one.

Unlike their Japanese counterparts (to be discussed shortly), Ameri-

Cover of *Atomic Rabbit* #9 (Charlton Comics, 1957). Atomic Rabbit was one of a cadre of atomic animals in the 1950s and 1960s that helped recast "the atom" from a source of fear to one of strength and justice.

can funny animals expressed no concern over issues of radiation. In fact, radioactivity provided most of them with their superpowers. In 1957, Charlton Comics' Tom Cat fell asleep next to "atomic rays," absorbing them to become "Atom the Cat." Atom the Cat revived his waning atomic power by consuming fish. During the early 1960s, Hanna-Barbera Studios created Atom Ant, who drew on his proportional strength to serve justice. Atom Ant also enjoyed a brief television career. Al Fago's Atomic Mouse and Atomic Rabbit stood out

as the most clever of the postwar atomic animals. Born in 1953, meek "Cimota" Mouse was badly treated until he swallowed some U-235 pills, donned cape and costume (with a large "A" on the chest), and reversed his forename. Afterward, he assumed a new role: "helping to keep peace and order throughout the universe." Lighthearted and cleverly drawn, Atomic Mouse lasted fifty-four issues, with both television and movie tie-ins.[35] In the 1970s Atomic Mouse bounced back for a second life with a Mexican publisher.

In 1955, Fago's artists tried to repeat this success by introducing "Atomic Rabbit," who gained his powers from munching radioactive carrots. On a 1957 *Atomic Rabbit* cover, "the President" proclaimed that "Atomic Rabbit is the fastest and most powerful crusader for law and order in the world." The name changed to *Atomic Bunny* the next year, but the nuclear rabbit hero disappeared after only nineteen issues. In their lighthearted fashion, these atomic animals helped domesticate the earlier fears represented by such villains as "Mr. Atom" and others. In the funny animal tales, "the atom" had again emerged as a source of strength and justice. But it had not been an easy journey.[36]

ATOMIC COMIC UTOPIAS, ESPIONAGE, AND THE COLD WAR

In the wake of Hiroshima, a number of scientists and science writers quickly revived the earlier 1939–41 dreams of an atomic utopia. Tucked amid the dire warnings of future wars, predictions of horrific destruction, and the need for UN control were countless statements that suggested, in physicist Enrico Fermi's words, that atomic energy might bring forth "an age of plenty for the human race." Others predicted that atomic energy would provide endless power to homes and factories, similar to the "free compressed air" then available at local service stations. But the local service stations, as well as the coal industry, would likely disappear. Although the petroleum industry would probably not collapse overnight, its products would be confined to the production of plastics. If a compact nuclear power plant for automobiles could be developed, "it would revolutionize our power uses." Neutrons could produce radioactive varieties (isotopes) of virtually every known element, and these would have untold medical applications.[1] The future looked promising indeed.

One of the most prominent scientific spokesmen for this revived utopian vision was Robert L. Langer, a physics research associate at Cal Tech. In the week after Hiroshima, Langer reiterated many of the same reckless predictions that he had made in 1940–41. "U235 is marvelously compact and easy to manage . . . ," he told *Popular Mechanics* magazine. "It can be used to incubate eggs or to give off a white hot incandescence. It can be turned on and off like an electric light." Cheap energy from nuclear sources will ultimately free the nation's farmers from reliance on the sun to grow food. Atomic automobiles will run on a small bit of U-235 placed in a water tank under the hood. Still, Langer did caution that "criminals and eccentrics" might misuse

this awesome power. Such comments caused a number of Manhattan Project veterans to squirm in their seats. It was not long before several began to wave caution flags. Countering his Cal Tech colleague Langer, J. R. Oppenheimer said in 1945 that "we do not think automobiles and airplanes will be run by nuclear units." People should not expect cars to be powered by U-235 pills, warned Los Alamos British Mission physicist Otto Frisch. A few minutes' ride would probably kill all the passengers. Moreover, what would happen if an atomic car rammed an atomic bus at rush hour in a major city? Dreams of atomic-powered cars and locomotives, cautioned Los Alamos British Mission leader Rudolph E. Peierls, belong "entirely to the realm of speculation." As early as 1947 science-fiction editor John Campbell concluded that the much ballyhooed predictions of atomic cars, planes, and trains had all been very badly oversold. Moreover, as Oppenheimer had observed in 1945, "Atomic energy cannot be developed for peaceful purposes without installations and activities potentially most dangerous to the security of the world."[2]

But utopian dreams do not easily fade. Science writers William Laurence and David Dietz, and others, kept them alive for middlebrow readers. And from the late 1940s onward, these dreams found a distinct home in two popular culture areas: the nonfiction comic books of the period and the fanciful illustrations of second-level popular science journals. Although the factual "news magazine" comic books had largely faded by 1950, the industry still kept up a modest nonfiction line. This genre began in 1943 when comics pioneer Max Gaines published *Picture Stories from the Bible* (Old Testament), with a New Testament edition appearing the following year. The initial *Picture Stories* sold a million copies. After the war, Gaines followed with *Picture Stories from American History* and *Picture Stories from Science*. By 1946, *Classics Illustrated* had also sold almost a million copies.[3]

The popularity of these educational comics in the early 1940s encouraged other organizations to venture into this area for their own purposes. During the war, Nelson Rockefeller's Office of Inter-American Affairs had freely distributed Spanish and Portuguese comic books throughout various Latin American nations. These comics denounced the Nazis and praised the American war effort. They proved

immensely popular. In 1948, the Democratic National Committee (DNC) distributed a free comic book version of Harry Truman's life. *The Story of Harry S. Truman*, a sixteen-page campaign biography in comic book form, took Truman from his farm youth—where he plowed "the straightest furrow in the county"—to the establishment of the United Nations. (No mention was made of Hiroshima and Nagasaki.)[4] Afterward the DNC noted with interest that their slim margin of victory in the 1948 election coincided almost exactly with the number of free Harry Truman comic books they had distributed. In a similar fashion, large corporations, such as US Steel, Buster Brown Shoes, General Mills, and even the US Navy produced a variety of educational comic books. In a strange sense, the atomic hopes of 1939–41 and 1946–50 found their eventual home in these revived educational comic books.

Virtually all the nonfiction comic book publications that dealt with science predicted a rosy atomic future. In 1957, Classics published *Adventures in Science*, which contained "Andy's Atomic Adventures." In this now-classic tale, Andy's dog Spot runs into a Nevada aboveground test zone and has to be temporarily quarantined. Simultaneously, Andy's mother is being treated by radiation for an unspecified major illness. After a well-illustrated pictoral introduction to the fissioned atom, Andy concludes, "The world is going to be even more wonderful when all that atomic energy is really put to work." Three years later, *Classics* published *The Illustrated Story of Great Scientists*, which included a brief section on Einstein, as well as a ninety-six-page comprehensive survey titled *The Atomic Age*. This picture-and-text overview began with the observation: "A tremendous power has been set loose in the world. Like all power, it can serve man. It is the atom."[5] The most comprehensive atomic survey ever produced in comic book form, *The Atomic Age* reflected the mood of the Cold War era. It ignored radiation dangers and somehow overlooked the bombings of the Japanese cities. The only mushroom cloud came from Trinity Site, obviously drawn by an artist who had never been to New Mexico for he sketched the blast as rising from the top of a high mesa.

By the mid-1950s, the giants of American industry concluded that these nonfiction comic books could be used for various promotional purposes. From the late 1940s forward, the New York-based M. Philip

Copp Company produced over six and a half million comics for such companies as General Motors, IBM, BFGoodrich, Douglas Aircraft, American Airlines, and General Electric. These corporations distributed the books gratis, sometimes including them in their annual reports to stockholders. The executives at General Electric drew on these books with regularity. Over the years, GE produced at least eight different scientific comic book "giveaways," including: *Adventures in Electricity* (1947), *Adventures in Electronics* (1955), *Science in Your Future* (1956), *The Story of Light* (1957), and *Adventures in Jet Power* (1961). All of them urged American boys and girls to make science—especially nuclear science—their careers.

Most of these giveaways touched on nuclear issues, but two GE publications, *Adventures Inside the Atom* (1948) and *The Mighty Atom* (1950, 1966) treated the theme in detail. In 1948, General Electric contracted with General Comics to produce *Adventures Inside the Atom,* a somewhat clumsy attempt to explain how fission power would dominate the nation's future energy production. Although *Adventures Inside the Atom* portrayed atomic power as providing endless energy for the entire world, it also closed with a modest degree of caution. When the young protagonist asks about atomic flying machines, atomic pills for cars, and atomic disintegrator guns, his mentor chides him for "reading too many comics." Sixteen years later, GE had the book partially redrawn. Except for the addition of a section on fusion power, however, the message remained the same. In the second version, the young protagonist decides to join the nuclear industry to "help change a piece of science fiction into scientific fact."[6]

The Mighty Atom (1959), which also appeared as a popular cartoon under the same name, helped popularize the figure of "Reddy Kilowatt." Kilowatt came complete with an upbeat message, a full-fledged "Fusion song," and assorted doggerel:

I'm busy little atom!
I split myself in two!
I multiply as many times
as I have jobs to do.[7]

Disney Corporation actually hired a "science advisor," Heinz Haber, who produced an equally optimistic study, *Our Friend the Atom* (1956). In 1951 Westinghouse Electric Corporation also published a comic book dealing with television and atomic energy, specifically targeted as a teaching aid for science classes in junior high and high schools.[8]

As late as 1973, Portland General Electric Company produced a similar giveaway, *The Atom, Electricity, and You,* to assist in its efforts to establish the Trojan Nuclear Power Plant in southwest Washington state. When a woman inquires about potential radiation dangers to people living nearby, she is assured that continual monitoring would solve this problem. (She then turns to her husband: "I'm certainly glad to know that! It clears up a question I've had for a long time.") Nuclear power, the book concludes, would be "great for all of us."[9]

The M. Philip Copp Company's *The Atomic Revolution* (1955) ranks as the epitome of this genre. Commissioned by General Dynamics, whose president had publicly predicted atomic-powered trans-Atlantic travel within a few weeks, the thirty-two-page comic combined superb artwork with a glowing introduction by Gordon Dean, former chairman of the Atomic Energy Commission. Noting that the central problem of the atomic age involved curbing the atom's destructive power while simultaneously releasing its potential for good, Dean suggested that mastery of the contents of *The Atomic Revolution* would enable readers to act with wisdom in the future. The product of a team of writers and artists, *The Atomic Revolution* combined a brief visual history overview of the atomic age with an over-the-top message of optimism. Pointing to the recently launched atomic submarine *Nautilus,* the book predicted that the fissioned atom "might revolutionize *all* forms of travel—not only on the sea but on land and in the air," as well as transform agriculture, industry, medicine, and scientific research. Americans would soon control their environment by building germ-free cities, even in Antarctica, as well as mass producing food by artificial means. Endless energy would be soon supplemented by intergalactic space travel. The benefits would transform not just the United States but the world. The book highlighted President Dwight Eisenhower's recent speech to the United Nations on the Atoms for Peace plan to strip the atom of its military casing and adapt it to peace-

ful purposes." The initial print run was five hundred thousand, far more than the combined total of all serious scientific explanations of the nuclear world published to that date.[10] With the *Atomic Revolution*, the utopian dreams of 1940 had finally found their graphic art voice.

The second focus for postwar nuclear utopian dreams resided in the illustrated "prediction" articles in such popular science journals as *Popular Mechanics, Motor Trend, Flying, Popular Science,* and *Mechanics Illustrated.* For several decades, these monthly journals carried tease articles on the atomic utopia that lay just around the corner. Atomic-powered planes were "almost here!" *Flying* magazine assured its readers in June 1957. The only limit to atomic aircraft rested with the crew's ability to remain aloft while confined to the cockpit, said *Science and Mechanics* four years later. Scores of other popular magazines unleashed similar predictions. The atomic car is "not a dream," *Car Life* observed in July 1954; it will be on the road "in the next few years." These brief essays all demanded illustrations, of course, but since editors could not rely on actual photographs, they fell back on futuristic sketches, often created by former comic book artists. Frank Tinsley ranked among the most prominent of these illustrators, and he had deep roots in the comic book world. During the 1930s Tinsley drew striking covers and interior sketches for several pulp fiction aviation monthlies, including the popular *Bill Barnes, Air Adventurer.*[11] From 1940 to 1945 he illustrated the newspaper comic strip *Yankee Doodle* (later renamed *Captain Yank*).

In the postwar era, Tinsley lent his considerable artistic skills to depicting the exact details of atomic-powered planes and trains. As he noted in 1955, "Atomic planes are closer than you think." The next year he sketched the cover and wrote the lead story on the arrival of atomic trains. He predicted that they would travel at three hundred miles per hour through a nationwide network of transparent glass tubing. Such coast-to-coast atomic travel, he said, would combine aircraft speeds with surface travel comfort. His elegant illustrations showed precisely how these atomic trains and tubes would look. In 1955, Tinsley drew upon Howard Hughes's famed aircraft, the "Spruce Goose," to depict the typical atomic-powered plane. A talented artist, Tinsley was widely recognized as the master of futuristic illustration.[12] In a simi-

lar vein, the popular Joe Simon and Jack Kirby comic *Boy Commandos* (#36, 1949) briefly featured a nuclear-powered automobile that functioned as car, plane, and submarine.

In a sense, Frank Tinsley's fanciful sketches resembled many actual experiments of the day. During this immediate postwar era, a University of Utah research team devoted considerable time and effort to designing a 7,000-horsepower atomic locomotive. Chrysler touted itself as an industry pioneer in the peaceful uses of atomic energy. The Ford Motor Company similarly contributed a million dollars to the University of Michigan Phoenix Project to explore nuclear possibilities for the automobile industry. In 1951 an engineer, who preferred to remain nameless, assured readers that Detroit could build an atomic car any time it wished. During this era, one could also find an illustrated technical handbook subtitled "A Guide for Tradesmen and Technicians" for small businesses interested in applying nuclear power to their products. Similarly, *Atomic Energy for Your Business* touted a variety of immediate industrial applications, ranging from food preservation to atomic batteries, as the key to future profits in the private sector.[13]

The US Air Force harbored its own set of atomic dreams, one of which involved establishing a nuclear missile site on the moon. Closer to home, they produced a plan for an atomic-powered B-36, the prototype of which made at least forty-seven top-secret flights between 1955 and 1957 over Texas and New Mexico. Eventually, however, the vast technical problems involving weight, component erosion, maintenance, and (especially) radiation shielding for pilots and passengers doomed the Air Force's dream of atomic aircraft. In 1961 President John F. Kennedy cancelled the project.[14] Somehow, atomic airplanes could never quite realize the high drama first introduced by Airboy's Birdie or Batman's Batplane.

The decade and a half after the end of the war also produced a number of industrial/agricultural nuclear breakthroughs, but they seldom made headlines. Engineers utilized radioactive isotopes to ensure the safety of offshore oil rigs, to measure the thickness of heavy industrial materials, to sterilize agricultural pests, to find oil pipeline leaks, to test engine oil efficiency, to date archaeological discoveries, and so on. Several major corporations invested large sums in the hopes of discovering untold nuclear-related benefits. But the 1946 Bikini detona-

tions had also alerted radiologists to the fact that radiation from plutonium was far more dangerous than imagined and that any industry/hospital that handled radioactive materials would be forced to assume "the most meticulous type of incessant watchfulness." "The avoidance of radiation, "remarked Dr. Clarence J. Brown in 1949, "has become a way of life."[15]

A number of oceangoing vessels, however, were soon fitted with atomic-powered engines. In 1954 the United States launched the world's first nuclear submarine, *Nautilus,* and five years later the first atomic-powered ocean liner, *Savannah,* left its New Jersey port. The Soviet Union also produced an atomic-powered icebreaker.[16] But ordinary people do not usually visit offshore oil rigs, ride on submarines or ice breakers, or travel on ocean liners. Consequently the promised utopian nuclear benefits never reached the average household. Any authentic atomic "progress" remained locked up in very specialized technological niches, well out of the ken of the average citizen. The various graphic illustrators had raised atomic hopes far too high. Ironically, the rosy predictions of the educational comics and the popular science magazines virtually ignored the theme of nuclear medicine. By the mid-1950s, however, the medical applications of nuclear power were well known. The fissioned atom had proved especially helpful in treating cancer and thyroid malfunction, as well as assisting with various treatments of diseases of the heart, lung, and brain.

Indeed, from 1945 onward, nuclear medical research progressed at a slow but steady rate. Perhaps the most heralded advances came with the introduction of short-lived radioactive tracer isotopes that permitted a wide range of diagnostic techniques. As Laura Fermi observed, "tracer isotopes have been called the most important research tool to be developed since the microscope." In 1947 British reactors produced the first radioactive isotopes for hospitals. In 1954, Congress passed the Nuclear Energy Act, which inaugurated major funding for American nuclear medicine. It was not long before scientists had produced about a hundred different nuclear medical imaging procedures. By 1954, the US government had sent over $25,000 worth of shipments of radioactive isotopes to about a thousand American institutions and thirty-four foreign nations, primarily for medical applications. In 1954, Congress held three-day hearings on how atomic energy had affected

the field of medicine. The chair of the session predicted that eventually the peaceful potentials of atomic energy would far overshadow any military uses.[17]

Although comic book artists ignored medical themes, the popular magazines of the era were filled with tales of the potential benefits of nuclear medicine. "The power which brought death to thousands of people halfway across the world is now being used to give new life to thousands who would otherwise be doomed," *True Romance* magazine assured its readers in 1956. During the recent period, as physician Walter D. Claus observed in 1958, the medical use of isotopes had become almost standard practice in the profession. Even so, the slow nature of atomic advances proved frustrating. In *Nuclear Medicine* (1949), the first book on the subject, physician Clarence J. Brown expressed his dismay that the four years since Trinity "have resulted in so little of practical benefit to mankind." Interestingly, Brown was quick to point out that physicians had had nothing to do with the atomic bombings of Japan. The physicists and chemists had created the atomic bombs, he noted, not the doctors. The immense physical destruction and suffering was "not of medicine's contriving." Nobel Prize-winning Japanese author Kenzaburo Oe took the same approach in his classic book *Hiroshima Notes*. His heroes were the Japanese physicians who had treated the victims of the bombings.[18]

No comic book artist has ever attempted to portray the advances in nuclear medicine. No cartoon figure named "Iggy the Isotope" emerged to rival "Reddy Kilowatt." Except for brief mention in "Andy's Atomic Adventures," and *The Atomic Revolution,* the major comic books completely ignored the theme. Somehow, the story of nuclear medicine could never be universalized.

The comic book industry faced a similar problem with the story of nuclear power plants. Indeed, the tale of the slow construction of a gigantic power plant contains few dramatic moments. I have been able to discover only two nuclear power plant adventure stories in comic book form. In one, the Peacemaker discovers a hidden nuclear power plant under the South Pole, created by "a minor Balkan nation," and destroys it. In the other, a firefighter hero halts a nuclear power plant blaze at the very last minute.[19] Like the theme of nuclear medicine, the

emergence of nuclear power proved impossible to dramatize. More-over, neither atomic medicine nor atomic energy fit easily into the par-allel emerging world of television. By its very nature, television found itself drawn to dramatic events, such as space launchings and actual or simulated atomic bomb explosions. Slow and steady healing, medical research, or power plant construction ever lacks dramatic potential.

The postwar dreams of atomic utopia, however, also had to confront the persistent issue of radiation dangers. In spite of science-fiction warnings about "inconvenient rays," the US government long down-played the radiation hazards of the Japanese bombings. Although the Bikini tests had alerted experts to the dangers, the American public remained largely unaware of the situation until over a year later. On August 11, 1947, *Life* published a grim description of how the radia-tion from Shot Baker at Bikini had entered the food chain: the blast made plankton radioactive; small fish who ate the plankton were later consumed by larger fish; and so on. In addition, as former Manhattan Project medical director Stafford L. Warren noted, the radiation dangers following the Baker blast—which might well have killed two million people if it had been detonated over New York City—"demonstrated an entirely new danger of atomic warfare."[20] Since *Life* had access to actual government photographs, they had no need for graphic artists to illustrate these potential dangers. But graphic artists were desper-ately needed in realms where photography was not available. In the 1950s the federal government tapped the cartoon industry for comic books to illustrate its variegated programs for civil defense (CD). Most of the governmental advice books relied heavily on illustration, and Al Capp once lent his character L'il Abner to push the CD) comic *Opera-tion Survival* (1957), with its motto: "Alert today, Alive tomorrow." The Department of Agriculture produced an illustrated pamphlet for farm-ers entitled "Your Family Survival Plan."

The civil defense comics that received, perhaps, the largest distribu-tion were *If an A-bomb Falls* (1951) and *The H-bomb and You* (1954). "If an A-bomb Falls" first appeared in the *Washington Post* in July 1951 as a multipanel sequence, the first of its kind. In daily installments, the *Post* reprinted Commercial Comics cartoonists' rendition of the civil defense booklet "Survival Under Atomic Attack." As the clearly drawn

panels suggested, there were many things that people could do to survive. The graphic novel showed housewives how to prepare a shelter area in the home, how to respond if caught outdoors, and how to wash after being exposed to radioactive fallout. Among the suggestions: "Do not repeat rumors. Panic can cause more casualties than a bomb." Several Federal Civil Defense administrators praised the *Washington Post's* willingness to aid the government's public education program. The series ran in the *Post* for a full week. *If an A-bomb Falls* also circulated as an eight-page comic book. Exact distribution numbers are not available, but they must have reached the tens of thousands. Although double the length, *The H-bomb and You* (1954) proved considerably less optimistic than its predecessor. By then, both the United States and the Soviet Union possessed hydrogen weapons, which approached over a thousand times the power of the atomic bombs that had destroyed Hiroshima and Nagasaki. Still, the pamphlet said, chances of surviving an H-bomb attack were "probably better than you think." Linking civil defense with historic American patriotism, the book urged all citizens to be on constant alert.[21]

Although the nonfiction atomic comics saw extensive distribution, the major thrust of postwar comics rested with the comic book adventure tales that treated the atomic world or dealt with threats posed by nuclear weapons and the arms race with the Soviet Union. From the 1950s onward, this theme became grist for thousands of artists' mills.

Although a single atomic bomb story might have minimal impact, taken as a whole the results are far more significant. In fact, it is highly probable that comic books created *more* stories dealing with atomic dangers than any other form of popular media. The quality varied widely, of course, but no popular genre—not even American film and television—produced as many mushroom clouds as did comic book artists of this era.[22]

Early Cold War Comics

The Cold War comic book treatment of the 1950s nuclear world fell largely into two categories: relatively short-lived atomic spy tales and a far more lasting set of thrilling atomic adventures, including a variety of post-holocaust narratives.

In 1949, America's nuclear monopoly ended when the Soviet Union detonated its first atomic weapon. Shortly afterward, naturalized British scientist Klaus Fuchs, who had worked at Los Alamos during the war as a member of the British Mission, was arrested and convicted of passing atomic secrets to Soviet spies. Simultaneously, Harry S Truman gave the go-ahead for America's hydrogen bomb program and selected the Nevada Test Site northeast of Las Vegas as the primary continental location for nuclear testing. Until the moratorium of 1958, and the partial test-ban treaty of 1963, the United States conducted over one hundred aboveground tests at the Nevada Test Site.[23] These atomic-related headlines soon found a voice in the comic books.

Avon's *Atomic Spy Cases* (March/April 1950) seized on the theme of atomic espionage. Fronted by a painted cover that reflected the pulp art of the 1930s far more than the comic book covers of the era, *Atomic Spy Cases* opened with a warning that could have been lifted directly from the *New York Times* or *Time* magazine: "History's darkest pages contain no more violent and explosive passages than those now being written in the intense struggles of foreign powers to learn the secret of the atom bomb. Only the eternal vigilance of our own undercover agents keeps this deadly information from the evil hands that would turn this powder keg of desperate hates and vicious emotions into a world-wide cataclysm." The central story revolved around the enemy agents' theft of plutonium. After a chase to the top of a deserted Nevada mountain, federal agents detonated the weapon (and the spies) from long distance. "It was worth it," an officer concluded. "We lost the plutonium but our nation's secret remains safe!"[24]

Atomic Spy Cases also features "U-231" bombs, elaborate disguises, a Nazi code embedded in an heirloom watch, a truth serum dissolved in a cocktail, a femme fatale, and an agent who inked a secret map onto his bald pate and then covered it with a wig. Except for the addition of plutonium, the characters and plots were borrowed intact from the popular world of pulp fiction. That may account for the fact that no second *Atomic Spy Cases* ever appeared.

The atomic spy theme proved so pervasive, however, that several rival companies drew on it to capture public interest. American Comics Group's *Spy and Counterspy* appeared in August/September 1949, while Marvel's *Spy Cases* (September 1950) and *Spy Fighters* (March 1952),

plus Atlas's *Spy Thrillers* (November 1954), followed in due course. These spy stories covered enormous ground, but the overall theme was well voiced in the opening statement by the most memorable character of the lot, Jonathan Kent of *Spy and Counterspy:* "I'm one of that small band who risked their lives every day to preserve the American Way! . . . It's dangerous business! You can't get to know us, for reasons of security, but I think you ought to learn what we're doing!"[25]

Spy comics readers of the late 1940s and early 1950s soon learned a good deal. Because espionage proved international, artists could place their agents in such exotic locales as Egypt, Iran, Greece, Switzerland, England, the Philippines, Morocco, Berlin, China, Malaysia, North and South Korea, plus, of course, the Soviet Union. All the spy comics boasted that they were "based on true stories," or "true-to-life," while simultaneously denying any resemblance to persons living or dead.

From 1949 to the early 1950s, atomic-related espionage tales provided the engine that drove the spy comic genre. In one story a "Dr. Oppenheim" (J. Robert Oppenheimer) discovered a new anesthetic gas, while in another federal agents foiled Nazi attempts to capture uranium; in yet another tale, the US Border Patrol stymied an attempt to steal secrets from the "White Sands Testing Range" in Alamogordo, New Mexico. *Spy Cases* 8 (December 1951) featured a classic atomic blast on its cover, and so on.[26]

Spy Hunters also drew on the nuclear theme with regularity. *Spy Hunters* #4 (February/March 1950) devoted three of five stories to atomic issues, while #7 (August/September 1950) featured an H-bomb as cover art. *Spy Hunters* #8 (October/November 1950) devoted one-third of its stories to the nuclear world, including one on the hydrogen bomb. Even the advertisements joined in. The US Royal advertisement in *Spy Hunters* #8, "After the Atom Spies," showed how owning proper bicycle tires could help bring enemy agents to justice.

But editors could stretch the theft of atomic secrets only so far. By late 1951, both *Spy Fighters* and *Spy Cases* had begun to deemphasize nuclear espionage for a basic war format. The conflict in Korea had moved comic book espionage cases to a new level: plans for guided missiles, secret formulas to destroy metal ships, and even biological warfare. Yet these stories somehow lacked the intense drama associated with the search for atomic spies.

By the early 1950s, the various spy comics had begun to falter. *Spy and Counterspy* had folded in 1951, and *Spy Cases, Spy Fighters,* and *Spy Hunters* all expired by late 1953. *Spy Thrillers* survived only a year and a half longer. The reason for their demise was obvious. By this time, the atomic bomb, theft of which had become the backbone of the spy comics genre, had become an integral part of Soviet and American life. In fact, it began to border on the commonplace.[27]

Then came the infamous 1954 national "Comic Book Crisis" that changed the way that the industry operated. From the mid-1930s forward, social critics, teachers, and librarians had remained skeptical of comic books. They accused comics of diminishing reading skills and distracting students from a love of good literature. One critic denounced them for fomenting crude racial stereotypes. This criticism slackened during the war, but it emerged again in the late 1940s as numerous contemporaries linked the rise of juvenile delinquency with the popularity of comics among adolescents. By early 1948, ABC's *America's Town Meeting of the Air* discussed "What's Wrong with the Comics?" and it was not long before popular magazines such as the *Saturday Review of Literature, Reporter, Reader's Digest,* and *Ladies' Home Journal* all followed suit. The *Journal of Educational Sociology* devoted its entire December 1949 issue to this topic.[28]

Virtually all comments were critical. Terms such as "major disgrace" and "sadistic drivel" were common. Organized opposition appeared in over a hundred communities, ranging from San Francisco, California, to Dubuque, Iowa, to Sarasota, Florida. A variety of local ordinances banned the sale of specific comics, much to the dismay of magazine dealers who protested that they had no time to read all books they sold. Sixteen state legislatures wrestled with some form of prohibition of certain comic book titles. There were public burnings of comics in several American communities, and in 1951 the British Parliament actually banned the importation of American comic books.[29]

The most vigorous assault on comics came from social psychologist Fredric Wertham. In 1954, he wrote *Seduction of the Innocent,* a potboiler that essentially laid the blame for postwar teenage social problems at the comic book industry's door. Eventually a US Senate subcommittee held hearings on the matter, later issuing an official report entitled *Comic Books and Juvenile Delinquency* (1955).[30]

To protect itself, the industry (Dell and Classics excepted) established a self-regulatory body, the Comics Code Authority, which is still in effect.[31] They hastily terminated the worst offenders of the day—crime and horror books—and after 1954 few retailers would carry any comic that did not bear the proper seal. This self-censorship lasted until the emergence of "underground comix" in the mid-1960s and the accompanying shift in mainstream public tolerance that arrived a decade or so later.

Although the 1954 Comics Code Authority forbade portrayal of kidnapping, hidden weapons, vampires, overt sexuality, horror themes, disrespect for authority, and so on, it said nothing about atomic weapons. The comics code did not prohibit graphic depictions of tensions with the Soviet Union either. Indeed, Cold War "atomic combat" themes became a staple of artists and writers for over four decades. In 1952, St. John Publications produced five issues of *Atom-Age Combat*. In 1958, Fago magazines published two issues under an identical title, which caused St. John to revive its own *Atom-Age Combat*. In the latter version, the text announced that "this is the Atom Age! The unbelievable has already begun to come true." Although *Atom-Age Combat* stated that its stories were factual rather than science fiction, the editors had their categories reversed. Virtually every issue contained some form of science-fiction adventure tale. In one story, the hero discovered that the enemy were actually Martians.[32]

From the 1950s forward, nuclear explosions appeared on literally thousands of comic book covers or large interior "splash panels." The number of comic book mushroom clouds far exceeded the over one hundred aboveground US nuclear tests in Nevada. By the mid-1960s, at the latest, the mushroom cloud had emerged as one of the dominant symbols of the age.[33]

Although comic book artists often drew atomic explosions and devastated cities, because of the code they could never depict actual death scenes. One precode exception came with the Harvey Kurtzman/Wally Wood story "Atom Bomb" in *Two-Fisted Tales* (1953). Wood's brief artistic depiction of dying children was the first to seriously treat this theme. Similarly, writers seldom mentioned fallout or radiation sickness. Moreover, artists frequently depicted soldiers and/or civilians and atomic explosions in the same panel. In one tale, Captain Amer-

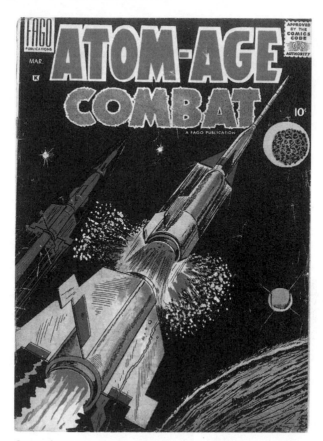

Cover of *Atom-Age Combat* #3 (Fago, March 1959). Threats posed
by nuclear weapons and the arms race with the Soviet Union
emerged as common themes in comic books in the 1950s.

ica watches a Nevada explosion from close range. In another, Rex the
Wonder Dog saves his family from a Nevada blast by leading them to
a nearby cave. Yet another tale shows navy frogmen swimming within
yards of the base of a mushroom cloud.[34] In a strange sense, the comics
code allowed graphic artists to depict (unknowingly) numerous scenes
of grave radioactive danger in a completely misleading manner.

The "atomic war" books of the 1950s provided a number of graphic
nuclear adventure tales. *Atomic War* and *World War III* created a very
grim world as they depicted "the war that will never happen if America
remains strong and alert." One cover showed American aircraft drop-

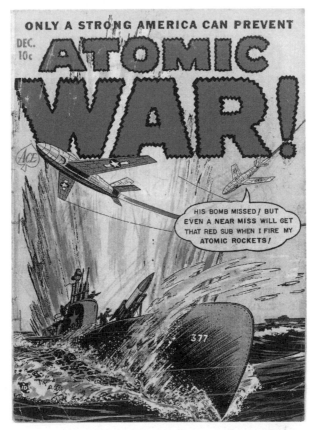

Cover of *Atomic War!* #2 (Junior Books, December 1952). Despite prohibitions against horror themes, overt sexuality, disrespect for authority, and similar subjects, the 1954 Comics Code Authority did not forbid graphic depictions of atomic-themed warfare.

ping hydrogen bombs on the Kremlin in revenge for the destruction of New York, Chicago, and Detroit. Other stories solemnly discussed "the atomic exchange" of 1960. One tale included such memorable lines as "Amerikansiki, I'll get you . . . Aargh" and "Yiii . . . It's the end of the world." These series expired after only a few issues.[35]

Artists with a lighter touch simultaneously created their own atomic adventure tales. Among the best were *Commander Battle and the Atomic Sub* and *The Atomic Knights*. The well-publicized success of the first nuclear submarine, *Nautilus,* soon found its way into comic

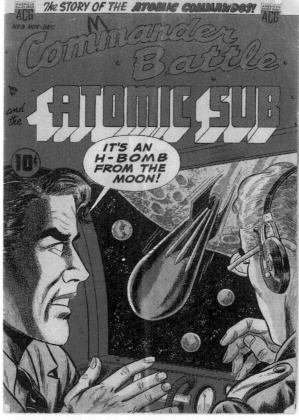

Cover of *Commander Battle and the Atomic Sub* #3 (Titan,
November–December 1954). Comic books reflected the general
anxiety of the early atomic age, but they also revealed specific
breakthroughs in nuclear technology. This issue of *Commander
Battle* was published shortly after the commissioning of the first
nuclear submarine, the *Nautilus*.

book format. Begun in 1954, the *Commander Battle* series featured a
strong hero, a likeable crew, and a junior-high whiz kid who served as
the sub's "advisor." In spite of the title, the stories were really science
fiction. In one tale, the atomic sub flew into outer space to stop an
enemy from sending H-bombs from the moon. In another, the atomic
sub bored into the center of the earth. The last issue portrayed the
commandos battling flying saucers.[36]

The Atomic Knights first appeared in DC's *Strange Adventures* in 1960. The story is set just after "the great hydrogen war of 1986." In this post-holocaust world, the Knights, which include a spunky heroine, remain a lone voice of sanity. Although the Knights wear the nuclear symbol on their helmets, they also dress in medieval armor as protection from radiation. In the initial stories, the Knights try to recreate a democratic world from the ruins of New York. Toward the end of their four-year run, however, they had begun to battle mole creatures and enemies from Atlantis. The series concluded in 1964.[37]

Other companies devoted considerable attention to the nuclear world as well. In a later interview, Marvel comic's mainstay promoter Stan Lee confessed that he resisted having his company enter into the political turmoil that surrounded the Vietnam era and the rise of the counterculture. In 1971 Lee said that the "Marvel Philosophy" meant, in essence: "We support people everywhere—people striving to improve themselves and their lives—people working and praying for a better world, a world without war. . . . We espouse no cause save the cause of freedom—no philosophy save the brotherhood of man. Our purpose is to entertain—to take the world as it is and show it as it might be—as it could be—and perhaps as it should be." In essence, this philosophy was echoed by DC, the other major company (together they controlled about 69 percent of the market). This also meant that each company felt free to produce a wave of cautionary atomic tales. In a classic EC *Weird Science* story (September/October 1950), a race of miniature people who had inhabited earth 500,000 years ago (and fled just before their own atomic war) return to warn Albert Einstein of a similar fate. In the lengthy "Children of Doom" (1963), Charlton Comics artists treated the same theme. Here an old woman closes the story with the warning: "We may not have a second chance."[38] The EC science-fiction tales of the era also warned of nuclear holocaust. Excluding the GE giveaways and the civil defense series, from the 1950s to the present the term "atomic" on a comic book cover usually implied a tale of espionage, an "almost" nuclear exchange with the Soviets, or a variety of cautionary post-holocaust tales.

Along the way, the early ambiguity had completely vanished from comic book depictions of the fissioned atom. The editorial warnings to young people to "use the power wisely" had dissolved into wide-

spread Cold War anxiety. The hopes for atomic cars, planes, trains, and electricity had all sputtered out, save for occasional mention in educational comics and the fanciful illustrations of popular science magazines. And comic book creators could find no vocabulary to convey the authentic advances in nuclear medicine or the mixed potential of the nation's nuclear power plants. Almost by default, the comic book industry fell back on tales of (potential) apocalypse and post-holocaust survival adventures. The cartoon atomic world had become very solemn, indeed.

PART III

ATOMIC COMICS
CHANGE DIRECTION:
THE MID-1950S TO
THE PRESENT DAY

AMERICAN UNDERGROUND COMIX, POLITICAL AND INTERNATIONAL CARTOONISTS, AND THE RISE OF JAPANESE MANGA

The rose-colored visions of nuclear power without consequence and the whistle-in-the-dark civil defense warnings faded amid the widespread social upheaval that followed the election of John F. Kennedy in 1960. So, too, did comic book depictions of grim nuclear exchanges with the Soviet Union. But the rampant parodies first sparked by *Mad* and *Humbug* remained alive and well. The radical cartoonists seized on the Watergate political scandal, the official statements regarding "progress" in the Vietnam War, and the resignation of President Richard M. Nixon in 1974 as proof of their position. Three major technological disasters of the 1970s/1980s added further grist to their mill: the near collapse of the Three Mile Island nuclear power plant (1979); the explosion of the space shuttle *Challenger* (January 1986); and the near meltdown of the nuclear power plant at Chernobyl, USSR (April 1986).[1] The malfunction of these gigantic technological systems seemed to confirm all the cynical predictions of Stanley Kubrick's film *Dr. Strangelove* (1964). No politician or large technological system could be trusted. Ever.

It is difficult to pin down the first anti-nuclear cartoon book, but one can make a good case for Laurence Hyde's *Southern Cross: A Novel of the South Seas* (1951). This "wordless novel" consists of 118 wood engravings that lambaste the 1946 US atomic detonation on Bikini Island. A British Quaker living in Canada, Hyde labored for years to produce this poignant book, which depicts a Pacific Eden that American soldiers completely destroy with the simple push of a button. The only survivor in Hyde's tale is a child, whose future remains uncertain.[2] Hyde struggled to find a publisher, however, and *Southern Cross* always remained a bit of an oddity.

Beginning in the late 1960s, however, anti-nuclear underground "comix" reached a much wider audience. In retrospect, the emerging underground comics in the late 1960s and 1970s served as an ideal medium through which to express cultural dissent. Comics could be produced relatively cheaply in a basement or garage, and their visual images had great appeal to a generation raised with television. The chief problem lay with distribution. Although drug paraphernalia shops ("head shops") initially stocked underground books, circulation remained modest—from one thousand to ten thousand per issue—until the rise of the comic book specialty stores in the mid-1970s. Borrowing from the movie rating system, the stores introduced similar "mature audiences" or "adults only" sections, which assured at least a partial survival. Talented artists such as Robert Crumb were no longer forced to peddle their books on the streets of San Francisco. Although the underground comix produced more than their share of "self-indulgence and bad art," they also provided a training ground for a bevy of talented visual satirists. Indeed, the industry "grandfather," former editor of *Mad, Humbug, Trump,* and *Help!* Harvey Kurtzman, once termed the early counterculture artists "a remarkable phenomenon." He praised their energy, and their enthusiasm. He also credited them with adding a completely new dimension to the world of cartooning. Social critic Jay Lynch went even further. He argued that "underground comics were the most important art movement of the twentieth century." With wanton abandon, the new artists began a total assault on Middle American values. They lambasted gender relations, the business world, and the politics of the Nixon era. Simultaneously, they celebrated drug use (chiefly LSD and marijuana), street language, sexual liberation of all kinds, and a variety of "revolutions." Although the West Coast Beat poets and writers remain far better known, the underground comix artists probably reached a wider audience as a grim "us" versus "them" world slowly began to emerge.[3]

Without exception, underground artists lambasted all things nuclear. In *Forbidden Knowledge* (1977), Last Gasp comix artists drew melting flesh, women impaled by flying glass, and other examples of atomic carnage. In *Slow Death* #9 (1978) talented satirist Greg Irons drew exceptionally graphic scenes of nuclear destruction. In their quest for shocking realism, the artists outdid themselves in depicting

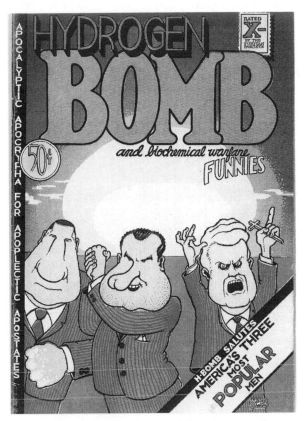

Cover of *Hydrogen Bomb (and Biochemical Warfare) Funnies* #1 (Rip Off Press, 1970). Through its caricatures of Spiro Agnew, Richard Nixon, and Billy Graham in front of an exploding hydrogen bomb, this Rip Off Press comic expressed a distrust of politics that pervaded the radical youth culture of the late 1960s and early 1970s.

past and future nuclear atrocities. The books worked on many levels. In addition to its title, *Hydrogen Bomb and Biochemical Warfare Funnies* (Rip Off Press, 1970) denounced the politics of the Nixon White House, while Last Gasp's *Dr. Atomic* (1973) celebrated marijuana. Slave Labor Graphic's *It's Science . . . with Dr. Radium* (1987) ridiculed science. One issue portrayed the antihero contemplating the creation of a deadly virus. When asked about the wisdom of such an endeavor, he replied, "Science is the solution to *everything*." The premier issue of *Itchy Planet*

Cover of *Dr. Atomic* #1 (Last Gasp Eco-Funnies, September 1972). On the cover of this issue, the titular character of the series, Dr. Otto Atomic, smokes marijuana—one of the youth counterculture's drugs of choice—with his hippie neighbor, Billy Kropotkin.

(Spring 1988) denounced the "contemporary nuclear predicament," while *Doc Schnuke's Atomic Water Story* (1975) billed itself as a coloring book that promised "atomic water would end all or cure everything (or your money back)." The first issue of *Corporate Crime Comics* explored the mysterious 1974 death of Karen Silkwood, a worker at the Kerr-McGee plant in Oklahoma that processed plutonium. (The story was also made into a popular film.) Silkwood was on her way to speak to a *New York Times* reporter about dangerous safety violations when she died in a single-car accident. Rumors flew that she had been targeted

Cover of *Doc Schnuke's Atomic Water Story* #1 (Waffle Comics, 1975). The claim that atomic water would be a "cure all for everything" in this Waffle Comics title parodied the notion that atomic science is wholly beneficial to the individual and society.

by Kerr-McGee assassins, and the story ends with the question: "What did Karen Silkwood know that we should know too?"[4]

Only on rare occasions did the comix artists pull back from scathing depictions of nuclear horror. *Slow Death* #9, which was entirely devoted to anti-nuclear themes, made a slight step in that direction. In perhaps the most thoughtful story, visitors from space discovered that earth had abandoned all nuclear activity: "But it was too late. The entire population had been exposed—the next generation was mutated. The entire culture was lost. . . . We might as well return to

the ship. . . . There's nothing we can do here!" Far more representa-
tive, however, was their "civil defense" advice on how best to respond
to a nuclear disaster: "Bend over, put your head between your knees,
and kiss yer ass goodbye."[5] As the first large museum exhibit of under-
ground comic art revealed, however, nuclear themes took a back seat
to other social concerns. But when they did depict the atomic world,
the underground artists were of a single mind. In their eyes, the terms
"atomic," "nuclear," and even "science" pointed to the thrust of the
demonic into history.

As the shock value of the early comix faded and their sexual explicit-
ness and hard-edged satire became more acceptable in Middle America,
critics realized that a number of the artists ranked as authentic visual
geniuses. Jack Jackson applied the new western history to the Texas
past through his graphic novels *Comanche Moon* and *El Alamo*. Wil-
liam Stout used his artistic skills in *Slow Death* #8 (1977) to push envi-
ronmental issues, such as Greenpeace. Trina Robbins's work opened
the door for future female cartoonists. Gilbert Shelton's *Fabulous Furry
Freak Brothers* sold in the six figures. And Art Spiegelman's *Maus* even-
tually won a special Pulitzer Prize in 1992.

Robert Crumb emerged as the most respected of the early coun-
tercultural cartoonists. Although nuclear concerns ranked low on his
horizon, when he did treat them, he proved especially effective. In
one famous sequence, Crumb depicted himself sending a cartoon to
his favorite philosopher, Bertrand Russell. In the next panel, a hydro-
gen bomb falls. "Gee," says the artist, "now I'll never know if Bertrand
Russell liked my cartoons." In a 1979 story, Crumb drew a malevolent
Reddy Kilowatt who encouraged all power plants and denounced "this
crazy ecology crap."[6] Marvel Comics' semihero *Howard the Duck* (#3,
February 1980) quickly borrowed Crumb's character, Greedy Killer-
watt, and even parodied the song:

> I am Greedy Killerwatt,
> If you want Nukes I got a lot,
> The Stuff I push is really hot,
> The Power of Tomorrow!
>
> I'm the guy who raises cane [*sic*],
> Pollutes the Fish, Poisons the Day,

But if you want watts you can't complain,
My Laughter is your sorrow![7]

The 1980 election of Republican Ronald Reagan raised the nuclear ante even higher. Reagan not only intensified Cold War rhetoric, in 1983 he also proposed a $26 billion Strategic Defense Initiative—dubbed "Star Wars" by the skeptical press—to defend against potential atomic attack. This acceleration of the danger of potential nuclear conflict produced a wave of serious atomic-themed academic analyses, but none of them sold well.[8] Reagan's hard-edged anti-Soviet rhetoric, especially his terming the USSR an "Evil Empire," sent cartoonists around the world racing to their drawing boards. Harvey Kurtzman once observed that the American underground movement had made a deep impression on foreign cartoonists, and this certainly proved true here. British, Australian, and Japanese cartoonists soon propelled the comix anti-nuclear message into the mainstream press.

After the initial postwar era, the period from the late 1970s to the early 1990s probably ranks as the heyday of anti-nuclear cartooning. In 1978, Pantheon Books reprinted the British publication *Nuclear Power for Beginners* under the more accurate title *Anti-Nuclear Handbook*. With text by Stephen Croall and art by Sempler Kaianders, the book set forth all the counter-arguments against a nuclear world in a clear, coherent fashion. After raising the issue of Iran's desire for a nuclear weapon and noting that "a speck of inhaled plutonium can give you cancer," the book closed with an appeal for solar, wind, and water power.[9] Australia, which had suffered major fallout problems from an ill-advised series of aboveground tests, produced *No Fission: A Collection of Anti-Nuclear Cartoons by Australian Artists* (1983); then came the Canadians with David Rosen and Farley Mowatt's *Megatoons: Cartoonists Against Nuclear War* (1984), along with Steven Heller's joint American-British publication *War Heads: Cartoonists Draw the Line* (1983), which featured artists from around the world. There were so many nuclear weapons/energy cartoons that Leonard F. Romano compiled a book of them for high school classroom use, entitled *A Look at History Through Political Cartoons* (1990).

The Newspaper Political Cartoonists

The role of newspaper cartoonists in conveying nuclear themes to the public has been largely overlooked. In the aftermath of Hiroshima and Nagasaki, virtually every major political cartoonist rushed to his drawing board. The *Chicago Tribune* published an image of a fuse linking Pearl Harbor to Hiroshima, with the inevitable explosion and a dismembered head saying "so sorry." The *Atlanta Constitution* featured a bomb catapulting people into the air under the rubric "Land of the Rising Sons." The *Columbia Dispatch* depicted the real sun punching the "Rising Sun" with the comment: "A new GI gets into the war." The New York left-wing *PM* newspaper showed Japan absorbing two punches, one marked "Russian Declaration" and the other "atomic bomb." The British *Evening Standard* cartoonist David Low even dipped his pen in prophecy: On August 9, 1945 he drew a scientist offering an infant labeled "Humanity" a toy, with the caption "Baby play with nice ball?"[10] For the next six decades, newspaper cartoonists returned to this theme with regularity.

Hy Rosen of the *Albany Times Union,* Mike Konopacki of the *Madison Press Connection,* Jim Borgman of the *Cincinnati Enquirer,* Len Norris of the *Vancouver Sun,* Dick Wallmeyer of the *Long Beach Press-Telegram,* and M. G. Lord of *Newsday* all depicted the nuclear crisis in various editorial cartoons. So, too, did the acknowledged giants of the profession: Herblock of the *Washington Post,* Jules Feiffer of the *Village Voice,* D. R. Fitzpatrick of the *St. Louis Post-Dispatch,* and Leslie Gilbert Illingworth of Britain's *Daily Mail.* In fact, three atomic cartoons eventually won Pulitzer prizes: the *New York Sun's* Rube Goldberg for an image of a gigantic weapon, on which sat civilization, teetering between "world control" and "world destruction" (1947); the *Des Moines Register's* Frank Miller for an image of a destroyed planet where one survivor shouts to another "I said, we sure settled that dispute, didn't we?" (1963); and the *Miami News's* Don Wright for a similar image of a devastated planet where a survivor says to his counterpoint, "You mean you were bluffing?" (1966).[11]

The most prominent political cartoonists of the immediate postwar era were probably Leslie Gilbert Illingworth of Britain's *Daily Mail,* David Low of the British *Evening Standard,* D. R. Fitzpatrick of the *St.*

Louis Post-Dispatch, and Herbert Block (Herblock) of the *Washington Post.* All dipped their pens in anti-nuclear ink, but not as often as one might expect. For example, the Illingworth collection of 4,363 images, now housed at the National Library of Wales in Aberystwyth, contains only fifteen nuclear-related cartoons. He penned his most powerful atomic images in August 1945: "Humanity" opens a bottle marked "atomic energy" that releases a menacing figure (August 14, 1945); a man peers through a microscope labeled "science" at a slide marked "atomic energy" (August 9, 1945); and a woman, "Science," holding a cup marked "atomic energy" high above her head to prevent various military and political villains from grabbing it (August 8, 1945).[12] In these three now-forgotten cartoons, all drawn in white heat within a single week, Illingworth encapsulated the postwar nuclear dilemma with astonishing clarity.

Like his Welsh counterpart, David Low drew relatively few atomic-themed cartoons. His collection *Low Visibility* (1958) includes only seven (of 159) on this theme. The same is true for D. R. Fitzpatrick. His collection *As I Saw It* (1953) includes only six images on nuclear issues out of about three hundred. Since potential atomic crises lay largely in the realm of "possibility," most newspaper cartoonists focused on more immediate political concerns; in this way they were always driven by the fact that history is not logical nor humankind very predictable.

The newspaper cartoonist who contributed most to popular understanding of the atom was Herblock, whose poignant and often devastating images appeared not only in the *Washington Post* but were also syndicated in scores of papers across the nation. On August 27, 1946, Herblock introduced "Mr. Atom" to the American public. A hulking unshaven personification of the atomic (later hydrogen) bomb, Mr. Atom initially asks a man marked "World Diplomacy": "Pardon me, Mister—Do you know what time it is?" Although not intended as a continuing character—he grew more menacing as the years rolled on— Mr. Atom made regular appearances from 1946 through the 1980s. Indeed, Mr. Atom was the most long-lasting nuclear image created by any newspaper cartoonist. As he was based in the nation's capital, Herblock's main focus naturally lay with the endlessly fascinating Washington, DC, political merry-go-round, but he also drew atomic-related cartoons on a semi-regular basis. He unleashed a string of anti–Atomic

Energy Commission images when the AEC deprived J. Robert Oppen-
heimer of his security clearance in 1954: for example, Oppenheimer
seated behind a wall studying the atom with the caption: "Who's
being walled off from what?" (April 15, 1954). He also denounced the
aboveground tests of the hydrogen bomb in the Pacific with a cartoon
showing a hand labeled "H-bomb" juggling the world (August 11,
1953). And he had nothing good to say about the nation's erratic civil
defense program. In one cartoon, Mr. Atom sneers at Uncle Sam hold-
ing a flimsy umbrella marked "Civil Defense" and notes that "It looks
darling" (September 3, 1954).[13]

When the US Air Force lost four hydrogen bombs over the Atlantic
Ocean near Palomares, Spain, he sketched a bewildered officer asking
a peasant in broken Spanish if he had seen a missing hydrogen bomb.
(As it turned out, a scene like this actually occurred.) The disagreeable
Mr. Atom reappeared periodically over the issue of nuclear prolifera-
tion and the proposed missile defense systems. After the Three Mile
Island disaster of 1979, Herblock drew a family wandering in the dark
with the caption "Unknown Effects of All Radiation."[14]

His contemporary Pat Oliphant created a similar corpus of biting
nuclear cartoons that both reflected and helped shape American public
opinion of the day. His grotesque "Nuclear Power" beast followed in
the wake of Three Mile Island, and he was merciless with Chernobyl,
Ronald Reagan's Strategic Defense Initiative, and US-Soviet nuclear
negotiations. In a January 15, 1987, parody of a parody, he sketched
President Reagan—dressed up as Buck Rogers—playing poker with
Mikhail Gorbachev and saying to himself: "Well might you be wary!
Thinks Rex Reagan, Ace of Space."

However, most of the newspaper nuclear-themed political cartoons
proved decidedly of the moment. They lacked staying power. None of
them, either individually or collectively, could approach the impact
of two works of graphic-art fiction: Dr. Seuss's *The Butter Battle Book*
(1983) and Raymond Briggs's *When the Wind Blows* (1982). The rea-
son is obvious. Most political cartoons have a finite life span. One has
to understand the immediate context in order to grasp the satire. But
Dr. Seuss and Raymond Briggs moved their anti-nuclear messages into
well-illustrated stories, and when couched in a narrative, the message
carried far more weight. Dr. Seuss (Theodor Seuss Geisel) forged his *The*

Butter Battle Book with the same skill as his better-known *Cat in the Hat* and *Green Eggs and Ham*. Two adversaries, the Yooks and the Zooks (neither drawn as evil figures) glare at each other over a gigantic wall as each tries to build a more powerful weapon. The main area of disagreement lies with the fact that the Yooks eat their bread butter side up, while:

> In every Zook house
> And in every Zook town
> Every Zook eats his bread
> With the butter side down![15]

The story ends with the young narrator watching nervously as each side threatens his opponent over the wall while brandishing his "Bitsy big-boy boomeroo."

> Grandpa! I shouted. Be careful! Oh, gee!
> Who's going to drop it?
> Will *you* . . . ? Or will *he* . . . ?
> "Be patient," said Grandpa. "We'll see.
> We will see, . . ."[16]

The *New York Times* listed *The Butter Battle Book* as one of their notable books of the year, and it was quickly turned into a television special.

British illustrator Raymond Briggs's *When the Wind Blows* proved even more powerful. In a masterful blend of picture and text, Briggs tells the tale of a retired lower-middle-class Sussex couple, Jim and Hilda Bloggs (based on his parents), who strive earnestly to comprehend the Cold War nuclear standoff. Unfortunately, they often confuse the Soviet Union with Nazi Germany and contemporary political leaders with Winston Churchill and Adolph Hitler. *When the Wind Blows* is a master of visual understatement. Unlike the American over-the-top depictions of nuclear holocaust, no dismembered body parts bespatter Briggs's panels. He depicts the actual dropping of hydrogen bombs on England via two completely blank pages, tinged only slightly red at the upper edges. Similarly, the radiation sickness that eventually destroys the Bloggses occurs off panel. Clearly the artist had mastered the Japanese concept of "idea present, pen not needed."

Reviewers lavished praise on *When the Wind Blows*. British TV pro-

with its unique cartoon format, with its wide-eyed characters and cine-
matic rather than logical story progression. From his Seattle base, Rifas
continues to carry the progressive flag. In a 1984 interview he criticized
mainstream comic publishers for creating a sense of powerlessness and
fueling "our mad rush toward oblivion." Later he suggested that the
main reason he published Nakazawa's books "was partly to encour-
age opposition to nuclear weapons, . . . [but] primarily to advance my
agenda of promoting comic books as a powerful medium for educa-
tional and political-organizing projects." He remains convinced that
the underground comix movement helped subvert the values that so
underpinned the atomic age.[20]

Japanese Comics

Shocking and explicit though they were, the European and American
anti-nuclear comics could never match the power of their Japanese
counterparts. For obvious reasons, manga artists created atomic-related
stories with far more bite. Their atomic-based heroes confronted not
just villains but also suffering, tragedy, and, eventually, a call for
responsibility. The manga artists of Japan naturally approached the
atomic age from a very different perspective. Although Japanese com-
ics can be traced to the mid-1920s, manga as we know it did not really
emerge until the years of the American occupation. Yet in a sense,
manga roots stretched deep into Japanese history, with the traditional
Japanese emphasis on visual presentations as seen in historic scroll
paintings and in the iconic imagery of such nineteenth-century master
artists/engravers as Hokusai. Some have argued that Japanese society
is "traditionally more picto-centric than cultures of the West." Others
have described manga as both a powerful medium of entertainment
and a channel for the widespread diffusion of values. Similarly, his-
torian Frederik Schodt has argued that no outsider can hope to com-
prehend contemporary Japan without some understanding of the role
played by manga. Indeed, manga may account for 40 percent of the
literature published in Japan today.[21]

In the fall of 1945, Japanese young people—who had been fed
almost entirely on nationalistic propaganda during the conflict—
found themselves starved for entertainment. An estimated ten thou-
sand traveling storytellers eked out a living by walking from village

to village to ply their trade. Although American comic books arrived with the occupying soldiers, the 1930s world of Walt Disney had already sown the seeds for the creative genius of Japan's most famous cartoonist—indeed the person who virtually created the nation's manga industry—Osamu Tezuka (1928–89). A medical doctor turned cartoonist, his enormous creative output—over 170,000 images—had direct links with his wartime experience. As he later recalled, the day that peace was announced, he looked over his native city of Osaka and thought: "With the view of the city of Osaka in sight on August 15, I indeed felt that I could live for another several decades. Never in my life had I felt happier. I still remember the feeling vividly." Tezuka continued: "The feeling that I am alive, or something like an ode to life, unconsciously shows in whatever I create."[22]

As a child in the 1930s, Tezuka had been exposed to the numerous American films that his father had brought home, such as Buster Keaton's and Charlie Chaplin's comedies, as well as several of the early Disney cartoons. He later admitted that much of his creative energies drew from his prewar exposure to those American works, added to the simple fact that he had survived the conflagration.[23] Thus the atomic bomb always loomed large in Tezuka's mind.

Abandoning his medical career to become a full-time cartoonist, Tezuka first explored these themes in the manga *Metropolis* (1949) in which a Dr. Lorton creates an androgynous superhero, Michi, who, thinking he is human, attempts to discover his nonexistent parents. When Michi learns from the villain that he had been created from artificial cells and has no parents, he falls into despair and tries to destroy Metropolis. But at the last moment, he loses his power and melts away. The manga ends with the following cautionary message: "Michi's life is over. The creation of life made possible by the consummation of modern technology has only resulted in disturbing our society. Technology may get out of control and be used against mankind someday."[24]

Metropolis was followed by *The Future World* (1951), Tezuka's personal response to the Cold War between the United States (Star Republic) and the Soviet Union (Uran Union). In this tale, Dr. Yamadano, a physicist, discovers a tiny creature named Rococo on Horseshoe Island, where the Star Republic had conducted hydrogen bomb experiments. The creature is a "Fumoon," an advanced species mutated from

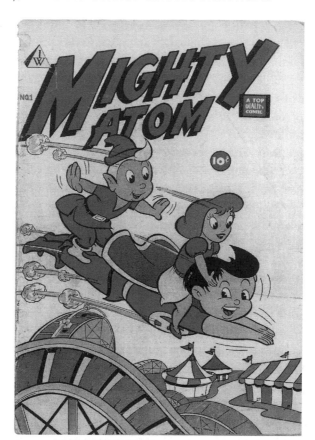

Cover of *Mighty Atom* #1 (IW Enterprises, 1963 reprint). Created by Osamu Tezuka—the artist who virtually invented the Japanese manga industry—*Mighty Atom* (a.k.a. *Astro Boy* in the United States) reflected the concerns of post–World War II Japan, including anxieties over the atom.

cerns. Tezuka wove the prevailing anxiety over the atom into numerous tales. In a manner echoing his American superhero counterparts, Astro Boy periodically saved Japan from destruction from atomic or hydrogen bombs. Because of his medical training, Tezuka knew well the world of science, and he infused scientific themes into many of the *Astro Boy* stories. Still, he never succumbed to the idea that science could answer all human problems. "I was a foolish scientist, and now I'm paying the price," one character confesses before he expires. "He

[Garon] really did not destroy himself," a character remarks in another story. "It shows what happens when a person has too much power."[30]

But Tezuka's work clearly reflects the culture from which it sprang. Unlike in American stories, many of the evil characters sincerely apologize to Astro Boy or to his teacher Mr. Mustachio. (To have the Joker apologize to Batman or Lex Luthor to Superman would have been unthinkable.) Surely this theme of apology reflected Japanese cultural norms, but it may also have pointed to a national yearning for an official American apology for the use of atomic weapons, an apology that never came. Not only do a number of villains apologize, but Astro Boy and his friends often recognize a spark of goodness in even the most fiendish of opponents. As the professor notes in a 1968 story, "He [Judas Pater] was an evil man, but sometimes God gives even evil people a spark of good." Similarly, Astro Boy observes: "So if you see any people acting bad around you . . . they may have been possessed by a strange mist! But they're not really bad!!"[31] A popular 2009 American film emphasizes Astro Boy's essential good nature.

In *Hiroshima Notes*, Kenzaburo Oe observed that, because the race to build atomic weapons would likely never cease, he sought only "decent and humanistic ways to contribute to the healing and reconciliation of all peoples." In a similar vein, this theme of "reconciliation" lies at the heart of many an Astro Boy tale. While the last panels of most American superhero comics show them sending the captured villains to prison—and well they deserve it—Astro Boy offers an alternative to incarceration. Consistently he tries to smooth over tragic conflicts, be they between humans and animals, robots and robots, or robots and humans. In a number of early tales, Astro Boy—who was once enslaved himself—attempts to prevent humans from treating other robots in a similar fashion. (Perhaps a reference to other nations looking down on a defeated Japan?) "Robot citizens," a speaker says to his human compatriots in one story, "we cannot live without you . . . but neither can you live without us."[32] Clearly, the suffering caused by the bombs propelled artists like Tezuka into a search for models of reconciliation and a concern about an excessive reliance on science.

Equally important, from 1945 through 1951, strict American censorship during the occupation dictated what could be presented to the Japanese public. For example, the occupying forces employed over

eight thousand censors who virtually silenced the voices of those who had suffered from the atomic bombs. One censor even punished a cartoonist for depicting Americans with red noses. Although the Americans departed in 1951, cautious Japanese governments continued the policy of suppressing overt atomic-related themes as late as the 1970s.[33] Such censorship often allowed manga artists a freedom in their fiction that was denied other commentators. Under the guise of fantasy and allegory, Astro Boy and Godzilla could present views on the atomic age that a Japanese editorial columnist or magazine writer could voice only with difficulty.

Although not exclusively a comic book character, Godzilla deserves mention here. On March 1, 1954, the United States conducted a hydrogen bomb test at Bikini Atoll in the Marshall Islands. When the bomb (code name Bravo) was detonated, *Lucky Dragon No. 5* (Daigo fukuryumaru), a Japanese tuna fishing ship, happened to be approximately 160 kilometers northeast of the test site. As a result, all of the twenty-three crew members were exposed to radioactive fallout for five long hours and later suffered from severe radiation sickness. When the newspaper *Yomiuri Shimbun* broke the news on March 15, it sent a shockwave across the whole nation, exacerbating anti-American sentiment. After all, it had been only nine years since the end of the war, and the memories of Hiroshima and Nagasaki were still fresh in the minds of Japanese citizens. Many viewed the incident as the "third nuclear attack" on Japan. In their eyes, Japan had become not only the first *atomic* bomb victim, it was also the first *hydrogen* bomb victim. This chain of incidents acted as a catalyst for the growth of numerous anti-nuclear campaigns.

The tuna from the vessel was immediately disposed of in Tokyo but not before some had reached consumers in Osaka, spreading a fear of irradiated tuna (*genbaku maguro*) throughout the nation. Over 450 tons of fish were confiscated and buried underground. Later surveys by Japanese scientists discovered widespread contamination of the North Pacific.[34] Meanwhile, rain contaminated by the radiation from the explosion fell in many parts of the country. The crises reached a tragic conclusion when Aikichi Kuboyama, the radio operator of the boat, died six months later.

From this heated atmosphere came the most infamous fictional

monster in history: Godzilla. Tellingly, the film opens with Godzilla attacking a fishing boat.[35] The story suggests that Godzilla belongs to an obscure prehistoric species—some form of cross between an oceanic reptile and a terrestrial animal that had survived two million years since the Jurassic period. But after being exposed to radiation from a hydrogen bomb test, the creature emerges as a forty-five-foot monster. Thus, Godzilla essentially functioned as a walking nuclear reactor, breathing out radiation. It also seemed attracted to light, for it usually attacked Tokyo at night—perhaps a reference to the wartime blackouts and the omnipresent B-29 bombers. After ravaging downtown Tokyo, Godzilla is finally dispatched by the powerful weapon named "Oxygen Destroyer" invented by Dr. Serizawa, a one-eyed scientist. Dr. Serizawa believes that modern technology should be used for the welfare of humankind—and not for its detriment, as the A-bomb had been. Fearing that the weapon could fall into malevolent hands, Dr. Serizawa destroys all his research, kills Godzilla with his Oxygen Destroyer, and then kills himself in a kamikaze-like suicide mission to annihilate Godzilla. The film ends with the elegiac music composed by Akira Ifukube soaring in the background while Dr. Yamane, a paleontologist, played by Takashi Shimura, states the following: "I don't think that is the last Godzilla. There will be another somewhere in the world if we keep conducting hydrogen bomb tests." Not only does Godzilla underscore the Japanese fear of atomic energy, it also serves as a warning against potential human folly involving modern technology. The impact of the March 2011 tsunami on the Fukushima Daiichi nuclear power plant illustrates the enduring wisdom of these words.

Originally a powerful allegory for the dangers of hydrogen bombs, Godzilla soon became an industry all its own. Twenty-eight subsequent Godzilla films, plus a host of spin-off artifacts, followed. When American producers released their own version in 1956, the tale conveyed a completely different message from the original. From 1977 to 1979, Marvel Comics published a twenty-four-issue monthly series detailing Godzilla's adventures for American readers. Here, the artists attempted (rather unsuccessfully) to enlist him on the side of virtue. Similarly, in 1976, the film *Godzilla vs. Megatron* portrayed Godzilla as a benign monster, noting: "When the fight is monster against monster the outcome is irrelevant . . . because good will always triumph over

evil."[36] Neither of these American ventures left any lasting impression. It is artistically difficult to turn a radioactive monster destroying Tokyo into a variety of "funny animal" deriving his power for good from munching radioactive carrots.

Barefoot Gen

In its initial form, Godzilla functioned as an allegory, not a direct atomic statement. Because of this relative silence on the moral issues involved, Keiji Nakazawa's *Barefoot Gen* (turned into anime in 1995) holds a unique position in comic book history.

From 1945 to 1972, few American or Japanese creative artists raised the question of the "responsibility" for the decision to use the atomic weapons on Hiroshima and Nagasaki. The reason for the American silence is obvious, but the relative reluctance of Japanese artists is harder to explain. In *The Bells of Nagasaki,* Roman Catholic physician Takashi Nagai suggests that the atomic bomb must be understood as part of God's providence, and that the lost lives were sacrificial lambs offered to God for the sins of humankind. Although drawing primarily from a Buddhist rather than a Christian perspective, the early *hibakusha* (A-bomb survivor) films shared a similar point of view. *Children of Hiroshima* (Gembaku no ko) (1952) by Kaneto Shindo, the first hibakusha film released in the post-occupation period, conveyed an overarching atmosphere of sadness and elegy. There was no fist shaking or naming names in these works. Instead, the sorrow and anger of the survivors seemed to be directed *inward.* By strictly refusing to be political, Japanese hibakusha cinema succeeded in appealing to the popular sentiments of the Japanese to see themselves as *victims* without explicitly blaming any particular party. They clearly helped transform Nagasaki and Hiroshima into symbols of peace with which the Japanese could readily identify. The questions of how the tragedy occurred and precisely who should be held accountable for it are conspicuous by their absence.[37] Even Astro Boy and Godzilla are no exception. This silence is what makes the cartoon story of *Barefoot Gen* unique.

Born in 1939 in Hiroshima, Keiji Nakazawa was only six when the atomic bomb was dropped on his hometown. Thanks to the concrete wall of his school, he survived with only minor injuries, but he lost his father, sister, and brother to the ensuing conflagration. He later

credited his artistic inspiration to his father, a painter, who had often predicted that Japan would lose the war, and to Osamu Tezuka. Like Tezuka, he also had been exposed to the Walt Disney comics and the comic strip *Blondie* in his childhood. "I thought American comics were second to none when it came to the quality of the drawing," Nakazawa recalled. The fact that Nakazawa was an A-bomb survivor and had lost his loved ones dominated his artwork. Once, when asked how he felt about comics that addressed social issues, Nakazawa replied, "I think the best cartoonists all do that. That's why I admire Tezuka so much."[38] When it comes to comments on ultimate responsibilities, however, even Tezuka's works pale in comparison to Nakazawa's.

The manga *Struck by Black Rain* (1968) presages all the qualities that would later go into *Barefoot Gen,* and its no-holds-barred accusations against the Americans are boldly stated. The protagonist of this short manga is an assassin named Jin, whose mission is to kill American businessmen living in Japan. The Americans are black marketeers trading weapons, and they miserably beg for their lives on all fours as Jin kills them. Other Americans in the story are depicted just as negatively. When Jin comes across American drunkards making a pass at women, he strikes them, saying, "I cannot bear to see those barbarians that have just been to Vietnam walking around in Japan." When he spots an American tourist spitting out his gum at the peace memorial park, he punches him in the face and demands that he pick up the gum: "What kind of place do you think Hiroshima is? Under the ground you are standing on are buried millions of humans. I can't bear to see you desecrate this place." Jin then shouts: "You murdered hundreds of thousands of civilians just to test the atomic bombs. You are more brutal than the Nazis." Later, Jin comes across a little girl named Heiwa (meaning "peace"). Born blind because of the effect of the A-bomb disease that her mother suffered, Heiwa lives with her grandfather. The only way to restore her vision rests with a cornea transplant, but she has yet to meet a donor. Heiwa's grandfather, who suffers from A-bomb disease himself, complains that the government does almost nothing to assist them. Jin then goes out to kill an American marketeer, but in so doing he sustains a fatal stab wound himself. As he drags himself back to Heiwa's home with a knife sticking out of his back, he offers to give his corneas to her. Jin's last message: "Heiwa, you can soon have

your vision. But promise me one thing. Please see to it that Japan will never let a war happen again, and that an atomic bomb will never be dropped again."[39]

Struck by Black Rain was written in aftermath of Nakazawa's mother's death in 1966, when she finally succumbed to the radiation sickness that she had suffered from since 1945. Having received a telegram telling him of his mother's deteriorating condition, Nakazawa rushed back to Hiroshima, only to find her in a coffin. Later, when he went to the crematorium to collect her ashes, he was dismayed at what he found. Nakazawa recalled: "It was an incredible shock to me. I think the radiation must have invaded her bones and weakened them to the point that they just disintegrated in the end." Until then, Nakazawa had largely bypassed the nuclear theme in his art. But he was so enraged by his mother's death (and the way she died) that he decided to take atomic themes more seriously. "The more I thought about it, the more obvious it was that the Japanese had not confronted these issues at all," Nakazawa said. "They hadn't accepted their own responsibility for the war. I decided from then on I'd write about the bomb and the war and pin the blame where it belonged."[40] The sociopolitical atmosphere of the late sixties made it much easier for both cartoonists and publishers to take on political issues. His resolution crystallized into one of the most significant manga books ever published in Japan: *Barefoot Gen.*

Serialized in 1972 and 1973 in the boys' comic weekly *Shonen Jump, Barefoot Gen* is Nakazawa's semiautobiographical story, and Gen (roughly translated as "everyman") experiences what Nakazawa himself went through. The work is composed of two parts: the first half illustrates how Gen and his family lived through prewar and wartime Hiroshima, followed by how they survived the bombing and its aftermath; the second half brings the story to the uplifting conclusion where Gen, who is finally reconciled to the deaths of his younger sister Tomoko and his mother, leaves Hiroshima for Tokyo in pursuit of a professional cartooning career.[41]

The artist Keiji Nakazawa was himself a hibakusha, but *Barefoot Gen* differs from many other hibakusha films or manga in several important ways. Whereas most protagonists in the hibakusha films are women who suffer and endure, *Barefoot Gen* features men as the

main characters. That *Barefoot Gen* is essentially a father-and-son story adds to the masculine nature of the work. The tone is set at the outset when Daikichi, Gen's father, brings his sons' attention to the fact that wheat bears fruit no matter how many times it is trampled upon, and tells the boys to grow like wheat. Daikichi's message appears as flash-backs at every critical juncture of the work; every time it appears, Gen takes the message to heart. Nakazawa once recalled his father's com-ment that "the war was wrong, that Japan would lose for sure, and that maybe then, and only then, the country would get better. The cartoon-ist's views about the war were clearly shaped by his father. Inuhiko Yomota, a Japanese critic of popular culture, has argued that eyes are used most frequently to distinguish one character from others and that a major protagonist is often characterized by large, wide eyes, as well as a prominent nose. Yomota concludes that all the major characters in *Barefoot Gen* share these facial features—a way to express their strength as well as show the will to protest.[42]

What makes *Barefoot Gen* truly special among manga, A-bomb-related films, and atomic anime lies in the way it deals with the hiba-kusha. While most other works dealing with the hibakusha usually focus on the lives of the survivors in the postwar period, *Barefoot Gen* provides wider vistas. It does not shy away from such crucial issues as the restriction of freedom of thought and freedom of speech in prewar Japan; the subsequent discrimination against the hibakusha after the war, even by their relatives (some people refused to shake their hands); and the terrible conditions of the war orphans, who often fell into the hands of the Yakuza (an organized crime syndicate) amid the chaos and confusion of the postwar era. In addition, *Barefoot Gen* is also one of the few major A-bomb-related works written in Japan to address the issue of how Korean residents were treated during that time period. Mr. Pak, Gen's Korean neighbor, is portrayed quite sympathetically. He is the only one who sides with Gen and his family throughout the ordeal.

In spite of the gravity of the theme and the tragedies that occur throughout the graphic novel, *Barefoot Gen* is a life-affirming tale. This is in no small part because of the way that Gen and the other children are portrayed. Living by their wits amid the postwar confusion, the children are far more energetic and resilient than many of the adult

characters. If they occasionally despair for their lives, they soon rise to the occasion and move on with renewed vigor. *Barefoot Gen* is indeed the story of the ultimate victory of the trampled masses. Just as John Steinbeck's classic novel *The Grapes of Wrath* (1939) concludes with a powerful ode to life, so, too, does *Barefoot Gen*. Struck by the fact that his hair has finally started to grow back, plus a vision of his father's recurring accolade to the enduring strength of spring wheat, the young hero eventually concludes: "I'll go on living whatever it takes! I promise." The last panel shows him skipping merrily into the sunset.

With sales of over eight million copies, *Barefoot Gen* ranks as the most popular manga in Japanese history. It is available in a ten-volume Japanese version, as well as a four-volume English translation. A team of volunteers has translated it into several other languages as well. *Barefoot Gen* has been made into a full-length film, a musical, and even an opera. Each generation reads it with fresh eyes. For years, Nakazawa also delivered between twenty and twenty-five talks a year on the theme. As he later recalled, "It was the first time people had heard the truth. That's what they told me everywhere I went." In another interview he remarked, "I'm a cartoonist, so cartoons are my only weapon [to effect change]."[43] Only US citizen Ted Nomura's unfinished comic book series *Hiroshima: The Atomic Holocaust* (2005) reflects the same intensity as *Barefoot Gen*.

The European and American cartoonists meant well, but their Japanese counterparts spoke from the heart when they constructed manga tales of nuclear power or crafted stories of the atomic bomb; they knew exactly what they were doing. And, unlike their US or European colleagues, they succeeded in placing the complex story of nuclear energy at the very heart of their culture.

THE NEVER-ENDING
APPEAL OF ATOMIC
ADVENTURE TALES

A firm believer in the educational potential of graphic art, Leonard Rifas once observed that "Comic books are not the inconsequential, harmless escapist fun that people assume they are."[1] Rifas's *All-Atomic Comics* perhaps to the contrary, comics have probably succeeded best when they cast their message in a story line. Over the last six decades, atomic adventure tales have far outnumbered their factual counterparts, either pro- or anti-nuclear. Publication figures would suggest that most readers absorbed their atomic information as a by-product of reading nuclear-themed adventure tales. This chapter will discuss those adventure tales under the following sections: (a) A discussion of the bevy of nuclear-powered heroes that emerged during the last five decades of the twentieth century; (b) an analysis of some of the key stories and their now-classic covers; (c) a discussion of the pseudo-atomic figures that flourished after the end of the Cold War in 1989–90 and the radical Islamist attacks of 2001; and (d) a coda on the dramatic power of the opera *Doctor Atomic*.

The appearance of several new atomic-related superheroes in the 1960s provided welcome relief from the previous decade's tales of nuclear conflagration. During this period a revived Atom (1961), Captain Atom (1960), Doctor Solar (1960), Spider-Man (1962), Hulk (1962), Firestorm, the Nuclear Man (1978), and Nuklon (1987) all breathed new life into the atoms-for-justice ethos. A good many of their foes had nuclear connections as well.

The Atom Revived

In September/October 1961 *Showcase* #34, DC Comics brought back its 1940s character the Atom. In the new version, Ivy University sci-

entist Ray Palmer finds a meteor fragment from a white dwarf star and makes a "reducing lens" from it. This lens shrinks him to six inches in height but allows him to retain the power of a 180-pound man. He also sports a striking new costume. In the mid-1960s, when Gardner Fox plotted the stories and Murphy Anderson and Gil Kane furnished the art, the "world's smallest super hero" finds himself caught in a variety of well-plotted adventures. Many of these tales incorporated various aspects of science, and since the Atom could change size at will, they involved subatomic themes as well. A number of issues contained educational science pages, one of which (March 1963) discussed early atomic theories.[2]

Comic book art is a collective enterprise, however, and the Atom did not fare as well when Fox turned the scripting over to others. Over time, the Atom married, found his wife in the arms of another, divorced, and in 1995 became a teenager again. In 1981, he helped his nephew Nuklon begin his career. In 1997, DC inaugurated a Tangent comics series that told of the adventures of Atom's "grandson," replete with contemporary interests and new costume. Surely the continual appeal of this rather bland character can be traced, in part, to the magic of his name.[3]

Captain Atom

In October 1960, veteran artist Steve Ditko created a new character for Charlton Comics' *Space Adventures,* Captain Atom. An air force pilot, Captain Adam, drops a screwdriver while working on a nuclear test missile, and the missile takes off while he is searching for it. The subsequent explosion turns Adam into "Captain Atom, the Indestructible Man," who carries "an atomic punch in each fist." Forced to devise a body shield to protect others from his radiation, Captain Atom receives a special commission from the president to defend law and order. He does so immediately by capturing a stray hydrogen-tipped missile, which causes the president to remark, "With your help, perhaps all of us can live in a world of peace."[4] Later, DC Comics acquired the character and in the 1980s gave him both a new costume and new "quantum" powers.

As with his "Atom" namesake, creation by committee proved hard on Captain Atom. Soon the DC hero became involved in soap opera

adventures that focused on his dead wife and the fates of their children. In later attempts to bring about justice, Captain Atom visited war-torn Latin America and Cambodia. On occasion, he battled the nuclear villain "Atomic Skull." In the classic graphic novel *Kingdom Come* (1997) the "nuclear-powered Captain Atom" is dispatched by the villain in the opening chapter. In the even more recent *Captain Atom: Armageddon* (2007), a well-drawn adventure tale that revolves around potential nuclear conflagration, Captain Atom bemoans the fact that he is considered only a "second-level superhero" in a world of giants.[5] He got that one right.

The Hulk

In 1962, Marvel's creative team of Stan Lee and Jack Kirby produced yet another industry icon with a semilikeable monster who raged at a great many things, including the army and various forms of injustice. As the initial cover put it: "Is he MAN or MONSTER or . . . is he both?" In a by now rather familiar scenario, Dr. Bruce Banner attempts to rescue a young man who has wandered into a nuclear explosion and unfortunately suffers a severe dose of gamma radiation. As a result, Banner turns into the Hulk when he becomes angry. As Stan Lee observed in a later interview, "I don't know any more about gamma bombs than I do about brain surgery, but I didn't try to explain how it worked. I just said he became the Hulk because of gamma radiation . . . at least it sounds scientific." Although the misunderstood, "loner" character faltered briefly in the mid-1960s, he returned as the "Incredible Hulk" and has remained a Marvel mainstay ever since.[6] The Hulk also appeared in a daily newspaper adventure strip and a popular TV series in the late 1970s. In 2008 a Hollywood Hulk film opened to very mixed reviews. One might think that a bulky green monster who smashes things and grunts his views of the world would reach only so far, but the Hulk has earned a place as an authentic nuclear comic figure.

Doctor Solar

Gold Key Comics' first original character, "Doctor Solar: Man of the Atom," proved far more imaginative. This atomic hero appeared in the same year as Ditko's Captain Atom and had a similar origin. Nuclear

scientist Phil Seleski suffers an accidental exposure to radiation that transforms him into pure energy, "a walking atomic pile." Because he is radioactive, Doctor Solar has to wear a complete body suit, with a special visor to render him harmless to his friends. Initially he restored his power by taking U-235 pills. Doctor Solar's well-plotted adventures frequently pitted him against a nuclear villain. In addition to the atomic-themed Solar tales, many Gold Key issues also contained four pages of "Professor Harbinger," a scientist who simplified atomic facts for readers. The 1960s Doctor Solar stories were decidedly pro-nuclear.[7] Overall, these Solar adventures continued for thirty-one issues, spaced over twenty years.

In 1990, Valiant Comics revived the character of a man composed of pure energy, adding especially flashy art work. The Valiant Doctor Solar, with red tights, goggles, and a nuclear emblem on his chest, proved far more complex than the earlier versions. This 1990s Solar experienced both angst and guilt. He visits a psychiatrist on a regular basis and once cries out in anguish. "I can't fix everything." In spite of these self-doubts, Doctor Solar did save nuclear power plants from exploding and at least once prevented the outbreak of nuclear war.[8] In the late 1990s, Valiant writers introduced various millennial themes, hinting that Solar had become a "god." The new "pure energy" powers given to Superman in 1997 clearly borrowed from Gold Key's original Doctor Solar. Although the revived Doctor Solar retains a considerable following, he has yet to reach the status of authentic nuclear icon.

Firestorm

A similar nuclear explosion produced DC's Firestorm, who first appeared in March 1978, just before the Pennsylvania Three Mile Island nuclear accident. Here young Ronnie Raymond joins a militant anti-nuclear group to impress his girlfriend. When the marchers sneak onto the grounds of a power plant, it explodes. The resulting nuclear detonation fuses young Raymond with the body of chief scientist Martin Stern to form a single person: "Firestorm, the nuclear man."[9]

With most of the stories written by John Ostrander, Firestorm emerged with a nuclear personality, "a kid who can switch his atomic structure at will." He could also use his powers to rearrange the atomic structure of other objects. Drawn with flames erupting from his hel-

met, Firestorm was depicted as a teenage "hot head," who once became jealous of Captain Atom and even fought with him on occasion. As the Cold War ended, Firestorm's scientific component (Stein) was replaced by a Russian scientist who had been caught in a similar Soviet nuclear disaster. This combination proved a fitting way to close the Cold War aspect of the nuclear comics genre. The *Firestorm* series expired in 1990 after a hundred issues, although the second-level hero occasionally has cameo appearances elsewhere.[10] He, too, can boast only a modest atomic superhero career.

Spider-Man

There is no dispute that the greatest atomic character of the 1960s was Spider-Man. Created in 1962 by Stan Lee and Steve Ditko, Marvel Comics' Spider-Man became the most popular costumed hero of his era. The story drew on familiar themes, but with a lighter, far more artistic touch. Peter Parker, a shy high school student, attended a public science exhibit on radiation. Unfortunately, a spider fell into the demonstrator's "radioactive ray gun" beam and bit Parker just before it expired. Because of this, Peter Parker acquired the spider's proportional strength, including the ability to climb walls, as well as a sixth sense regarding the presence of danger.

Like Superman and Captain America before him, Spider-Man be=came a cultural icon for his era. Somehow the figure of an angst-ridden, quasi-nuclear costumed hero answered a variety of social needs. In one tale, the hero has to borrow bus fare to track down the villain. By the mid-1970s, Spider-Man sales had topped even those of Superman. In 1965, *Esquire* magazine noted that Spider-Man's image was as popular in radical campus circles as that of revolutionary leader Che Guevara.[11]

Unlike previous superheroes, Peter Parker/Spider-Man expressed numerous doubts about his role. When his Uncle Ben was killed by a burglar whom Parker had allowed to escape (since he didn't want to become involved), Parker suffered guilt as well. Reluctantly, he decided he had to work for justice, musing that "with great power must also come great responsibility."[12]

Spider-Man appeared in a daily newspaper strip—with interminable plot lines—and also starred in an expanding series of comic book

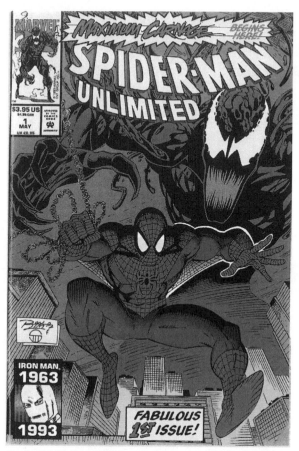

Cover of *Spider-Man Unlimited* #1 (Marvel Comics, May 1993).
Spider-Man was the greatest of the atomic-themed superheroes
who have emerged from the 1960s forward, most of whom
conveyed atomic information as a by-product of their adventure
tales. Spider-Man, Marvel, TM and © Marvel Entertainment,
LLC.

titles. His image could be found on countless commercial items, rang-
ing from lunch boxes to shirts to backpacks. The runaway success
of recent Hollywood Spider-Man films—with topflight computer
graphics—helped restore Marvel to financial solvency. Of all the
atomic superheroes, Spider-Man stands with Astro Boy as a rare trans-
national atomic comic figure.

.

In a 1993 reminiscence, Lee confessed that from a writer's point of view, it had become increasingly difficult to devise believable circumstances to give a superhero his or her powers. But the old reliable—a "nuclear accident"—could be called upon for a variety of purposes. Not only did this malfunction provide a superhero with his powers, it could be used to create atomic villains as well. During this period, comic artists produced an equally impressive array of nuclear villains. Spider-Man's foe, nuclear scientist Otto Octavius was turned into the evil "Dr. Octopus" when an atomic accident welded metal tentacles to his body. In 1977, Superman and Supergirl battled the Projector and Radion, both of whom were turned to their evil ways after surviving nuclear disasters. (In the end they destroyed themselves.) Similarly, Superman battled the "Atomic Skull," who had radium in his brain, and "Neutron," the man with the nuclear punch, while Firestorm fought "Multiplex," who had been created by radiation and could duplicate himself. DC's All-Star Squadron confronted an enemy named "Nuclear." With the mainstreaming of the counterculture ethos, DC introduced new heroes, the "Outsiders," whose enemy, the cloying, conventional Nuclear Family planned to blow up Los Angeles. Marvel's Iron Fist faced Atomic Man, while their Black Goliath tangled with Atom Smasher.[13] If one adds Mr. Atom, and Dr. Radium, to the list, one finds almost as many nuclear villains as nuclear heroes.

Other minor atomic figures rose and fell with regularity. Dell's Nukla—in real life Matthew Gibbs—found he could hurl nuclear energy from his fingertips, but (fortunately) this produced no harmful side effects. As the comic carefully explained, Nukla's power was *pure* atomic energy: "There is no fallout and very little radiation as the explosions he creates . . . are products of his nuclear charged will."[14] Nukla lasted for four issues.

Virtually the only effort to reassert the theme of nuclear complexity in the 1960s came with Dell's half-baked character Neutro (1967). A man-machine built from parts left over by space visitors, the creature was described as one who "knew neither good or evil." The comic closes by admonishing readers that Neutro is simultaneously the most terrifying menace and the strongest force for good that the world has ever seen. Whoever controls Neutro holds the fate of the world in his

hands. "Who will it be?"[15] Alas, the world had to remain hanging, as Neutro never appeared for a second issue.

Since tales of potential atomic disaster drew heavily from biblical archetypes regarding the end of time, they resonated on a multitude of levels. Indeed, from 1945 to the present day, atomic-themed comic book adventures have never lost their appeal. In his lengthy list, Robert Beerbohm counted over 180 such tales from 1953 to 1989.[16] From Donald Duck to the Gumps, from the Flash to Green Lantern, from Superman to Wonder Woman, it would be hard to find a cartoon character who did *not* confront nuclear themes. The following examples must serve as representative of a story genre that still continues, albeit in more subdued form since the end of the Cold War in 1989–90. Whether one looks at humorous or serious stories, the atomic theme is ever present.

The first issue of *The Gumps* (March/April 1947) featured a mushroom cloud on the cover, while in *Joe Palooka* #23 (August 1948) Joe helps select "Miss Atomic Blonde" for 1948. Super Duck's nephew Fauntleroy invents an "atomic gun," while *Destroyer Duck* #5 and *Super Pup* #4 both sported atomic bomb covers. In the hundredth issue of *Big Shot* (April 1949), Sparky Watts and Dotty Dash discover that civilization has been destroyed by atomic bombs and germ warfare, and they remain the only couple left alive. (Fortunately this is only a dream sequence.) In *Marge's Tubby* (March/April 1957), Tubby has misadventures with an "atomic violin," while in *Candy* (January 1953), "America's favorite teen-age Girl" watches a TV warning regarding an atomic blast while her boyfriend prepares to pop a paper bag. Naturally, the lighthearted comics treated nuclear themes in a similar manner.

The bulk of the adventure stories took a far more serious approach. In *Strange Adventures* #50 (July 1955) a visitor from outer space— Radium Man—steals a massive amount of American radium but has to leave it behind because it affected the space-drive mechanism of his rocket ship. In *Showcase* #23 (1960), Green Lantern stops an invisible villain from detonating an atomic bomb. Four years later, the Flash (May 1964) drew on his super speed to keep a nuclear bomb from obliterating a city. In 1965, Superman's hands became coated with invisible chemicals so that one clap would trigger an atomic explosion. In *Adventure Comics* #442 (December 1975), Aquaman barely stopped a

nuclear missile. The short-lived Marvel Boy (1950–51), whom Stan Lee erroneously declared "the first Super-Hero of the atomic age," bested his foes by dropping an atom bomb on them: "whoom!!!"[17] Airboy (February 1951) battled a foe who possessed "atomic rifles," while Dick Tracy (June 1957) defeated a villain who had invented a blinding "atomic flash." Wonder Woman (July 1963) barely prevented an underwater "atomic invasion." Eleven years later she had to stretch the fibers of her golden lasso to contain the blasts from two accidentally released hydrogen bombs exploding over Moscow (October/November 1974). Batman and Robin confronted Atomic Man, who could change the molecular structure of buildings. Later Rogue Trooper (November 1986) battled the "Raiders of the Atomic Desert." And so on, ad infinitum. Taken collectively, this endless stream of atomic-themed adventure stories made the world appear a great deal worse than it actually was.

In addition to the numerous "near miss" tales, comic book industry writers also regularly introduced stories set in the aftermath of all-out nuclear conflagration. The cover of the September/October 1970 *Strange Adventures* wondered which of the eight nations with H-bombs (in "1986") would trigger World War III. DC artists often depicted Superman or Superboy wrestling with similar dangers. In 1983, they previewed "the Great Atomic War of 1986," and the next year they highlighted "the day they nuked Superman." In 2005, Malibu Comics began a Terminator 2: Judgment Day series, *Nuclear Twilight*—with exceptionally graphic covers. In 1999, DC echoed this theme with a Superman "Nuclear Nightmare" issue (v1 #339), the same year that Marvel issued a Captain America tale with an identical "Nuclear Nightmare" subtitle. The *Adventures of Superman* (February 1999) cover featured not one but two simultaneous H-bomb explosions. The British version of this apocalyptic scenario can be seen in *Judge Dredd*, whose title character serves as "The Law" in post-holocaust "Mega-City One."

Two especially strong post-Armageddon story lines emerged with Charlton's *Children of Doom* (mid-1960s) and *Doomsday + 1* (mid-1970s). In *Children of Doom*, Sergius O'Shaughnessy (Denny O'Neil) and artist Pat Boyette describe a post-holocaust earth that has left survivors with strange mutant powers, such as the ability to see without eyes. Two American space travelers, aided by a mutant who can

travel through time, accidentally set off the hidden timer on an atomic doomsday machine, which they succeed in dismantling only at the last minute. Says the mutant at the end: "It is our task to build a new world . . . a world without weapons of war." If another bomb is ever set off, the blind seer states, "We may not have a second chance." In *Doomsday + 1*, writer Joe Gill and artist John Byrne set forth a similar scenario whereby a "lunatic despot" who is about to be dethroned fires nuclear missiles at both New York and Moscow, which leads to World War III. Although the Earth is largely destroyed, three US astronauts— two female—return safely to Greenland. Here they discover a third-century Goth who has just emerged from being frozen in a glacier and quickly learns modern ways. Together they battle a variety of villains from Earth and outer space in a brief series of well-plotted, thoughtful adventures. As the cover of issue 5 notes, "We four are the only survivors. There's no one else alive."[18] These tales fell between the film classic *On the Beach* (1957) and the television production *The Day After* (1991), but they kept this theme very much alive for the era.

Striking cover art formed an essential part of the atomic comics offerings. As in *Life* magazine, comic book covers and interior splash panels depicted an endless array of mushroom clouds.[19] In *Action Comics* #328 (September 1965) Superman accidentally "wiped out" Metropolis; in *Action* #342 he became a "Super-Human Bomb." The 1980s accentuated this theme. In *Action* #550 (December 1983), he faced "The day the earth exploded"; *Action* #598 (March 1986) showed a hydrogen bomb cover with no additional message. The two "Nuclear Nightmare" covers by Marvel and DC proved equally strong. The cover of *Alien Encounters* #8 (August 1986) juxtaposed Marilyn Monroe holding down her dress against a backdrop of a mushroom cloud, the ultimate iconic merger of sex and violence. But the most striking atomic bomb cover of all came with *Superman* #408 (June 1985). Here DC artists depicted the Man of Steel on his knees in anguish: "They did it. They finally had a nuclear war. And nobody survived except me!"

The end of the Cold War in 1989–90 took some of the edge off comic book depiction of nuclear villains or atomic holocausts. The only remaining atomic-related theme with dramatic cachet seemed to be nuclear terrorism. Crusade Comic's *Atomic Angels*, a team of smart-talking teenagers trained for "nuclear crisis intervention," addresses

this concern. The team's attitude is decidedly flip—"even the smallest atomic blast can just about ruin your day!"—and the stories include little genuine atomic connection.[20]

Modern comic book illustrators still draw on radiation to create their superheroes, but usually in a more lighthearted vein. In 1984, Kevin Eastman and Peter Laird created their popular Teenage Mutant Ninja Turtles to parody the superhero genre. The turtles acquired much of their power from inundation by a "glowing ooze." The Adolescent Radioactive Black Belt Hamsters (1986), a parody of a parody, received their power from radioactive jello. One can also find mention of Colossal Nuclear Bambino Samurai Snails and Radioactive Wrestling Rodents.[21] The recent animated cartoon character Sponge Bob Square Pants (first TV show 1999) tellingly lives in Bikini Bottom.

Muttonman (1981) by Vincent Craig (1950–2010) and Matt Groening's *Radioactive Man* (1993) demonstrate this genre to perfection. Although few outside the Southwest recognize Navajo artist Craig's *Muttonman*, his mock hero appeared weekly in the *Navajo Times* in the late 1970s and early 1980s to great acclaim. In Craig's rendition, an ordinary Navajo herder eats some sheep that had slurped liquid from the rupture of the Church Rock, New Mexico, uranium waste mill pond. The (authentic) collapse of the mill pond sent a wall of radioactive water west to Gallup, New Mexico, and into Arizona, and although no deaths were reported, it released far more radiation into the environment than the far better known Three Mile Island near-meltdown in Pennsylvania. (Both occurred in 1979.) "This mutton sure tastes weird," the sheepherder says, but the end result is to turn him into Muttonman, the first Navajo Nation superhero. Described as "faster than a jackrabbit, more powerful than the Bureau of Indian Affairs, and able to leap Shiprock at a single bound," Muttonman begins to right various wrongs on the reservation. In one clever tale, he foils the evil "Frybread Monster"—an uncontrolled, doughy ooze—that had been created when Grandmother cooked her daily frybread on a piece of Mysterious Metal that had fallen from an errant spaceship. With the help of a Navajo code talker, Muttonman lures Frybread Monster into a natural sandstone hole in the rock, where he becomes permanently stuck. "That will teach you to mess with the Navajo nation!" declares the hero, while the cheering crowd urges him to run

for the tribal council.[22] Today, Muttonman's image adorns numerous T-shirts and coffee mugs.

Matt Groening's *Radioactive Man* (1993) draws from the same fount of parody. True to tradition, the hero missed the sign warning of an explosion at the Nevada Test Site and became engulfed in the atomic blast. The result was to create "this brightly-garbed champion of justice, this defender of the USA, the enemy of non-conformity, this Radioactive Man." With his sidekick "Fallout Boy" the rather dense Radioactive Man goes about defending "authority." Groening's clever satires reflect the comix nihilistic view of all things nuclear and are a thorough send-up of comic book history.[23] Groening's equally satirical character Homer Simpson, an incompetent employee of the Springfield Nuclear Power Plant, where he regularly breeds havoc, reflects the same theme. For example, in *Simpsons Comics* #119 (2008) Homer's bumbling "causes everyone in town to be irradiated." But, like the good soldier he is, Homer Simpson always returns in the next issue to try again.

The present-day comic book industry remains in turmoil. Consequently, the picture of contemporary atomic comics is by no means clear. In 2008 the major corporations, DC and Marvel, controlled about 77 percent of a $700 million-a-year business, but the industry is facing stiff competition for the youth entertainment dollar. The advent of television, video arcades, and especially home computer games and game stations, with their far more realistic visual imagery, has severely hurt comic book production, while simultaneously infusing comic styles with a computer graphics look. Overall, sales have plummeted. In the early 1950s, for example, the industry produced about 60 million comic books per month; by the late 1980s, the number had dropped to 2.5 million. With its 500th issue (June 2009) once powerful *Mad* magazine dropped from monthly to quarterly. "Kids don't even read comic books anymore," complained Hulk film director Ang Lee, in 2003. "They've got more important things to do—like video games."[24] Had it not been for the profits from selling the film rights to their main characters, DC and Marvel might well have folded.

Ironically, as the comics industry contracted in the United States, it virtually exploded in Japan. Japanese comics, or manga, sell about

seven billion copies a year and account for 40 percent of all Japanese books and magazine publications sold annually. Historian Frederik L. Schodt has argued that Japanese cartoonists have raised comics to the highest level of artistic expression. The Walt Disney of Japanese manga, Osamu Tezuka, once defined the genre as follows: "*Manga* is virtual. *Manga* is resistance. *Manga* is bizarre. *Manga* is pathos. *Manga* is destruction. *Manga* is arrogance. *Manga* is love. *Manga* is kitsch. *Manga* is sense of wonder. *Manga* is . . . there is no conclusion yet."[25] Tezuka failed to mention that manga is also versatile. Indeed, a number of modern Japanese artists continue to turn out nuclear-themed manga. Baseball reigns as a popular sport in Japan—often couched in nationalistic terms—and publishers have even created atomic-themed baseball comics. One book features a player who is a hibakusha. Another stars a pitcher whose unbeatable "miracle pitch" is termed the "A-bomb ball."

Life in a post-holocaust world is poignantly treated by Katsuhiro Otomo and Takumi Nagayasu in *The Legend of Mother Sarah*. The story revolves around a mother's search for her children after a nuclear war. Katsuhiro Otomo's lengthy *Akira* is equally famous. It treats life in the year 2030, after World War III had destroyed the Japanese islands. Other atomic comics include Kanji Iwasaki's *Like Fire, Like Wind* and Hetsuo Aoki's *Wearing Red Shoes*. Each is a powerful treatment of atomic concerns.[26] Unlike their US counterparts, manga artists have placed the atomic theme at the core of Japanese life.

One finds only a dim reflection of similar concern in contemporary US graphic novels. In the DC classic by Mark Waid and Alex Ross, *Kingdom Come* (1997), for example, the mushroom cloud is portrayed as a form of "ultimate judgment." In Frank Miller's *The Dark Knight Returns* (1986, 1996) the main evil facing society seems to be social anarchy, rather than the atomic bomb that devastates much of the land. The recent elaborate graphic novel *Watchmen* (1987)—a success on the big screen as well—may be a modest exception. Here, writer Alan Moore and artist Dave Gibbons interweave atomic themes throughout this neo-Calvinist tale (all the major figures sport serious flaws), and "Dr. Manhattan," who was spawned by a nuclear explosion, functions as the artist's mouthpiece regarding the meaning of time. But Englishman Moore began his graphic novel during the years of the conservative prime minister Margaret Thatcher, and the themes of totalitarian

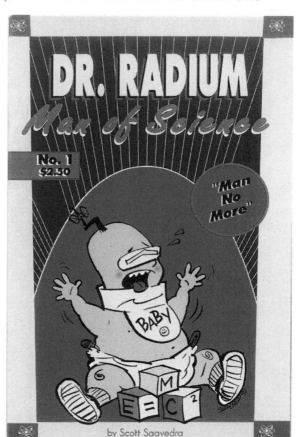

Cover of *Dr. Radium: Man of Science* #1 (Slave Labor Graphics, October 1992). Beginning in the 1990s, a number of smaller comic book companies began to introduce nuclear-themed titles. Most of these do not have any authentic nuclear links, such as *Dr. Radium: Man of Science,* which contains only an odd nuclear allegory.

rule and interior social collapse dominate the work. In the novel, the eventual destruction of New York City—brought about to cast suspicion on Dr. Manhattan—is not nuclear related.[27]

A number of smaller comic book companies have a stake in this game as well. Within the last few decades, the minor comic producers have introduced several nuclear titles, but seldom do they have any authentic nuclear links. *Reactor Girl* (1992), *Sub-Atomic Shock* (1993),

Quantum Leap (1992), and *Atomic City Tales* all go their own (non-atomic) way. *Atomic Chili* (1990) is a collection of graphic horror tales. *Dr. Radium: Man of Science* (1992) contains only an odd nuclear allegory. *Post Nuke Dick* is a heavy-handed satire set in a post-holocaust world. *Bulletin from Ground Zero* treats sexual innuendo, while all the issues in *A-bomb* are sexually explicit. The four-volume *Atomic Age* and *Fusion* rate as purely science fiction. Recently there has been a plethora of "atomic" titles: *Atomic City Tales* (Kitchen Sink), *Atomika* (Mercury), *Atomic Robo* (Red 5 Comics), *Atomic Toybox* (Image), *Atomic Overdrive* (Caliber), *Doris Nelson, Atomic Housewife* (Jake Comics), *Atomic Angels* (Crusade), *The Atomics* (AAA Pop Comics), *After Apocalypse* (Paragraphics), *Atomic Man* (BlackThorne), *Atomic Age* (Epic), *Atomic Ace* (Whitman), *Critical Mass* (Shortwave), *Johnny Raygun and the Nuclear Kids* (Jetpack), *Nuklear Renaissance* featuring the Atomic Weasel (Radius), *Atom Eve* (Image), *Atomic Rocket Group* (Atomic Diner), as well as two Saturday morning cartoon figures, *Atomic Betty* and *Atomic Mike*. In 2009, the world of Web comics introduced *Atomic Laundromat*.

Few of these "atomic" characters contain much heft, but this has been true from the beginning. Virtually all the nuclear-themed heroes—from Atomic Man of 1946 to the Atomic Angels of today—have been unable to convey the multifaceted implications that flowed from the splitting of the atom. If the atomic superheroes appear flat, the few semihistorical Manhattan Project graphic novels are simply tedious. In 2001, Jim Ottaviani and others published *Fallout,* a mixture of fact and fiction wrapped in a retelling of the Manhattan Project story. Eight years later Jonathan Elias and Jazan Wild followed with *Atomic Dreams: The Lost Journal of J. Robert Oppenheimer.*[28] Like the films *The Beginning or the End* and *Fat Man and Little Boy,* these cartoon renditions somehow made the saga of the Manhattan Project boring. Perhaps the actual history of the atomic bomb is so compelling that it simply overpowers any fictional rendition. In a sense the historians of the Manhattan Project have trumped the creative artists. Led by Richard Rhodes, their historical renditions carry more power than any fictional versions ever could.

Still, for better or worse, the cartoonists' depictions of the atomic age have influenced millions of people for over three generations. Buck Rogers and Flash Gordon may have anticipated the Manhattan Proj-

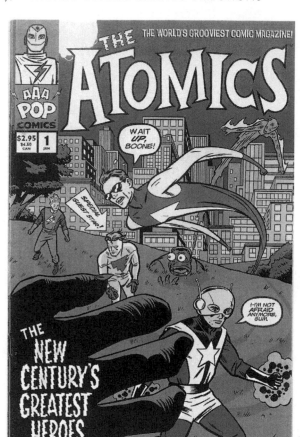

Cover of *The Atomics* #1 (AAA Pop Comics, January 2000). Like most nuclear-themed comic book heroes, the more recent creations, such as the characters in *The Atomics,* cannot convey the multifaceted implications that flowed from splitting the atom. Created, written, and drawn by Michael Allred; colors by Laura Allred.

ect, but after 1945 the graphic artists moved into full stride. For over six decades they sketched their variegated views of the atomic age, views that ranged from potential conflagration to a veritable energy utopia, with countless stops in between. They even modestly dipped their pens into the well of atomic humor. One has to be careful here. As Niels Bohr once remarked in wartime Los Alamos, there are some

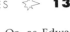

things so serious that you can only joke about them. Or, as Edward Teller quipped when he was told that some scientists worried that the proposed 1945 Trinity Site detonation might possibly ignite the atmosphere and thus destroy all life on earth: "Oh David, there are worse things that could happen." With the onset of the Cold War, many graphic artists depicted the nuclear work with cynicism, parody, resignation, or bland acceptance of the inevitable—a far cry from the initial awe, horror, and fingers-crossed optimism of the late 1940s. It is ironic that cartooning—the most "democratic" of all artistic media—seems no longer able to confront the *complexity* that the fissioned atom introduced to the world.[29] The result has been to produce an atomic banality, a nuclear numbness that has virtually trivialized the power of the fissioned atom.

The post–Cold War comic book treatment of atomic issues represents a distanced, almost abstract approach to facing the dilemmas of the fissioned atom. Although contemporary comics occasionally draw on tales of potential apocalypse, with some exceptions the inevitable cosmic disasters flow as much from earthquakes, meteors, volcanoes, or social breakdown as from nuclear conflagration. The majority of the vast array of modern "atomic" comic book heroes share one thing in common: they have virtually nothing to do with nuclear energy, in any form.

The same dilution of nuclear themes can be found in society at large. Just as a 1960s New Jersey amusement park once boasted an "atomic boat," so does a modern British band call itself "Atomic Kitten." There is a "nuclear red" hair dye, an *Atomic Ranch* magazine, and one pub serves a "nuclear cocktail" in a chemistry beaker. A Mexican wrestler terms himself "Atomic Blue." There are more "Atomic Diners" scattered across the West than one can count. A product in Hong Kong is even named "Atomic Enema." In the early twenty-first century, then, the term "atomic" has come to mean everything, anything, and, thus, ultimately nothing.

Dismay over this atomic trivialization eventually spurred impresarios John Adams (music) and Peter Sellars (libretto) to create the opera *Doctor Atomic*, which has been described by one critic as "an operatic masterpiece for the early 21st century." Adams once called the Manhattan

Project the American myth par excellence. Similarly, Sellars has argued that everyone has an emotional/spiritual dimension and that one task of the arts is to nourish that yearning. Their *Doctor Atomic* first opened in San Francisco in 2005 and then moved to the Netherlands, Chicago, New York, and Santa Fe. In *Doctor Atomic,* the ever-intertwined hopes, fears, and anguish of atomic energy/atomic weapons are portrayed in all their complexity. But the destruction of Trinity/Hiroshima is not. Instead, those world-shattering events are left to the most powerful of artistic devices—the human imagination. The opera concludes not with an on-stage "splash panel" atomic detonation but with the performers staring at the audience in total darkness, interspersed with a faint Japanese female voice asking for water. By blending the moral and scientific themes of nuclear power into composite characters represented by Edward Teller, meteorologist Jack Hubbard, J. Robert Oppenheimer, Kitty Oppenheimer, and a fictional Tewa Indian maid, Adams and Sellars have recreated a long-forgotten awe and respect for the power of the fissioned atom. As one reviewer noted, *Doctor Atomic* helps reawaken the "public understanding of our atomic heritage."[30] How ironic that the most elite form of entertainment, the opera, has revived the themes that the most democratic form, the comic book, had first introduced to the American public.

CONCLUSION

Although no artistic medium—film, art, fiction, song, theater, sculpture, history, photography, or opera—can ever encompass the entirety of the story of atomic energy, for over seven decades the world's cartoonists have contributed more than their share to public discourse. Recall Robert Crumb's gentle dismissal of his craft as "only lines on paper." Yet this very simplicity gave the cartoonists their power.[1] The vast implications that flowed from the emergence of the subatomic world proved so complex that Americans needed a new way to comprehend the incomprehensible. Buck Rogers and Flash Gordon introduced millions of readers to the ideas of endless power sources, horrific weapons, dangerous rays, and the need to keep both from the hands of evildoers. Atom Blake the Boy Wizard, Spacehawk, TNT Todd, Superman, and the Human Torch continued the theme during the World War II years. In August of 1945 Hiroshima and Nagasaki emerged as a terrible embodiment of these predictions. The subsequent development of the hydrogen bomb and the possibility of destroying life on earth—concepts too deep for words and well beyond human comprehension—made the pictorial representation of the atomic era even more necessary. The powerful cartoons of David Low, D. R. Fitzpatrick, Leslie G. Illingworth, Pat Oliphant, and (especially) Herblock provided essential frames of reference for their times. During the cultural revolt of the 1960s/70s, the underground artists inaugurated a wholesale anti-nuclear critique that mainstream cartoonists helped redirect into millions of households during the Reagan years. The range and intensity of nuclear-themed graphic art of that period is not likely to be duplicated.

All cartoons and comics, of course, are embedded in the larger

culture. Every cartoonist clearly reflects the times in which he or she draws. The General Electric and General Dynamics pro-nuclear comic books of the 1950s were echoed by such government-sponsored films as *Atomic Energy as a Force of Good* (1955) and *Plowshare* (1961). The underground comix emerged as part of the "Beatnik" counterculture of the West Coast. The anti-nuclear graphic novels of the Reagan years were complemented by the satirical Cold War film *The Atomic Café* (1982) as well as the profound 1983 Roman Catholic bishops' pastoral letter "The Challenge of Peace: God's Promise and Our Response," which denounced America's nuclear policy in the strongest terms: "Jesus must weep at such a world." This often-overlooked pastoral letter argued that the United States had never fully accepted its share of responsibility for the wartime use of the atomic bombs. The bishops said that the nation must express "profound sorrow" over the bombings (not exactly an apology) before it could begin to see its way toward repudiating such weapons.[2]

The shifting atomic ground from 1929 to the present plus the ambiguous nature of popular culture makes it a challenge to evaluate the cartoonists' precise role in shaping the popular understanding of the fissioned atom. Even the cartoonists themselves have been hesitant to make pronouncements. Leonard Rifas remains uncertain as to the impact of his classic *All-Atomic Comics*. Recalling the work of the early underground artists, Robert Crumb similarly doubted that they had much effect on the nation as a whole. "Nobody's ever done a comic that changed the world," he said. "That's for sure."[3] In a sense, Crumb is correct. But if no single cartoon or comic book has that power, how about an entire corpus? There is an old Russian proverb that quantity has a quality all its own. Over the last seven decades, comic artists and writers have produced *billions* of nuclear-themed cover art, splash panels, and interior stories. Such numbers cannot be discounted. The cartoonists were never of a single mind, of course, and their messages shifted dramatically over time. For obvious reasons, the dominant theme driving atomic comics has revolved around the terrible truth of atomic weapons. Any discussion of the "positive" side of the atomic equation—nuclear power and nuclear medicine—pales by comparison. Moreover, neither of these themes had any dramatic cachet. Aside from *Andy's Atomic Adventures* I could find only one comic book

adventure tale that treated nuclear medicine, the simply dreadful *Cancerman* (Edge 1994). Cancerman inflicted breast cancer upon women by using his ability to look through their clothing. This required the intervention of "Radical Surgery Man" and "Chemo-Boy" to help save the day. Indeed, the saga of atomic medicine still cries out for a Harvey Kurtzman to make it comprehensible to a popular audience. In fact, one might even argue that the *lack* of comic book treatment of nuclear medicine is the reason why Americans, as a whole, are not well informed on this topic. And, as nuclear power reemerges as a much debated response to global climate change, perhaps the same could be said for atomic power plants as well.

Although there is always an element of uncertainty regarding any analysis of popular culture—some things simply cannot be "proven"—the question of overall impact might best be understood within a generational context. True, young adults from seventeen to thirty form the main comic book audience today, but this was not always the case. Until the early 1980s, most comic books were aimed at young readers. Surely what people read when they are young will somehow affect their future thinking. As critic Arthur Berger has argued, comic book reading played a key role in the socialization of young people for generation after generation "by virtue of the simple fact that millions of children—and adults—cannot continually be exposed to a form of communication without something happening."[4]

Viewed from the early twenty-first century, however, it seems obvious that, in spite of all their differences, the cartoonists' treatments of the atomic age shared two themes. First, the initial cartoon response to the onset of the nuclear world emphasized its ambiguity. Although this theme faded over time, it never completely disappeared. This dualism turned the atomic age into the most powerful of all modern myths. As anthropologist Claude Lévi-Strauss once observed, most great myths are built around opposites (good/bad; light/dark, etc.). To make sense of the world, humankind has to confront this inherent dualism and come to some sort of peace with it.[5] The best comic artists reflected this dualism in a myriad of ways. Although wayward spider bites, miscellaneous nuclear detonations, radioactive mutton, and U-235 carrots might enable superheroes/superrabbits to perform noble deeds, the omnipresence of Mr. Atom, Atomic Man, Atomic Skull, Doctor Octo-

pus, and *All Atomic Comics* points to another side as well. The jury is still out on the question of nuclear power. The atomic comic book legacy has always been a double-edged sword.

Second, and equally important, for the most part the striking nuclear cover art, the political cartoons, and the nonstop array of atomic-themed stories have all pointed to the necessity of preventing another Hiroshima and Nagasaki. Even the 1950s stark war comics and the crude underground parodies could agree on this. The various heroic atomic cartoon characters share this sentiment as well. In fact, should this illustrious crew ever gather at some Cartoon Heaven coffee house, Buck Rogers, Flash Gordon, Superman, the Flash, Wonder Woman, Captain Marvel, the Atomic Thunderbolt, Atoman, Atomic Mouse, Atomic Rabbit, Atom the Cat, Spider-Man, the Hulk, Captain Atom, Firestorm, Astro Boy, Barefoot Gen, Muttonman, Radioactive Man—and probably even Mr. Atom, Doctor Octopus, and Homer Simpson—would all raise their half-caf cappuccinos and say: "Amen."

NOTES

Preface

1. Although the *Comic Book Marketplace* 46 (April 1997) devoted most of its stories to the subject, so far there have been only two overviews of atomic comic books: Leonard Rifas's four-page "U.S Comic Books and Nuclear War," in *Itchy Planet* #1 (Fantagraphics, 1988); and my essay "Atomic Comics: The Comic Book Industry Confronts the Nuclear Age," in *Atomic Culture: How We Learned to Stop Worrying and Love the Bomb,* edited by Scott C. Zeman and Michael A. Amundson (Boulder: University Press of Colorado, 2004), 11–32.

Introduction

1. Gerald Wendt and Donald Porter Geddes, eds., *The Atomic Age Opens* (New York: Pocket Books, 1945), 9, 66.

2. Laura Fermi, *Atoms for the World* (Chicago: University of Chicago Press, 1957), 41.

3. Bill Blackbeard and Martin Williams, eds., *The Smithsonian Collection of Newspaper Comics* (Washington, DC: Smithsonian Institution Press, 1977), 13. Crumb, quoted in James Dankey and Denis Kitchen, *Underground Classics: The Transformation of Comics into Comix* (New York: Abrams Comic Arts in association with the Chazen Museum of Art, 2009), 45. The Spiegelman quotation comes from *New York Jewish Week* 215 (May 31, 2002): 35.

4. The literature on the history of the comic book is extensive. The following list is only representative. Two indispensable works of reference are Ernst Gerber and Mary Gerber, comps., *The Photo-Journal Guide to Comic Books,* 2 vols. (Minden, NY: Gerber Publishing, 1989), and Ernst Gerber, *The Photo-Journal Guide to Marvel Comics,* 2 vols. (Gerber Publishing, 1991). The annual *Overstreet Comic Book Price Guide* is equally indispensable. See also Mike Benton, *The Comic Book in America* (Dallas: Taylor Publishing, 1989, 1993); Mike Benton, *Superhero Comics of the Silver Age* (Dallas: Taylor Publishing, 1991); Les Daniels, *Comics: A History of Comic Books in America* (New York: Bonanza Books, 1971); Les Daniels, *DC Comics: Sixty Years of the World's Favorite Comic Book Heroes* (Boston: Little, Brown, 1995); Les Daniels, *Marvel: Five Fabulous Decades of the World's Greatest Comics* (New York: Harry A. Abrams, 1991); Denis Gifford, *The International Book*

of Comics (Toronto: Royce Publishing, 1984); Ron Goulart, *Great American Comic Books* (Lincolnwood, IL: Publications International, 2001); Ron Goulart, *Over 50 Years of American Comic Books* (Lincolnwood, IL: Publications International, 1991); Roger Sabin, *Comics, Comix, and Graphic Novels* (London: Phaidon Press, 1996); Paul Sassienic, *The Comic Book* (London: Ebury Press, 1994); James Steranko, *The Steranko History of Comics*, 2 vols. (Reading, PA: Supergraphics, 1970, 1972); Brian Walker, *The Comics Before 1945* (New York: Harry N. Abrams, 2004); Brian Walker, *The Comics Since 1945* (New York: Harry N. Abrams, 2002); Nicky Wright, *The Classic Era of American Comics* (Chicago: Contemporary Books, 2000); Herb Galewitz, editor, *Great Comics Syndicated by the Daily News and Chicago Tribune* (New York: Crown, 1972); David Hajdu, *The Ten-Cent Plague: The Great Comic-Book Scare and How It Changed America* (New York: Farrar, Straus and Giroux, 2008); Jules Feiffer, comp., *The Great Comic Book Heroes* (New York: Dial Press, 1965). Will Eisner's *Comics and Sequential Art* (Tamarac, FL: Poorhouse Press, 1998) remains a classic, as does Scott McCloud's *Understanding Comics: The Invisible Art* (New York: DC Comics, 1994). For a listing of web-based cartoon resources, see Paul Commarata, "Editorial Cartoons on the Web," *C and RL News*, October 2006, 536–39.

5. *Washington Post*, December 4, 1949, L5; *New York Times*, December 13, 2000, B10.

6. Ritchie Calder, *Science in Our Lives* (New York: New American Library, 1955), 18; Hutchins is quoted in Mike Goodenow Weber, *Visionary Behavior: Creative Intelligence in Action* (West Coshohocken, PA: Infinity, 2007), 38.

7. J. Michael Barrier, ed., *A Smithsonian Book of Comic-Book Comics* (New York: Smithsonian Press, 1981); Bill Blackbeard and Dale Crain, *The Comic Strip Century: Celebrating 100 Years of an American Art Form* (Northampton, MA: Kitchen Sink Press, 1995). Art Spiegelman, *Maus*, 2 vols.; Will Eisner, *Comics and Sequential Art*, comment on the cover. Tezuka, as quoted in Ferenc M. Szasz and Issei Takechi, "Atomic Heroes and Atomic Monsters: American and Japanese Cartoonists Confront the Onset of the Nuclear Age, 1945–1980," *Historian* 69 (Winter 2007): 751.

8. Bill Bryson, *A Short History of Nearly Everything* (New York: Broadway Books, 2003), 140–41.

9. See Matthew Gurewitsch, "The Opera That Chooses the Nuclear Option," *New York Times*, September 25, 2005; Heidi Waleson, "All About the Bomb," *Wall Street Journal*, October 4, 2005, D7; and Alex Ross, "Countdown," *New Yorker*, October 2, 2005, 60–71.

1 ■ Comic Strips Confront the Subatomic World

1. Walter D. Claus, *Radiation Biology and Medicine* (Reading, MA: Addison-Wesley, 1958), 2; Alexi Assmus, "Early History of X Rays," *Beamline* (Summer 1995): 10–24.

2. Assmus, "Early History of X-Rays," 16, 21.

3. Otto R. Frisch and John A. Wheeler, "The Discovery of Fission," *Physics Today* 20, no. 11 (November 1967): 43–52. *New York Times*, January 8, 1922, 1. Henry DeWolf Smyth, *Atomic Energy for Military Purposes: The Official Report on the Development of the Atomic Bomb Under the Auspices of the United States Government, 1940–1945* (Princeton, NJ: Princeton University Press, 1947), 29.

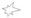

4. Einstein, as quoted in Paul A. Carter, *Another Part of the Twenties* (New York: Columbia University Press, 1977), 65; Carolyn D. Hay, "A History of Science Writing in the United States and of the National Association of Science Writers," MA thesis, Medill School of Journalism, Northwestern University, 1970, 161.

5. Edwin E. Slosson, *Easy Lessons in Einstein* (New York: Harcourt, Brace and Howe, 1920), 65, 77, 100.

6. David Dietz, "More Than Doom for Japs in Atomic Explosion," *El Paso Herald Post*, August 7, 1945, 1. Dietz, *Atomic Energy in the Coming Era* (New York: Dodd, Mead, 1945). It was also published in a pocketbook Armed Services edition. David Dietz, *Atomic Science, Bombs, and Power* (New York: Dodd, Mead, 1954).

7. William L. Laurence, "The Atom Gives Up," *Saturday Evening Post*, September 7, 1940, 12–13, 60–63. Laurence, *Men and Atoms: The Discovery, the Uses, and the Future of Atomic Energy* (New York: Simon and Schuster, 1959), 268. Lawrence, *Dawn over Zero* (New York: Knopf, 1946).

8. Carter, *Another Part of the Twenties*, 70. Bertrand Russell, *The ABC of Relativity* (New York: Signet, 1959; first published 1925), 9. *New York Times*, June 18, 1939, 23; many of these can be found in Laurence, "The Atom Gives Up."

9. Hay, "Science Writing," 379, 52.

10. Bud Fisher, *Forever Nuts: The Early Years of Mutt and Jeff*, edited by Jeffrey Lindenblatt (New York: Nantier, Beall, Minoustchine, 2008), 3–16. R. F. Outcault's *The Yellow Kid: A Centennial Celebration of the Kid Who Started the Comics* (Northampton, MA: Kitchen Sink Press, 1995), 15, 70.

11. *All Rare: Magazine of Fantasy: Buck Rogers* #1 (Spring 1980): 4, 50–51.

12. Phil Nowlan, Dick Calkins, and Rick Yager, *The Collected Works of Buck Rogers in the 25th Century*, edited by Robert C. Dille (New York: Chelsea House, 1969).

13. Philip Nowlan and Dick Calkins, *Buck Rogers in the 25th Century: The Complete Newspaper Dailies. Volume One, 1929–1930* (Neshannock, PA: Hermes Press, 2008).

14. George Cowan, *Manhattan Project to the Santa Fe Institute: The Memoirs of George A. Cowan* (Albuquerque: University of New Mexico Press, 2010), 15. *All Rare: Magazine of Fantasy: Buck Rogers* #1, 68.

15. *All Rare: Magazine of Fantasy: Buck Rogers* #1, 53.

16. Nowlan and Calkins, *Buck Rogers . . . Complete Newspaper Dailies, Volume One*, 19, 66. Dick Calkins and Phil Nowlan, *Buck Rogers in the Twenty-Fifth Century A.D.* (Racine, WI: Whitman, 1933), 256. Review of *The Comics*, by Coulton Waugh, *New York Times*, December 21, 1947, BR7.

17. Phil Nowlan and Dick Calkins, "Buck Rogers: An Autobiography," in Nowlan, Calkins, and Yager, *The Collected Works of Buck Rogers in the 25th Century*, xv–xxiii; Bill Borden, with Steve Posner, *The Big Book of Big Little Books* (San Francisco: Chronicle Books, 1997).

18. Arthur Asa Berger, *The Comic-Stripped American* (New York: Walker and Company, 1973), 93–100.

19. Austin Briggs, *Flash Gordon: Volume 1, 1940–1942* (Princeton, WI: Kitchen Sink

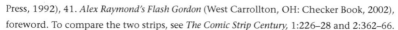

Press, 1992), 41. *Alex Raymond's Flash Gordon* (West Carrollton, OH: Checker Book, 2002), foreword. To compare the two strips, see *The Comic Strip Century,* 1:226–28 and 2:362–66.

20. Cover of *The Collected Works of Buck Rogers in the 25th Century.*

21. H. G. Wells, *The World Set Free* (Quiet Vision Publishing, 2000; first published 1914), 48–49. David Kyle, *A Pictorial History of Science Fiction* (London: Tiger Books, 1986), 165; Paul Brians, *Nuclear Holocausts: Atomic War in Fiction,* chap. 1. Available online at http://public.wsu.edu/~brians/nuclear/.

22. Herb Galewitz, ed., *Great Comics Syndicated by the Daily New and Chicago Tribune* (New York: Crown, 1972), vii–xv.

2 ■ The Comics and the Fissioned Atom

1. Frisch and Wheeler, "Discovery of Fission." *New York Times,* December 31, 1939, 27.

2. Laurence, "The Atom Gives Up," 12–13, 60–63. *New York Times,* May 30, 1940, 1. *New York Times,* December 29, 1940, D5.

3. *Popular Mechanics* 1 (January 1941); *New York Times,* May 5, 1940, 1.

4. R. M. Langer, "Fast New World," *Colliers* 106 (July 6, 1940): 18–19, 54–55, quotation on 18.

5. *New York Times,* May 12, 1940, 59.

6. Tony Goodstone, ed., *The Pulps: Fifty Years of American Pop Culture* (New York: Chelsea House, 1970), v, xiv. See, especially, the photographs of the covers, xx–xxvii. James Steranko, *The Steranko History of Comics,* vol. 1 (Reading, PA: Supergraphics, 1970), 15–33.

7. Dennis O'Neil, *Secret Origins of the Super DC Heroes* (New York: Warner Books, 1970), qtd. 14. Dennis Dooley and Gary Engle, eds., *Superman at Fifty: The Persistence of a Legend* (New York: Collier, 1987), 33, 59. Steranko, *Steranko History of Comics,* vol. 1, qtd. 41.

8. *The 100 Most Important Comics of All Time,* special issue of *Hero Illustrated,* May 1994, 8–9.

9. Jules Feiffer, *The Great Comic Book Heroes* (New York: Dial, 1965), 52. See also Scott McCloud, *Understanding Comics* (Northampton, MA: Kitchen Sink Press, 1993) for an explanation of how this art form works, as well as Eisner, *Comics and Sequential Art.* Gerard Jones, *Men of Tomorrow: Geeks, Gangsters, and the Birth of the Atomic Book* (New York: Basic Books, 2004), qtd. 135. Al Jaffee, interview by Danny Fingeroth, *Write Now!* 18 (Summer 2008), 14; Simcha Weinstein, *Up, Up, and Oy Vey! How Jewish History, Culture, and Values Shaped the Comic Book Superhero* (Baltimore: Leviathan Press, 2006).

10. Michelle Nolan, "Patriotic Heroes, The Red White & Blue of WWII," *Comic Book Marketplace* 2, no. 48 (June 1997): 13–18. Jon Berk, "National Comics: The Most Patriotic Title of Them All!" ibid., 34–43.

11. Ron Goulart, *Over 50 Years of American Comic Books* (Lincolnwood, IL: Publications International, 1991), 117.

12. See *Anti-Hitler Comics* #1 (Summer 1996) (New England Comics Press), for a col-

lection of these World War II stories. Bill Black, ed., *Golden Age Greats*, vol. 1 (Longwood, FL: Paragon, 1994).

13. Jones, *Men of Tomorrow*, 213. Jerry Robinson, *The Comics: An Illustrated History of Comic Strip Art* (New York: Putnam, 1974), 166. Mike Benton, *Superhero Comics of the Golden Age* (Dallas: Taylor, 1992), 4. "Escapist Paydirt," *Newsweek* 32 (December 28, 1973): 55, 58. Robert Alsop, "Comics Publishers Woo Kids with Top Dog and the Pope," *Wall Street Journal*, October 10, 1985, 1. Josette Frank, "Some Questions and Answers for Teachers and Parents," *Journal of Educational Sociology* 23 (December 1949): 211–12.

14. Robert Beerbohm, "Atomic/Nuclear Radiation Genre, Partial Index," copy in author's possession. *Wow Comics* #1 (Winter 1940–41) (Fawcett). *Starman*, in Mike Gold, ed., *The Greatest Golden Age Stories Ever Told* (New York: DC Comics, 1989), 137–50. Victor Pazmino, "TNT Todd," *Men of Mystery* #43 (AC Comics). "Spacehawk," *Blue Bolt Comic* v1 #5 (October 1940), in *Supermen! The First Wave of Comic Book Heroes, 1936–1941*, edited by Greg Sadowski (Seattle: Fantagraphics Books, 2009). *The Bouncer* (1944) (R. W. Voigt). *Whiz* #36 (October 1942) (Fawcett). *All Winners* (Spring 1941) (U.S.A. Comic Magazine Corp.), as found in *Marvel Masterworks Presents All Winners*, vol. 1 (New York: Marvel, 2005), 207–18. Ron Goulart, "The Second Banana Superheroes," in *All in Color for a Dime*, edited by Dick Lupoff and Don Thompson (Iola, WI: Krause, 1997), 230.

15. *Fred Kida's Valkyrie: From the Pages of Air Fighters and Airboy Comics* (Park Forest, IL: Ken Pierce, 1982), esp. 2, 16, 30, 58. *Air Fighters Classics* #3 (December 1942) (Hillman Periodicals). *Air Fighters Classics* #4 (December 1943) (Hillman Periodicals).

16. The best book on this theme is David Holloway, *Stalin and the Bomb: The Soviet Union and Atomic Energy, 1939–1956* (New Haven, CT: Yale University Press, 1994). Gordon Dean, *Report on the Atom: What You Should Know About Atomic Energy* (London: Eyre and Spottiswoode, 1954), 22.

17. Jack Lockhart (former chief, Press Division, Office of Censorship), "Best Kept Secret of the War" (AP article), *El Paso Herald-Post*, August 8, 1945, 1. John W. Campbell, *The Atomic Story* (New York: Henry Holt, 1947), 123.

18. John Lansdale, interview by Lawrence Suid, February 1, 1983, typescript. Copy provided by archivist Michael Brodhead, US Army Corps of Engineers.

19. *New York Times*, April 4, 1943, 18. Book review, *New York Times*, July 11, 1943, 19.

20. *New York Times*, October 22, 1944, E5.

21. *El Paso Herald-Post*, July 16, 1945, 1.

22. Frank M. Robinson and Lawrence Davidson, *Pulp Culture: The Art of Fiction Magazine* (Portland, OR: Collectors Press, 2007), 177. Campbell, *Atomic Story*, qtd. 249. Isaac Asimov, "Fact Catches Up with Fiction," *New York Times*, November 19, 1961, SM34. Campbell, *Atomic Story*, 118; H. Bruce Franklin, ed., *Countdown to Midnight: Twelve Great Stories About Nuclear War* (New York: DAW Books, 1984), 15–16.

23. Albert I. Berger, "The Triumph of Prophecy: Science Fiction and Nuclear Power in the Post-Hiroshima Period," *Science-Fiction Studies* 9 (July 1976): 143–45.

24. *Walt Disney, Mickey Mouse* (New York: Abbeville Press, 1978), 187–204, quotations from 193 and 204.

25. *Action Comics* #21 (February 1940); "Atomic Fuel Cylinders Stolen" (February 28, 1940); and "Threat to the Daily Planet" (March 1, 1940), as found on *The Adventures of Superman* CDs (Wallingford, CT: Radio Spirits, 2005).

26. "Dr. Dahlgren's Atomic Beam Machine," "Atomic Fuel Cylinders Stolen," and "Threat to the Daily Planet," as found on *The Adventures of Superman* CDs (Wallingford, CT: Radio Spirits, 2005).

27. *The Greatest Superman Stories Ever Told* (New York: DC Comics, 1986), 43–44.

28. Louis N. Ridenour, "Military Secrecy and the Atomic Bomb," *Fortune,* November 1945, 218–23. Franklin, *Countdown to Midnight,* 14–17.

29. Lansdale to Parsons, as printed in *Harper's* 196 (April 1948).

30. Wendt and Geddes, *Atomic Age Opens,* 38.

31. Wendt and Geddes, *Atomic Age Opens,* 206.

32. Paul Boyer, *By the Bomb's Early Light: American Thought and Culture at the Dawn of the Atomic Age* (New York: Pantheon, 1985), xix, 307. Wendt and Geddes, *Atomic Age Opens,* 42, 43, 46, quotation on 38.

33. James Gunn, *Alternate Worlds: The Illustrated History of Science Fiction* (Englewood Cliffs, NJ: Prentice Hall, 1995), 170.

34. Bradbury quoted in Boyer, *By the Bomb's Early Light,* 257.

35. *Time,* September 3, 1945, letters section. Wendt and Geddes, *Atomic Age Opens,* 41.

36. *Time,* November 12, 1945, 29.

37. Speech by General Leslie R. Groves in a session titled "The Atomic Bomb," January 10, 1946. Typescript in author's possession. Copy provided by Timothy Moy.

38. See the essays in Scott C. Zeman and Michael A. Amundson, eds., *Atomic Culture: How We Learned to Stop Worrying and Love the Bomb* (Boulder: University Press of Colorado, 2004). *Los Angeles Times,* April 15, 1940, 1. *New York Times,* July 23, 1944, SM3. Lewis, as cited in J. Samuel Walker, *Prompt and Utter Destruction: Truman and the Use of Atomic Bombs Against Japan* (Chapel Hill: University of North Carolina Press, 1997), 77. *New York Times,* August 17, 1945, 1. *New York Times,* February 10, 1946, 90; Richard Rhodes, *Dark Sun: The Making of the Hydrogen Bomb* (New York: Simon and Schuster, 1995), 362. *Washington Post,* August 3, 1947, 81. Bob Considine, "The Beginning or the End!" *Movie Story Magazine* 27 (February 1947): 29.

39. Walter J. Ong, "The Comics and the Super State," *Arizona Quarterly* 1 (Autumn 1945): 34–35.

3 ■ Coming to Grips with the Atom

1. *Serving Through Science: A Series of Talks* (United States Rubber Co., 1945). Molly Roth, interview by Gabe Schraeger, History 338 Classroom assignments, copy in author's possession.

2. Eldred C. Nelson and Leonard I. Schiff, *Our Atomic World* (Albuquerque: University of New Mexico Press, 1945). Dexter Masters and Katherine Way, eds., *One World or None* (New York: McGraw-Hill, 1946). Russell R. Williams, "The Atomic Age," *Saturday Review,* December 1, 1945. David Dietz, *Atomic Energy in the Coming Era* (New York: Dodd Mead,

1945); Campbell, *Atomic Story.* James Bryant Conant, "The Scientific Education of the Layman," *Yale Review* 36 (Autumn 1946): 15–36. *Washington Post,* June 20, 1947, C8.

3. "The Atomic Bomb," January 10, 1946, transcript (published February 15, 1946); copy given by Tim Moy and in author's possession. Philip Morrison, "If the Bomb Gets Out of Hand," in Masters and Way, *One World or None* (New York: McGraw-Hill, 1946), 6. Louis N. Ridenour, "There Is No Defense," in Masters and Way, *One World or None,* 33. Nelson and Schiff, *Our Atomic World,* 6. Federation of American (Atomic) Scientists, "Survival Is at Stake," in Masters and Way, *One World or None,* 78; Lewis Mumford, "Gentlemen: You Are Mad!" *Saturday Review of Literature* 29 (March 2, 1946): 8.

4. Alice Kimball Smith, *A Peril and a Hope: The Scientists' Movement in America, 1945–1947* (Chicago: University of Chicago Press, 1947). See Ferenc Morton Szasz, *The Day the Sun Rose Twice: The Story of the Trinity Site Nuclear Explosion, July 16, 1945* (Albuquerque: University of New Mexico Press, 1984, 1994). Szasz, *The British Scientists and the Manhattan Project: The Los Alamos Years* (New York: St Martin's, 1992). Atom Train Exhibition (n.p.: n.p. 1947).

5. Federation of American (Atomic) Scientists, "Survival Is at Stake," 78. "The Available Facts," *Popular Science* 16 (August 1955): 77. (The editors were recalling events of a decade earlier.)

6. Considine, "The Beginning or the End!" 76–78. "On the Set of the Beginning or the End!" *Movie Story Magazine,* 77.

7. Considine, "The Beginning or the End!" 76.

8. "The 36-Hour War," *Life* (November 19, 1945): 27–35. *New York Times,* June 23, 1946, SM4.

9. Steven E. Mitchell, "Slaughter of the Innocents, Part Four," *Comics Buyer's Guide* #1561 (October 13, 2008), 30. See chap. 2, "The Bomb," in William W. Savage Jr., *Comic Books and America, 1945–1954* (Norman: University of Oklahoma Press, 1990), 14–23.

10. "The Atomic Bomb," *Real Life Comics* #27 (dated 1945 but probably January 1946).

11. *Science* #1 (January 1946) (Humor).

12. *True Comics* #47 (March 1946), 3. *Picture News* (January 1946 and February 1946) (Lafayette Street Corporation).

13. *Jim Ray's Aviation Sketchbook: Picture Stories of Prizes and Pilots* #1 (March/April 1946) (Vital Publications); *Future World* #1 (Summer 1946). *Air Ace* (February/March 1946) (Street and Smith). William John De Grouchy, *Science Is in the Air: An Inspirational Textbook Told Almost Exclusively in Pictures* (New York: Street and Smith, 1947). *The Secret Voice* (1945) (Great American Comics).

14. Joe Musial, *Dagwood Splits the Atom* (1949) (King Features). Such comic book depictions were much more sophisticated than the nuclear songs found in the country music of the era. See Charles Wolfe, "Nuclear Country: The Atomic Bomb in Country Music," *Journal of Country Music* 6 (January 1978): 4–22. "Joe Musial, 72, Drew Katzenjammer Kids," *New York Times,* June 8, 1977, 62.

15. *Atomic Man* (December 1945) by Young and Bennet. Observed at *Atomic Man* #1,

Library of Congress copy; not in guide (9/14/2009). *Atomic Comics* #1 (January 1946) (Daniels Publications); *Atomic Comics* #1 (January 1946) (Green Publishing). *Atomic Comics* (1945) (Jay Burtis).

16. *Headline Comics* #19 (November/December 1945). *Headline Comics* #17 (January/February 1946). *Headline Comics* #16 (November/December 1945).

17. *The Atomic Thunderbolt* #1 (February 1946).

18. *Atoman* #1 (February 1946). See also Benton, *Superhero Comics of the Golden Age,* 57–62.

19. *X-Venture* #1 (July 1947) and #2 (November 1947) (Victory Magazine Corporation).

20. Denis Gifford, *The International Book of Comics* (Toronto: Royce, 1984), 113, 127, 154. "The Nuclear Pay-Off," *Marvelman* #314 (August 24, 1959), 19.

21. *T-Man* #20 (December 1954) (Quality Comics Group of Comic Magazines). *Young Men* #25 (February 1952) (Interstate Publishing).

22. *The Durango Kid* #7 (October/November 1950) (Magazine Enterprises); "The Nuclear Pay-Off," *Marvelman* #314 (August 24, 1959), 19. Savage, *Comic Books and America,* 20.

23. Benton, *Superhero Comics of the Golden Age,* 67–69.

24. *Action* #101 (October 1946) (National Periodical Publications/Detective Comics).

25. *The Superman Radio Scripts,* vol. 1, *Superman vs. the Atom Man* (New York: Watson-Guptill, 2001) 4, 10, 53, 201–3. Eric Hoffman, "Superman: The Columbia Serials," *Comics Feature* 35 (January 1957): 40–45.

26. *Captain Marvel Adventures* #66 (October 1946) (Fawcett).

27. *Captain Marvel Adventures* #122 (July 1951) (Fawcett); see also *Captain Marvel Adventures* #131 (April 1952) (Fawcett).

28. *Whiz Comics* #150 (October 1952) (Fawcett); Savage, *Comic Books and America,* 20–21.

29. *Whiz Comics* #82 (February 1947) (Fawcett). *Captain Marvel Adventures* #107 (April 1950) (Fawcett). *Captain Marvel Adventures* #78 (November 1947) (Fawcett). Bradford W. Wright, *Comic Book Nation: The Transformation of Youth Culture in America* (Baltimore: Johns Hopkins University Press, 2001), 69–71. *Captain Marvel Adventures* #76 (September 1947) (Fawcett), 46–47.

30. George McManus, *Fun for All: A Collection of Jokes, Anecdotes, and Epigrams . . . A Lighthearted Reflection of These First Years of the Atomic Era . . .* (Cleveland: World Publishing, 1948), 107. Robert Osborn, *War Is No Damn Good* (New York: Doubleday, 1946). Robert Mankoff, ed., *The Complete Cartoons of the "New Yorker"* (New York: Black Dog and Leventhal, 2004), passim. Mort Walker, *Beetle Bailey: The First Years, 1950–1952* (New York: Checker, 2008), 147.

31. Ron Goulart, *The Comic Book Reader's Companion: An A-to-Z Guide to Everyone's Favorite Art Form* (New York: HarperPerennial, 1993).

32. *Hoppy the Marvel Bunny* v2 #8 (February 1947) (Fawcett).

33. *Hollywood Funny Folks* #48 (July/August 1952) (DC Comics).

34. *Donald Duck's Atom Bomb* (1947), Cheerios Giveaway, Walt Disney Corporation. "Atomic Tot," *All Humor Comics* #2 (Summer 1946) (Comic Favorites).

35. *Atom Ant* #1 (January 1966) (Gold Key). *Atomic Mouse* #1 (March 1953) (Fago). See also Steve Sibra, "Atomic Animals," *Comic Book Marketplace* 2 (April 1994): 30–34.

36. See Allan M. Winkler, *Life Under a Cloud: American Anxiety About the Atom* (New York: Oxford University Press, 1999).

4 ■ Atomic Comic Utopias, Espionage, and the Cold War

1. Enrico Fermi, foreword to Nelson and Schiff, *Our Atomic World*, 3. Nelson and Schiff, *Our Atomic World*, 49, 53. Harold C. Uery, "How Does It All Add Up?" in Masters and Way, *One World or None*, 55.

2. Robert M. Langer in Wendt and Geddes, *Atomic Age Opens*, 178. R. M. Langer, "The Miracle of U-235," *Popular Mechanics* 75 (January 1941): 1–5. J. Robert Oppenheimer, "The Atomic Age," in *Serving Through Science: The Atomic Age* (New York: US Rubber Company, 1945): 14. O. R. Frisch, *Meet the Atoms: A Popular Guide to Modern Physics* (New York: A. A. Wyn, 1947), 220–21. R. E. Peierls and John Enogat, eds., *Science News: An Atomic Energy Number* (Middlesex, Hammondsworth: Penguin Books, 1945), 17. John W. Campbell, *The Atomic Story* (New York: Henry Holt, 1947), 261–62. J. Robert Oppenheimer, in US Department of State, *The International Control of Atomic Energy* (Washington, DC: GPO, 1946), 37.

3. For the story of Classics, see William B. Jones Jr., *Classics Illustrated: A Cultural History, with Illustrations* (Jefferson, NC: McFarland, 2002).

4. *Newsweek* 32 (December 27, 1943): 55–58. *The Story of Harry S. Truman* (Democratic National Committee, 1948).

5. "Andy's Atomic Adventures," *Adventures in Science* (1957) (Classics Illustrated). *The Illustrated Story of Great Scientists* (February 1960) (Classics illustrated); *Adventures in Science* (June 1957) (Classics Illustrated); *The Atomic Age* (June 1960) (Classics Illustrated).

6. *Adventures Inside the Atom* (1948) (produced for General Electric Company by General Comics). *Adventures Inside the Atom* (1964) (Pictorial Media).

7. *The Mighty Atom* (1959) (Western).

8. Heinz Haber, *The Walt Disney Story of Our Friend the Atom* (New York: Dell, 1956). *New York Times*, January 7, 1951, 34.

9. *The Atom, Electricity, and You* (1973) (Custom Comics).

10. M. Philip Copp, *The Atomic Revolution* (New York: General Dynamics Corporation, 1957). Copp, *Atomic Revolution*, passim. Richard Rutter, "Industry Turns to Comic Books," *New York Times*, July 16, 1955, 19.

11. See the counterside in Scott C. Zeman, "'Taking Hell's Measurements': *Popular Science* and *Popular Mechanics* Magazines and the Atomic Bomb: From Hiroshima to Bikini," *Journal of Popular Culture* 41 (2008): 695–711. *Flying* #60 (June 1957): 25ff; quotation from front cover. James Joseph, "Details on the NX2-Our Atomic Plane," *Science*

and Mechanics 32 (January 1961): 66–70. Mick Nathanson and Richard Elfenbein, "The Atomic Car . . . Fact or Fiction," *Car Life* 1 (July 1954): 22–27. Robinson and Davidson, *Pulp Culture,* 92–93.

12. Frank Tinsley, "Atomic Planes Are Closer Than You Think," *Mechanics Illustrated* 51 (August 1955): 71–75. Frank Tinsley, "A-Powered Trains in Glass Tubes," *Mechanics Illustrated* 32 (December 1956): 62–67. Frank Tinsley, "Air-Power Transport" *Air Trails* 37 (January 1952): 26–27.

13. Harry Cushing, "Atomic Power!—In Your Car," *Motor Trend* 3 (April 1951): 15–17, 48. See also James J. Duderstadt, "The Energy Wars: Some Lessons Learned," Millennium Project Papers, http://milproj.dc.umich.edu/publications/UM_Energy_Symposium /index.html (accessed November 11, 2009). Leo Meyer, *Atomic Energy in Industry: A Guide for Tradesmen and Technicians* (Chicago: American Technical Society, 1963). Arnold Kramish and Eugene M. Zuckert, *Atomic Energy for Your Business: Today's Key to Tomorrow's Profits* (New York: David McKay, 1956), esp. chap. 5.

14. See James Ersfeld, "Taking the High Ground: The Military in Space, 1955–1966," MA thesis, University of New Mexico, 2009. For the atomic stories in film and fiction, see Jerome F. Shapiro, *Atomic Bomb Cinema: The Apocalyptic Imagination on Film* (New York: Routledge, 2002); Kim Newman, *Apocalypse Movies: End of the World Cinema* (New York: St. Martin's Griffin, 2000); and Paul Brians, *Nuclear Holocausts: Atomic War in Fiction,* available online at http://www.wseu.edu/brians/nuclear/preface.html (accessed October 11, 2009).

15. Clarence J. Brown, "Scope and General Background of Atomic Medicine," in *Atomic Medicine,* edited by Charles F. Behrens (New York: Th. Nelson and Sons 1949), 6.

16. Lorna Arnold, comp., *The Development of Atomic Energy, 1939–1984* (Bournemouth, Dorset: Bourne Press, 1980), 1.

17. Laura Fermi, *Atoms for the World: United States Participation in the Conference on the Peaceful Uses of Atomic Energy* (Chicago: University of Chicago Press, 1957). US Congress, *Hearings Before the Subcommittee on Research and Development of the Joint Committee on Atomic Energy . . . ,* June 2, 3, and 4, 1954 (Washington, DC: GPO, 1954), 1.

18. "The Doctor Tells You How Atomic Medicine Now Works Miracles for You," *True Romance* 61 (February 1956): 59–60. Walter D. Claus, ed., *Radiation Biology and Medicine* (Reading, MA: Addison-Wesley, 1958), 3. Brown, "Scope and General Background," in Behrens, *Atomic Medicine,* 3. Kenzaburo Oe, *Hiroshima Notes,* trans. David L. Swain and Toshi Yonezawa (New York: Marion Boyers, 1995).

19. *The Peacemaker* #1 (March 1967); *Danger* #14 (1955).

20. "What Science Learned at Bikini," *Life* 23 (August 11, 1947): 74–85; Stafford L. Warren, "Conclusions," ibid., 86–87.

21. "If an A-bomb Falls," *Washington Post,* July 15, 1951, M11; July 16, 1951, B1; July 18, 1951, B1; July 19, 1951, B1; July 20, 1951, B1, etc. The quotation is from the comic book version, *If an A-bomb Falls* (1951) http://www.ep.tc/comics/a-bomb/ (accessed August 7, 2009). "Series of 7 Illustrated Panels Shows How to Survive an Attack," *Wash-*

ington Post, July 15, 1951, M1. *The H-bomb and You,* http://www.ep.tc/comics/h-bomb/ (accessed August 19, 2009).

22. For the atomic stories in film and fiction, see Shapiro, *Atomic Bomb Cinema;* Newman, *Apocalypse Movies;* and Brians, *Nuclear Holocausts.*

23. The best studies on this theme are Boyer, *By the Bomb's Early Light;* Winkler, *Life Under a Cloud;* and Spencer R. Weart, *Nuclear Fear: A History of Images* (Cambridge: Harvard University Press, 1968).

24. *Atomic Spy Cases* v1 #1 (March/April 1950) (Avon Periodicals).

25. *Spy and Counterspy* #1 (August/September 1949) (Best Syndicated Features).

26. *Spy Cases* v2 #8 (December 1951) (Hercules Publishing); *Spy Fighters* v1 #8 (May 1952) (Classic Syndicate).

27. *Spy Hunters* #8 (October/November 1950) (Best Syndicated Features); *Spyman* #1 (September 1966) (Illustrated Humor); *The World Around Us—Spies* #35 (August 1961) (Gilbertson World Wide).

28. Margaret Frakes, "Comics Are No Longer Comic," *Christian Century* 59 (November 4, 1942): 1349. Ong, "The Comics and the Super State," passim. James Gilbert, *A Cycle of Outrage: American Reaction to the Juvenile Delinquent in the 1950s* (New York: Oxford University Press, 1966), 80; Roger Sabin, *Comics, Comix, and Graphic Novels* (London: Phaidon, 1996), 68.

29. Henry E. Schultz, "Censorship or Self Regulation?" *Journal of Educational Sociology* 23 (December 1949), 217. Sabin, *Comics, Comix, and Graphic Novels,* 68.

30. Mike Benton, *The Comic Book in America: An Illustrated History* (Dallas: Taylor, 1993; first published 1989), 51–53; Fredric Wertham, *Seduction of the Innocent* (New York: Rinehart, 1954), passim.

31. See Amy Kiste Nyberg, "Seal of Approval: The Origins and History of the Comics Code," PhD diss., University of Wisconsin, Madison, 1994.

32. Greg S. McCue, with Clive Bloom, *Dark Knights: The New Comics in Context* (Boulder, CO: Pluto Press, 1993). *Atom-Age Combat* #1 (February 1958) (St. John Publications). *Atom-Age Combat* #1 (March 1959) (Fago).

33. A. Constandina Titus, "The Mushroom Cloud as Kitsch," in Zeman and Amundson, *Atomic Culture,* 65–81.

34. "Atom Bomb," *Two-Fisted Tales* (1953) (EC Comics). *The Adventures of Rex the Wonder Dog* #11 (September/October 1953) (National Comics).

35. *World War III* #2 (May 1953) (Ace); *Atomic War!* #3 (February 1953) (Ace Comics).

36. *Commander Battle and the Atomic Sub* #3 (November/December 1954), #6 (May/June 1955), #7 (August/September 1955).

37. *Strange Adventures* #160 (January 1964) (DC Comics). Gerard Jones and Will Jacobs, *The Comic Book Heroes* (Rocklin, CA: Prima Publications, 1997), 24.

38. David Kasakove, "Stan's Writing and Editing," *Write Now!* 18 (Summer 2008), qtd. 59. *Weird Science* #14 (September/October 1950) (EC Comics).

5 ■ American Underground Comix, Political and International Cartoonists, and the Rise of Japanese Manga

1. Richard Rhodes, *Arsenals of Folly: The Making of the Nuclear Arms Race* (New York: Knopf, 2007), 227. See also the essays in Bruce Hevly and John M. Findlay, eds., *The Atomic West* (Seattle: University of Washington Press, 1998).

2. Lawrence Hyde, *Southern Cross: A Novel of the South Seas* (Los Angeles: Ward Ritchie Press, 1951).

3. Stanley Wiater and Stephen R. Bissette, *Comic Book Rebels: Conversations with the Creators of the New Comics* (New York: Donald I. Fine, 1993), xiii. M. Thomas Inge, "Comic Books," in *Handbook of American Popular Literature*, edited by M. Thomas Inge (New York: Greenwood Press, 1988), 74–99. Harvey Kurtzman, "An Interview with the Man who Brought Truth to the Comics, Harvey Kurtzman," by Kim Thompson, *Comics Journal* 67 (October 1981): 98–99. Jay Lynch, introduction to *Underground Classics: The Transformation of Comics into Comix*, edited by James Danky and Denis Kitchen (New York: Abrams Comic Arts, in association with the Chazen Museum of Art, 2009), 15. See also Dez Skinn, *Comix: The Underground Revolution* (New York: Thunder's Mouth Press, 2004). Sabin, "Going Underground," *Comics, Comix, and Graphic Novels*, 92–129.

4. See Wiater and Bissette, *Comic Book Rebels. It's Science . . . with Dr. Radium* #2 (January 1987) (Slave Labor Graphics). *Dr. Schnuke's Atomic Water Story* (n.d.) (Waffle Comics). *Corporate Crime Comics* #1 (1977) (Kitchen Sink).

5. *Slow Death* #9 (1978) (Last Gasp).

6. "Mr. Sketchum," *Hydrogen Bomb and Biochemical Comics* #1 (1970) (Rip Off Press). *Itchy Planet* #1 (Spring 1988) (Fantagraphics).

7. *Howard the Duck* #1 (February 1980) (Marvel).

8. Edwin McDowell, "Nuclear Books Proliferate, but Few Sell Well," *New York Times*, November 4, 1982, C25; Paul Brians, "Americans Learn to Love the Bomb," *New York Times*, July 17, 1985, A23.

9. Stephen Croall and Kainders, *The Anti-Nuclear Handbook* (New York: Pantheon, 1978). There was also an *Official Government Nuclear Survival Manual*, which consisted entirely of blank pages.

10. James P. Delgado, *Nuclear Dawn: The Atomic Bomb, from the Manhattan Project to the Cold War* (Oxford: Osprey, 2009), 117–18. David Low, *Low Visibility: A Cartoon History, 1945–1953* (London: Collins, 1953).

11. See the excellent compilation by Brian Cronin, "A Month of Pulitzer Prize Winning Cartoons," available at http://goodcomics.comicbookresources.com/category /month-of-pulitzer-prize-winning-cartoons/, Day 4, Day 10, Day 19 (accessed November 11, 2009).

12. The images are available at the National Library of Wales's e-Resources catalog (http://cat.llgc.org.uk/cgi-bin/gw/chameleon).

13. Herbert Block, *Herblock's Here and Now* (New York: Simon and Schuster, 1955), 193, 198, 22.

14. Herbert Block, *The Herblock Gallery* (New York: Simon and Schuster, 2005), 95, 99. Block, *Herblock on All Fronts* (New York: New American Library 1981), 66.

15. Dr. Seuss, *The Butter Battle Book* (New York: Random House, 1984), 5.

16. Dr. Seuss, *Butter Battle Book*, 42.

17. Raymond Briggs, *When the Wind Blows* (London: Penguin 1982), back cover.

18. Leonard Rifas, "Cold War Comics," *International Journal of Comic Art* 2 (Spring 2001): 3–32; Rifas, "Underground Comix," in *Encyclopedia of the American Left*, edited by Mari Jo Buhle, Paul Buhle, and Dan Georgakas (New York: Oxford University Press, 1998); and Rifas, "Cartooning and Nuclear Power: From Industry Advertising to Activist Uprising and Beyond," *PS: Political Science and Politics* 40 (April 2007): 255–60.

19. *All-Atomic Comics* (1976) (Educomics). Last page of *Gen of Hiroshima* #2 (1981) (Educomics). See also Kevin Rafferty et al., *The Atomic Café: The Book of the Film* (Toronto: Bantam, 1982).

20. Back covers of *Gen of Hiroshima* #1 and 2 (1980, 1981) (Educomics). Leonard Rifas, ". . . Before It's Too Late: An Interview with Leonard Rifas, The Cartoonist/Publisher with a Social Conscience," by Dale Luciano, *Comics Journal* 92 (August 1984): 87–109, quotation on 109. Rifas, "Globalizing Comic Books from Below: How Manga Came to America" (unpublished essay by Rifas, in the author's possession, p. 1). Rifas, "U.S. Comic Books and Nuclear War," *Itchy Planet* #1 (Spring 1988) (Fantagraphics), 28–32.

21. Paul Gravett, *Manga: Sixty Years of Japanese Comics* (New York: Collins Design, 2004), esp. chap. 2. Susan J. Napier, *Anime: From Akira to Princess Mononoke: Experiencing Contemporary Japanese Animation* (New York: Palgrave, 2000), 7. Cited in Lee A. Makela, "Manga! The Great Japanese Comic Book Invasion," *Gamut* 30 (Summer 1990): 134–44. Frederik L. Schodt, *Dreamland Japan: Writings on Modern Manga* (Berkeley: Stone Bridge Press, 2002), 21.

22. Osamu Tezuka, *Boku no manga jinsei* [My Cartoonist Life] (Tokyo: Iwanami Shoten, 1997), 63–67. Ibid., 64–65. A nice summary of his career can be found in Gravett, *Manga*, chap. 3.

23. In the late 1930s, Japanese companies even produced bisque miniatures of Snow White and the Seven Dwarfs, both for home and foreign consumption. Tezuka, *boku no manga jinsei* [My Cartoonist Life], 63–67.

24. Tezuka, *Metolopolisu* [Metropolis] (Tokyo: Kadokawa Bunko, 2003), 160.

25. Tezuka, *Kitaru beki sekai* [The Future World] (Tokyo: Kadansha Bunko, 2003), 149.

26. Eiji Otsuka, *Atomu no meidai: Tezuka Asamu to sengo manga no shudai* [Atom's Proposition: Tezuka Osamu and the Subject of the Postwar Manga] (Tokyo: Tokuma Shoten, 2003), 246.

27. Tezuka, "The Birth of Astro Boy," in *Astro Boy*, 18 vols. (San Francisco: Last Gasp Press, 2003; first published in 1975), 1, passim. "Tezuka Osamu," Japan Zone Originals, http://www.japanzone.com/modern/tezuka_osamu.shtml (accessed May 5, 2009).

28. Tezuka, *Tetsuwan atomu* [Astro Boy], 12 vols. (Tokyo: Kodansha Manga Bunko, 2002).

29. Schodt, *Manga! Manga! The World of Japanese Comics* (New York: Kodansha Inter-

national, 1983) is the best treatment of the subject. Fred Patten, *Watching Anime, Reading Manga* (Berkeley, CA: Stone Bridge Press, 2004), 46. *Astro Boy* translation and introduction by Schodt (Milwaukie, OR: Dark Horse Comics, 2002). Frederik L. Schodt, *The Astro Boy Essays* (Berkeley: Stone Bridge Press, 2007), 15, quotation on p. 5.

30. "Astro vs. Garon," first published in 1962 in *Astro Boy* v10, 58; "Crucifix Island" (first serialized between January and April 1957 in *Shonen* magazine), as found in *Astro Boy* v5, 51.

31. The forgiveness theme may be found in "Roboids," in *Astro Boy* v12, 58; "Crucifix Island" (first serialized between January and April 1957 in *Shonen* magazine), as found in *Astro Boy* v5, 51. "The Man Who Returned from Mars," first published in 1968 in *Astro Boy* v11. *Astro Boy* v15, 231 (first published 1952).

32. Oe, 11. Tezuka, "His Highness Deadcross," *Astro Boy* v2 (Milwaukie, OR: Dark Horse Comics, 2002), 41.

33. See Monica Braw, *The Atomic Bomb Suppressed* (Armonk, NY: M. S. Sharpe, 1991), 89–133. Schodt, *Manga! Manga!*, 128. Jun Ishiko, "The Bomb Did Not Just 'Fall,'" in *Barefoot Gen: Life After the Bomb*, edited by Keiji Nakazawa (San Francisco: Last Gasp of San Francisco, 2005), 3:iii–v (first published in 1975).

34. *A Call from Hibakusha of Hiroshima and Nagasaki: Proceedings of the International Symposium on the Damage and After-Effects of Hiroshima and Nagasaki, July 21–August 9, 1997, Tokyo, Hiroshima and Nagasaki* (Tokyo: Japan National Preparatory Committee, 1928), 73, 183.

35. Mark Schilling, *The Encyclopedia of Japanese Pop Culture* (Trumbull, CT: Weatherhill, 1997), 57–62.

36. They have been collected as *Godzilla: King of the Monsters* (New York: Marvel, 2006), by Doug Moench, Herb Trimpe, Jim Mooney, Tom Sutton, et al. Comic book giveaway, *Godzilla vs. Megaton* (1976), Cinema Shares.

37. Yoshiaki Fukuma, *"Hansen" no media-shi: Sengo Nihon ni okeru seron to yoron no kikkō* [History of Antiwar Media: A Conflict Between Popular Sentiments and Public Opinion in Postwar Japan] (Tokyo: Sekai Shisosha, 2006), 208. Shindo would later comment that he did not want to create political films but artistic ones. Shindo Kaneto, *Genbaku o toru* [Shooting A-bomb Films] (Tokyo: Shin Nihon Shuppansha, 2005), 206. Fukuma, *"Hansen" no media-shi*, 236. Donald Richie, "Mono No Aware: Hiroshima in Cinema," in *Hibakusha Cinema: Hiroshima, Nagasaki, and the Nuclear Image in Japanese Film*, edited by Mick Broderick (London: Kegan Paul International, 1996).

38. Nakazawa, "The Keiji Nakazawa Interview," by Alan Gleason, *Comics Journal* 256 (October 2003): 38. "A Note from the Author," in Keiji Nakazawa, *Barefoot Gen: A Cartoon Story of Hiroshima*, vol. 1, (San Francisco: Last Gasp of San Francisco, 2004), viii–x. Nakazawa, "Keiji Nakazawa Interview," 46.

39. Keiji Nakazawa, *Kuroi ame ni utarete* [Struck by Black Rain] (Tokyo: Dino Box, 2005), 8, 12–13, 30.

40. Nakazawa, "Keiji Nakazawa Interview," 46. At the forefront of the public dis-

course in Japan from the late sixties to the early seventies were such important political issues as the anti-Vietnam War protest, the restoration of Okinawa, and the controversies surrounding the United States–Japan Security Treaty. Antiwar sentiments were running high in Japan during that period.

41. There are two four-volume English translations of *Barefoot Gen*. The first appeared in the 1990s from New Society and the second from Last Gasp of San Francisco. The translations come from a nonprofit, all-volunteer Tokyo group called Project Gen. The books have been translated into French, German, Italian, Portuguese, Swedish, Norwegian, Indonesian, Tagalog, and Esperanto. See "About Project Gen," in *Barefoot Gen*, 1:254ff.

42. *Black Rain* and *The Face of Jizo* (Living with Father) both have women as their protagonists but were written by male writers. *Yumechiyo Nikki* deals with the life of a female innkeeper who succumbs to radiation sickness. *Children of Hiroshima* features a female school teacher as a main character. See also Omote Tomoyuki, "Gen's Place in the History of Comics," in *Hadashi no gen ga ita fukei* [Barefoot Gen and Its Social Landscape], edited by Yoshiaki Fukuma and Kazuma Yoshimura (Tokyo: Azuma Shupaan, 2006), 61. Nakazawa, "Keiji Nakazawa Interview," 40. Nakazawa, *Barefoot Gen*, 1:1. Yomota Inuhiko, *Manga genron* [Principles of Comics] (Tokyo: Chikuma Gakugei Bunko, 1999), 168. *Barefoot Gen*, 1:1. Nakazawa, "Keiji Nakazawa Interview," 40. Nakazawa, *Barefoot Gen: A Cartoon Story of Hiroshima*, vol. 4 (San Francisco: Last Gasp of San Francisco, 2005), 281. Inuhiko, *Manga genron*, 168, 197.

43. See "Barefoot Gen, The Atomic Bombs and I: The Hiroshima Legacy," Nakazawa Keiji interviewed by Asai Motofumi, trans. by Richard H. Minear, http://www.japan focus.org/-Nakazawa-Keiji/2638 (accessed May 5, 2009). Nakazawa, "Keiji Nakazawa Interview," 8. Paul Gravett, "Keiji Nakazawa: Barefoot in Hiroshima," http://www.paul-gravett.com/index.php/articles/article/keiji_nakazawa/ (accessed August 8, 2009).

6 ■ The Never-Ending Appeal of Atomic Adventure Tales

1. Rifas, ". . . Before It's Too Late! An Interview with Leonard Rifas," *Comics Journal*, 109.

2. *Atom* #23 (February/March 1964); *Atom* #5 (March 1963) (DC Comics).

3. A good collection of Atom tales can be found in *Showcase Presents the Atom* (New York: DC Comics, 2008), by Gardner F. Fox, Gil Kane, and Murphy Anderson.

4. *Space Adventures* #36 (October 1960) (Charlton).

5. *Captain Atom* #22 (December 1988) (DC Comics). *Captain Atom* #37 (January 1990) (DC Comics). Will Pfeifer, Giuseppe Camuncoli, and Sandra Hope, *Captain Atom: Armageddon* (La Jolla, CA: Wildstorm Productions, 2007).

6. "Stan's Top Ten Tips for Writers," *Write Now!* 18 (Summer 2008), 68. Goulart, *Comic Book Reader's Companion*, "The Hulk."

7. *Doctor Solar, Man of the Atom* (Gold Key), *The Original Doctor Solar: Man of the Atom* #1 (April 1990) (Valiant), 66. *Doctor Solar, Man of the Atom* #2 (December 1962), #8 (July 1964), #17 (September 1966), #18 (December 1966) (Western).

8. *Solar: Man of the Atom* (June 1992); *Solar* (February 1993); *The Original Doctor Solar, Man of the Atom* #1 (April 1995) (Valiant).

9. *Firestorm: The Nuclear Man* #1 (March 1978) (DC Comics); *Secret Origins* #4 (July 1986) (DC Comics).

10. *Firestorm: The Nuclear Man* #1 (March 1978) (DC Comics). *Firestorm* #99 (July 1990), #100 (August 1990) (DC Comics).

11. Les Daniels, *Comix: A History of Comic Books in America* (New York: Bonanza Books, 1975), 139. See also Les Daniels, *Marvel: Five Fabulous Decades of the World's Greatest Comics* (New York: Harry N. Abrams, 1991) and Richard Reynolds, *Superheroes: A Modern Mythology* (Jackson: University Press of Mississippi, 1992).

12. Scott Brick, "The Many Faces of Spider Man," *Comics Buyer's Guide*, January 2, 1988, 30–34; Stan Lee, introduction to *The Uncanny X-Men Masterworks* (New York: Marvel, 1993), n.p.; Stan Lee, *The Incredible Hulk* (New York: Simon and Schuster, 1978); Mike Benton, *Superhero Comics of the Silver Age* (Dallas: Taylor, 1992), 20–22; Stan Lee, *The Best of Spiderman* (New York: Ballentine Books, 1986), 49.

13. *Superman* #308 (February 1977) (DC Comics); *All Star Squadron* (December 1982) (DC Comics). *Outsiders* (November 1985), *All Star Squadron* (December 1982) (DC Comics). *Black Goliath* v1 #2 (April 1976) (Marvel).

14. *Nukla* #3 (June 1966) (Dell).

15. *Neutro* #1 (January 1967) (Dell).

16. Robert Beerbohm's listing of atomic-themed books from 1958 to 1977; copy in author's possession

17. Daniels, *Marvel*. The Stan Lee quotation is from *Marvel Super Action* (a reprint of *Marvel Boy* #1) (November 1977), 10.

18. Phil Rushton, "The World's Last Knights," *Amazing Heroes* 51 (July 15, 1984): 45–53; *Children of Doom* v2, #2 (November 1967) (Charlton). *Doomsday + 1* #5 (March 1976).

19. Peter Bacon Hales, "Imaging the Atomic Age: Life and the Atom," in *Looking at "Life" Magazine*, edited by Erika Doss (Washington: Smithsonian Institution Press, 2001), 103–19.

20. See the section "The 1990s" in Paul Sassienic, *The Comic Book* (London: Ebury, 1994), 117–31,

21. Kevin Eastman and Peter Laird, *Teenage Mutant Ninja Turtles* (Chicago: First Comics, 1986), 16; Goulart, *Over 50 Years of American Comic Books*, 303.

22. *Navajo Times*, February 12, 1981; February 19, 1981. *Navajo Times*, August 27, 1981. For the Church Rock spill, see Harvey Wasserman and Norman Solomon, with Robert Alvarez and Eleanor Walters, *Killing Our Own: The Disaster of America's Experience with Atomic Radiation* (New York: Dell, 1982), chap. 9.

23. *Radioactive Man* #1 (1993) (Bongo); *Bartman*, with *Radioactive Man* #3 (1994) (Bongo).

24. "Ang Lee on Comic Books and Hulk as Hidden Dragon," *New York Times*, June 22, 2003, 2, 11.

25. Schodt, *Manga! Manga!;* Shelly Esaak, "Artists in 60 seconds: Tezuka Osamu," http://arthistory.about.com/od/namesoo/p/osamu.htm (accessed August 8, 2009).

26. Special thanks to Futoshi Saito for providing me with translations of these books.

27. Alan Moore and Dave Gibbons, *Watchmen* (New York: DC Comics, 1986–87).

28. Jim Ottaviani et al., *Fallout: J. Robert Oppenheimer, Leo Szilard, and the Political Science of the Atomic Bomb* (Ann Arbor: G.T. Labs, 2001); Jonathan Elias and Jazan Wild, *Atomic Dreams: The Lost Journal of J. Robert Oppenheimer* (Carnival Comics, 2009).

29. Teller, cited in Ferenc M. Szasz, *Larger Than Life: New Mexico in the Twentieth Century* (Albuquerque: University of New Mexico Press, 2006), 39. Rifas, "Globalizing Comic Books from Below," typescript in author's possession, 28.

30. Judy Richter, review of *Doctor Atomic,* The Richter Scale, November 14, 2008, http://opera.stanford.edu/reviews/dratomic.html. Jeremy Eichler, "An Opera That Hovers on Threshold of the Nuclear Age," *Boston Globe,* October 16, 2008; conversation with Peter Sellars, Santa Fe, NM, July 13, 2008. Matthew Gurewitsch, "The Opera That Chooses the Nuclear Option," *New York Times,* September 25, 2005. Melissa Fabros, "*Doctor Atomic,*" *Berkeley Science Review,* August 16, 2009, http://sciencereview.berkeley.edu /pdf/5.2/dr-atomic.pdf.

Conclusion

1. Crumb, quoted in Danky and Kitchen, *Underground Classics,* 45.

2. Paul Boyer, *Fallout: A Historian Reflects on America's Half-Century Encounter with Nuclear Weapons* (Columbus: Ohio State University Press, 1998), 9.

3. Quoted in Danky and Kitchen, *Underground Classics.*

4. Arthur Berger, "Comics and Culture," *Journal of Popular Culture* 5 (Fall 1971): 164–77, quotation on 164.

5. Edward Rothstein, obituary of Claude Levi-Strauss, *New York Times,* November 4, B16.

BIBLIOGRAPHY

Arnold, Lorna, comp. *The Development of Atomic Energy, 1939–1984*. Bournemouth, Dorset: Bourne Press, 1984.

Barrier, J. Michael. *A Smithsonian Book of Comic-Book Comics*. New York: Smithsonian Institution Press, 1981.

Bartter, Martha A. *The Way to Ground Zero: The Atomic Bomb in American Science Fiction*. New York: Greenwood Press, 1988.

Behrens, Charles F., ed. *Atomic Medicine*. New York: Thomas Nelson and Sons, 1949.

Benton, Mike. *The Comic Book in America: An Illustrated History*. Dallas: Taylor, 1989. First published 1993.

———. *The Illustrated Superhero*. Dallas: Taylor, 1991.

———. *Superhero Comics of the Golden Age*. Dallas: Taylor, 1992.

———. *Superhero Comics of the Silver Age*. Dallas: Taylor, 1992.

Berger, Albert I. "The Triumph of Prophecy: Science Fiction and Nuclear Power in the Post-Hiroshima Period." *Science-Fiction Studies* 9 (July 1976): 143–45.

Berger, Arthur. "Comics and Culture." *Journal of Popular Culture* 5 (Fall 1971): 164–77.

Black, Bill, ed. *Golden Age Greats*. Vol. 1. Longwood, FL: Paragon, 1994.

Blackbeard, Bill, and Dale Crain, eds. *The Comic Strip Century: Celebrating 100 Years of an American Art Form*. Northampton, MA: Kitchen Sink Press, 1995.

Blackbeard, Bill, and Martin Williams. *The Smithsonian Collection of Newspaper Comics*. Washington, DC: Smithsonian Institution Press and Harry N. Abrams, 1977.

Block, Herbert. "The Cartoon." Available at Herblock's History: Political Cartoons from the Crash to the Millennium at http://www.loc.gov/rr/print/swann/herblock /cartoon.html.

———. *Herblock: A Cartoonist's Life*. New York: Random House, 1993.

———. *The Herblock Gallery*. New York: Simon and Schuster, 2005.

———. *Herblock on All Fronts*. New York: New American Library, 1981.

———. *Herblock's Here and Now*. New York: Simon and Schuster, 1955.

———. *Herblock's Special for Today*. New York: Simon and Schuster, 1958.

Borden, Bill, with Steve Posner. *The Big Book of Big Little Books*. San Francisco: Chronicle Books, 1997.

Boyer, Paul. *By the Bomb's Early Light: American Thought and Culture at the Dawn of the Atomic Age.* New York: Pantheon, 1985.

———. *Fallout: A Historian Reflects on America's Half-Century Encounter with Nuclear Weapons.* Columbus: Ohio State University Press, 1998.

Braw, Monica. *The Atomic Bomb Suppressed.* Armonk, NY: M. S. Sharpe, 1991.

Brians, Paul. *Nuclear Holocausts: Atomic War in Fiction.* Available online at http://www.wsu.edu/~brians/nuclear/preface.html.

Brick, Scott. "The Many Faces of Spider Man." *Comics Buyer's Guide,* January 2, 1988, 30–34.

Briggs, Raymond. *When the Wind Blows.* London: Penguin, 1982.

Brodie, Bernard, ed. *The Absolute Weapon: Atomic Power and World Order.* New York: Harcourt, Brace and Co., 1946.

Brown, Clarence J. "Scope and General Background of Atomic Medicine." In *Atomic Medicine,* edited by Charle F. Behrens. New York: Th. Nelson and Sons, 1949.

Bryson, Bill. *A Short History of Nearly Everything.* New York: Broadway Books, 2003.

Calder, Ritchie. *Science in Our Lives.* New York: New American Library, 1955.

A Call from Hibakusha of Hiroshima and Nagasaki: Proceedings of the International Symposium on the Damage and After-Effects of Hiroshima and Nagasaki, July 21–August 9, 1997, Tokyo, Hiroshima and Nagasaki. Tokyo: Japan National Preparatory Committee, 1928.

Campbell, John W. *The Atomic Story.* New York: Henry Holt, 1947.

Carter, Paul A. *Another Part of the Twenties.* New York: Columbia University Press, 1977.

———. *The Creation of Tomorrow: Fifty Years of Magazine Science Fiction.* New York: Columbia University Press, 1977.

Claus, Walter D., ed. *Radiation Biology and Medicine.* Reading, MA: Addison-Wesley, 1958.

Conant, James B. "The Scientific Education of the Layman." *Yale Review* 36 (Autumn 1946): 15–36.

Considine, Bob. "The Beginning or the End!" *Movie Story Magazine* 27 (February 1947): 26–29.

Copp, M. Philip. *The Atomic Revolution.* New York: General Dynamics Corporation, 1957.

Couperie, Pierre, and Maurice C. Horn. *A History of the Comic Strip.* New York: Crown, 1968.

Cowan, George. *Manhattan Project to the Santa Fe Institute: The Memoirs of George A. Cowan.* Albuquerque: University of New Mexico Press, 2010.

Croall, Stephen, and Kainders. *The Anti-Nuclear Handbook.* New York: Pantheon, 1978.

Cronin, Brian. "A Month of Pulitzer Prize Winning Cartoons." Available at http://www.goodcomics.comicbookresources.com.

Cushing, Harry. "Atomic Power!——In Your Car." *Motor Trend* 3 (April 1951): 15–17, 48.

Daniels, Les. *Comic Books in America.* New York: Bonanza Books, 1971.

———. *Comix: A History of Comic Books in America.* New York: Bonanza Books, 1975.

———. *DC Comics: Sixty Years of the World's Favorite Comic Book Heroes.* Boston: Little, Brown, 1995.

———. *Marvel: Five Decades of the World's Greatest Comics.* New York: Harry A. Abrams, 1991.

———. *Superman: The Complete History [of] the Life and Times of the Man of Steel.* San Francisco: Chronicle Books, 1998.

Danky, James, and Denis Kitchen. *Underground Classics: The Transformation of Comics into Comix.* New York: Abrams Comic Arts, in association with the Chazen Museum of Art, 2009.

Dean, Gordon. *Report on the Atom: What You Should Know About Atomic Energy.* London: Eyre and Spottiswoode, 1954.

Delgado, James P. *Nuclear Dawn: The Atomic Bomb, from the Manhattan Project to the Cold War.* Oxford: Osprey, 2009.

Dietz, David. *Atomic Energy in the Coming Era.* New York: Dodd, Mead, 1945.

———. *Atomic Science, Bombs, and Power.* New York: Dodd, Mead, 1954.

Divine, Robert A. *Blowing on the Wind: The Nuclear Test Ban Debate, 1954–1960.* New York: Oxford University Press, 1978.

"The Doctor Tells You How Atomic Medicine Now Works Miracles for You." *True Romance* 61 (February 1956): 59–60.

Eisner, Will. *Comics and Sequential Art.* Tamarac, FL: Poorhouse Press, 1985.

Elias, Jonathan, and Jazan Wild. *Atomic Dreams: The Lost Journal of J. Robert Oppenheimer.* Carnival Comics, 2009.

Ersfeld, James. "Taking the High Ground: The Military in Space, 1955–1965." MA thesis, University of New Mexico, 2009.

Federation of American (Atomic) Scientists. "Survival Is at Stake." In *One World or None,* edited by Dexter Masters and Katherine Way. New York: McGraw-Hill, 1946.

Feiffer, Jules, comp. *The Great Comic Book Heroes.* New York: Dial Press, 1965.

Fermi, Laura. *Atoms for the World: United States Participation in the Conference on the Peaceful Uses of Atomic Energy.* Chicago: University of Chicago Press, 1957.

Fisher, Bud. *Forever Nuts: The Early Years of Mutt and Jeff.* Edited by Jeffrey Lindenblatt. New York: Nantier, Beall, Minoustchine, 2008.

Fitzpatrick, D. R. *As I Saw It.* New York: Simon and Schuster, 1953.

Fox, Gardner F., Gil Kane, and Murphy Anderson. *Showcase Presents the Atom.* New York: DC Comics, 2008.

Frakes, Margaret. "Comics Are No Longer Comic." *Christian Century* 59 (November 4, 1942): 1349–52.

Frank, Josette. "Some Questions and Answers for Teachers and Parents." *Journal of Educational Sociology* 23 (December 1949): 211–12.

Franklin, H. Bruce, ed. *Countdown to Midnight: Twelve Great Stories About Nuclear War.* New York: DAW Books, 1984.

Frisch, Otto R. *Meet the Atoms: A Popular Guide to Modern Physics.* New York: A. A. Wyn, 1947.

Frisch, Otto R., and John A. Wheeler. "The Discovery of Fission." *Physics Today* 20, no. 11 (November 1967): 43–52.

Fukuma, Yoshiaki. *"Hansen" no media-shi: Sengo Nihon ni okeru seron to yoron no kikkô* [History of Antiwar Media: A Conflict Between Popular Sentiments and Public Opinion in Postwar Japan]. Tokyo: Sekai Shisosha, 2006.

Galewitz, Herb, ed. *Great Comics Syndicated by the Daily News and Chicago Tribune.* New York: Crown, 1972.

Gerber, Ernst. *The Photo-Journal Guide to Marvel Comics.* 2 vols. Minden, NY: Gerber, 1991.

Gerber, Ernst, and Mary Gerber. *The Photo-Journal Guide to Comic Books.* 2 vols. Minden, NY: Gerber, 1989.

Gifford, Denis. *The International Book of Comics.* Toronto: Royce, 1984.

Gilbert, James. *A Cycle of Outrage: American Reaction to the Juvenile Delinquent in the 1950s.* New York: Oxford University Press, 1966.

Gold, Mike, ed. *The Greatest Golden Age Stories Ever Told.* New York: DC Comics, 1989.

Goodstone, Tony, ed. *The Pulps.* New York: Chelsea House, 1970.

Gornick, Larry. *The Cartoon History of the Modern World.* New York: Collins, 2007.

Goulart, Ron. *The Comic Book Reader's Companion.* New York: HarperPerennial, 1993.

———. *The Funnies: 100 Years of American Comic Strips.* Holbrook, MA: Adams, 1995.

———. *Great American Comic Books.* Lincolnwood, IL: Publications International, 2001.

———. *Over 50 Years of American Comic Books.* Lincolnwood, IL: Publications International, 1991.

———. "The Second Banana Superheroes." In *All in Color for a Dime,* edited by Dick Lupoff and Don Thompson. Iola: WI: Krause Publications, 1997.

Gravett, Paul. *Manga: Sixty Years of Japanese Comics.* New York: Collins Design, 2004.

The Greatest Superman Stories Ever Told. New York: DC Comics, 1986.

Gunn, James. *Alternate Worlds: The Illustrated History of Science Fiction.* Englewood Cliffs, NJ: Prentice Hall, 1975.

Haber, Heinz. *The Walt Disney Story of Our Friend the Atom.* New York: Dell, 1956.

Hacker, Barton C. *The Dragon's Tail: Radiation Safety in the Manhattan Project, 1942–1946.* Berkeley: University of California Press, 1987.

Hajdu, David. *The Ten-Cent Plague: The Great Comic-Book Scare and How It Changed America.* New York: Farrar, Straus and Giroux, 2008.

Hales, Peter Bacon. "Imaging the Atomic Age: Life and the Atom." In *Looking at "Life" Magazine,* edited by Erika Doss, 103–19. Washington, DC: Smithsonian Institution Press, 2001.

Hay, Carolyn D. "A History of Science Writing in the United States and of the National Association of Science Writers." MA thesis, Medill School of Journalism, 1970.

The H-bomb and You. http://www.ep.tc/comics/h-bomb/h-03.html.

Heller, Steven, ed. *Warheads: Cartoonists Draw the Line.* Middlesex, Eng.: Penguin, 1983.

Hevly, Bruce, and John M. Findlay, eds. *The Atomic West.* Seattle: University of Washington Press, 1998.

Hoffman, Eric. "Superman: The Columbia Serials." *Comics Feature* 35 (January 1957): 40–45.

Holloway, David. *Stalin and the Bomb: The Soviet Union and Atomic Energy, 1939–1956.* New Haven, CT: Yale University Press, 1994.

Horn, Maurice, ed. *100 Years of American Newspaper Comics.* New York: Gramercy Books, 1996.

Hyde, Lawrence. *Southern Cross: A Novel of the South Seas.* Los Angeles: Ward Ritchie Press, 1951.

If an A-bomb Falls. 1951. http://www.ep.tc/comics/a bomb/abomb4.html.

Inge, M. Thomas. "Comic Books." In *Handbook of American Popular Literature,* edited by M. Thomas Inge, 74–99. New York: Greenwood Press, 1988.

The International Control of Atomic Energy. Washington DC: GPO, 1947.

Inuhiko, Yomota. *Manga genron* [Principles of Comics]. Tokyo: Chikuma Gakugei Bunko, 1999.

Ishiko, Jun. "The Bomb Did Not Just 'Fall.'" In *Barefoot Gen: Life After the Bomb,* vol. 3, edited by Keiji Nakazawa. San Francisco: Last Gasp of San Francisco, 2005. First published 1975.

Jaffee, Al. Interview by Danny Fingeroth. *Write Now!* 18 (Summer 2008): 14.

Jones, Gerard. *Men of Tomorrow: Geeks, Gangsters, and the Birth of the Comic Book.* New York: Basic Books, 2004.

Jones, Gerard, and Will Jacobs. *The Comic Book Heroes.* Rocklin, CA: Prima Publications, 1997.

Jones, William B., Jr. *Classics Illustrated: A Cultural History, with Illustrations.* Jefferson, NC: McFarland, 2002.

Joseph, James. "Details on the NX2-Our Atomic Plane." *Science and Mechanics* 32 (January 1961): 66–70.

Kaneto, Shindo. *Genbaku o toru* [Shooting A-bomb Films]. Tokyo: Shin Nihon Shuppansha, 2005.

Kaplan, Arie. *From Krakow to Krypton: Jews and Comic Books.* Philadelphia: Jewish Publication Society of America, 2008.

Kasakove, David. "Stan's Writing and Editing." *Write Now!* 18 (Summer 2008).

Kramish, Arnold, and Eugene M. Zuckeet. *Atomic Energy for Your Business: Today's Key to Tomorrow's Profits.* New York: David McKay, 1956.

Kurtzman, Harvey. *From Aargh! To Zap! Harvey Kurtzman's Visual History of Comics.* Princeton, WI: Kitchen Sink Press, 1991.

———. "An Interview with the Man Who Brought Truth to the Comics, Harvey Kurtzman." By Kim Thompson. *Comics Journal* 67 (October 1981): 68–99.

Kyle, David. *A Pictorial History of Science Fiction.* London: Tiger Books, 1986.

Langer, R. M. "The Miracle of U-235." *Popular Mechanics* 75 (January 1941): 1–5.

Laurence, William L. "The Atom Gives Up." *Saturday Evening Post,* September 7, 1940, 12–13, 60–63.

———. *Dawn over Zero.* New York: Knopf, 1946.

———. *Men and Atoms: The Discovery, the Uses, and the Future of Atomic Energy.* New York: Simon and Schuster, 1959.

Lee, Stan. *The Best of Spiderman.* New York: Ballentine Books, 1986.

———. *The Incredible Hulk.* New York: Simon and Schuster, 1978.

Low, David. *Low Visibility: A Cartoon History, 1945–1953.* London: Collins, 1953.

Lupoff, Dick, and Don Thompson. *All in Color for a Dime.* Iola, WI: Krause Publications, 1997.

Lynch, Jay. Introduction to *Underground Classics: The Transformation of Comics into Comix,* edited by James Danky and Denis Kitchen. New York: Abrams Comic Arts, in association with the Chazen Museum of Art, 2009.

Mankoff, Robert, ed. *The Complete Cartoons of the "New Yorker."* New York: Black Dog and Leventhal, 2004.

Marvel Masterworks Presents All Winners. Vol. 1. New York: Marvel, 2005.

Masters, Dexter, and Katherine Way, eds. *One World or None.* New York: McGraw-Hill, 1946.

McCloud, Scott. *Understanding Comics: The Invisible Art.* New York: DC Comics, 1994.

McCue, Greg S., with Clive Bloom. *Dark Knights: The New Comics in Context.* Boulder, CO: Pluto Press, 1993.

McManus, George. *Fun for All: A Collection of Jokes, Anecdotes, and Epigrams . . . A Light-hearted Reflection of these First Years of the Atomic Era.* Cleveland: World Publishing, 1948.

Meyer, Leo. *Atomic Energy in Industry: A Guide for Tradesmen and Technicians.* Chicago: American Technical Society, 1963.

Moench, Doug, Herb Trimpe, Jim Mooney, Tom Sutton, et al. *Godzilla: King of the Monsters.* New York: Marvel, 2006.

Morrison, Philip. "If the Bomb Gets Out of Hand." In *One World or None,* edited by Dexter Masters and Katherine Way. New York: McGraw-Hill, 1946.

Mumford, Lewis. "Gentlemen: You Are Mad!" *Saturday Review of Literature* 29 (March 2, 1946): 5–6.

Nakazawa, Keiji. *Barefoot Gen: A Cartoon Story of Hiroshima.* Vol. 1. San Francisco: Last Gasp of San Francisco, 2004.

———. "*Barefoot Gen,* the Atomic Bombs, and I: The Hiroshima Legacy." Interview with Keiji Nakazawa by Asai Motofumi. Translated by Richard H. Minear. http://www.japanfocus.org/-Nakazawa-Keiji/2638.

———. "The Keiji Nakazawa Interview." By Alan Gleason. *Comics Journal* 256. Excerpt available at http://archives.tcj.com/256/i_nakazawa.html. Available at http://www.tcj.com/256/i_nakazawa.

Napier, Susan J. *Anime: From Akira to Princess Mononoke: Experiencing Contemporary Japanese Animation.* New York: Palgrave, 2000.

Nathanson, Mick, and Richard Elfenbein. "The Atomic Car . . . Fact or Fiction." *Car Life* 1 (July 1954): 22–27.

Nelson, Eldred C., and Leonard I. Schiff, eds. *Our Atomic World*. Albuquerque: University of New Mexico Press, 1946.

Newman, Kim. *Apocalypse Movies: End of the World Cinema*. New York: St. Martin's Griffin, 2000.

Nolan, Michelle. "Patriotic Heroes, The Red White & Blue of WWII." *Comic Book Marketplace* 2, no. 48 (June 1997): 13–18.

Nowlan, Philip, and Dick Calkins. *Buck Rogers in the 25th Century: The Complete Newspaper Dailies. Volume One, 1929–1930*. Introduction by Ron Goulart. Neshannock, PA: Hermes Press, 2008.

Nowlan, Phil, Dick Calkins, and Rick Yager. *The Collected Works of Buck Rogers in the 25th Century*. Edited by Robert C. Dille. New York: Chelsea House, 1969.

Nyberg, Amy Kiste. "Seal of Approval: The Origins and History of the Comics Code." PhD diss., University of Wisconsin, Madison, 1994.

Oe, Kenzaburo. *Hiroshima Notes*. Translated by David L. Swain and Toshi Yonezawa. New York: Marion Boyers, 1995.

Oliphant, Pat. *Oliphant!* Kansas City: Andrews and McMeel, 1980.

———. *Oliphant: The New World Order in Drawing and Sculpture, 1983–1993*. Kansas City: Andrews and McMeel, 1994.

———. *The Oliphant Book: A Cartoon History of Our Times*. New York: Simon and Schuster, 1969.

———. *Oliphant's Presidents: Twenty-Five Years of Caricature by Pat Oliphant*. Kansas City: Andrews and McMeel, 1990.

O'Neil, Dennis. *Secret Origins of the Super DC Heroes*. New York: Warner Books, 1970.

Ong, Walter. "The Comics and the Super State." *Arizona Quarterly* 1 (Autumn 1945): 34–48.

Osborn, Robert. *War Is No Damn Good*. Garden City, NY: Doubleday, 1946.

Otsuka, Eiji. *Atomu no meidai: Tezuka Asamu to sengo manga no shudai* [Atom's Proposition: Tezuka Osamu and the Subject of the Postwar Manga]. Tokyo: Tokuma Shoten, 2003).

Ottaviani, Jim, et al. *Fallout: J. Robert Oppenheimer, Leo Szilard, and the Political Science of the Atomic Bomb*. Ann Arbor, MI: G.T. Labs, 2001.

Patten, Fred. *Watching Anime, Reading Manga*. Berkeley, CA: Stone Bridge Press, 2004.

Peierls, R. E., and John Enogat, eds. *Science News: An Atomic Energy Number*. Middlesex, Hammondsworth: Penguin Books, 1945.

Pfeifer, Will, Giuseppe Camuncoli, and Sandra Hope. *Captain Atom: Armageddon*. La Jolla, CA: Wildstorm Productions, 2007.

Rafferty, Kevin, et al. *The Atomic Café: The Book of the Film*. Toronto: Bantam, 1982.

Raymond, Alex. *Alex Raymond's Flash Gordon*. 7 vols. West Carrollton, OH: Checker Book Publishing, 2007.

Reynolds, Richard. *Superheroes: A Modern Mythology*. Jackson: University Press of Mississippi, 1992.

R. F. Outcault's The Yellow Kid: A Centennial Celebration of the Kid Who Started the Comics. Introduction by Bill Blackbeard; foreword by William Randolph Hearst III. Northampton, MA: Kitchen Sink Press, 1995.

Rhodes, Richard. *Arsenals of Folly: The Making of the Nuclear Arms Race.* New York: Knopf, 2007.

———. *Dark Sun: The Making of the Hydrogen Bomb.* New York: Simon and Schuster, 1995.

Richie, Donald. "Mono No Aware: Hiroshima in Cinema." In *Hibakusha Cinema: Hiroshima, Nagasaki, and the Nuclear Image in Japanese Film,* edited by Mick Broderick. London: Kegan Paul International, 1996.

Ridenour, Louis N. "Military Secrecy and the Atomic Bomb." *Fortune,* November 1945, 218–23.

———. "There Is No Defense." In *One World or None,* edited by Dexter Masters and Katherine Way. New York: McGraw-Hill, 1946.

Rifas, Leonard. ". . . Before It's Too Late: An Interview with Leonard Rifas, The Cartoonist/Publisher with a Social Conscience." By Dale Luciano. *Comics Journal* 92 (August 1984): 87–109.

———. "Cartooning and Nuclear Power: From Industry Advertising to Activist Uprising and Beyond." *PS: Political Science and Politics* 40 (April 2007): 255–60.

———. "Cold War Comics." *International Journal of Comic Art* 2 (Spring 2001): 3–32.

———. "Underground Comix." *Encyclopedia of the American Left.* 2nd ed. Edited by Mari Jo Buhle, Paul Buhle, and Dan Georgakas. New York: Oxford University Press, 1998.

———. "U.S. Comic Books and Nuclear War." *Itchy Planet* #1 (Spring 1988): 28–32.

Robinson, Frank M., and Lawrence Davidson. *Pulp Culture: The Art of Fiction Magazines.* Portland, OR: Collections Press, 2007.

Robinson, Jerry. *The Comics: An Illustrated History of Comic Strip Art.* New York: Putnam, 1974.

Rushton, Phil. "The World's Last Knights." *Amazing Heroes* 51 (July 15, 1984): 45–53.

Russell, Bertrand. *The ABC of Relativity.* New York: 1959. First published 1925.

Sabin, Roger. *Comics, Comix and Graphic Novels.* London: Phaidon, 1996.

Sadowski, Greg, ed. *Supermen! The First Wave of Comic Book Heroes, 1936–1941.* Seattle: Fantagraphics Books, 2009.

Sadowski, Greg, and Gary Groth. *Harvey Kurtzman.* Comics Journal Library, vol. 7. Seattle: Fantagraphics Books, 2006.

Sassienic, Paul. *The Comic Book.* London: Ebury, 1994.

Savage, William W., Jr. *Comic Books and America, 1945–1954.* Norman: University of Oklahoma Press, 1990.

———. "Research and Comic Books: A Historian's Perspective." *Popular Culture in Libraries* 1 (1995): 85–90.

Schilling, Mark. *The Encyclopedia of Japanese Pop Culture.* Trumbull, CT: Weatherhill, 1997.

Schodt, Frederik L. *The Astro Boy Essays.* Berkeley, CA: Stone Bridge Press, 2007.

————. *Dreamland Japan: Writings on Modern Manga*. Berkeley: Stone Bridge Press, 2002.

————. "*Manga*: A Medium to Tell Stories: Interview with Mr. Frederik Schodt." *Japan Foundation Newsletter* 30 (June–July 2005).

————. *Manga! Manga! The World of Japanese Comics*. New York: Kodansha International, 1983.

Schultz, Henry E. "Censorship or Self Regulation?" *Journal of Educational Sociology* 23 (December 1949): 215–24.

Science Is in the Air: An Inspirational Textbook Told Almost Exclusively in Pictures. New York: Street and Smith, 1947.

Serving Through Science: The Atomic Age: A Series of Four Radio Talks Delivered by Professor Hans Albrecht Bethe, Professor Harold Clayton Urey, Professor James Franck, Professor J. Robert Oppenheimer on the New York Philharmonic Symphony Program, December 2-9-16-23, 1945. US Rubber Co., 1945.

Seuss, Dr. *The Butter Battle Book*. New York: Random House, 1984.

Shapiro, Jerome F. *Atomic Bomb Cinema: The Apocalyptic Imagination on Film*. New York: Routledge, 2002.

————. *Atomic Cinema: The Apocalyptic Imagination on Film*. New York: Routledge, 2002.

Sibra, Steve. "Atomic Animals." *Comic Book Marketplace* 2 (April 1994): 30–34.

Skinn, Dez. *Comix: The Underground Revolution*. New York: Thunder's Mouth Press, 2004.

Slosson, Edwin E. *Easy Lessons in Einstein*. New York: Harcourt, Brace and Howe, 1920.

Smith, Alice Kimball. *A Peril and a Hope: The Scientists' Movement in America, 1945–1947*. Chicago: University of Chicago Press, 1947.

Spiegelman, Art. *Maus: A Survivor's Tale*. 2 vols. New York: Pantheon, 1986–91.

Steranko, James. *The Steranko History of Comics*. 2 vols. Reading, PA: Supergraphics, 1970, 1972.

The Story of Harry S. Truman. Democratic National Committee, 1948.

The Superman Radio Scripts. Vol. 1, *Superman vs. the Atom Man*. New York: Watson-Guptill, 2001.

Szasz, Ferenc Morton. *British Scientists and the Manhattan Project: The Los Alamos Years*. New York: St. Martin's, 1992.

————. *The Day the Sun Rose Twice*. Albuquerque: University of New Mexico Press, 1994. First published 1984.

————. *Larger than Life: New Mexico in the Twentieth Century*. Albuquerque: University of New Mexico Press, 2008.

Szasz, Ferenc Morton, and Issei Takechi. "Atomic Heroes and Atomic Monsters: American and Japanese Cartoonists Confront the Onset of the Nuclear Age, 1945–80." *Historian* 69 (Winter 2007): 728–52.

Tezuka, Osamu. *Boku no manga jinsei* [My Cartoonist Life]. Tokyo: Iwanami Shoten, 1997.

————. *Kitaru beki sekai* [The Future World]. Tokyo: Kadansha Bunko, 2003.

————. *Metolopolisu* [Metropolis]. Tokyo: Kadokawa Bunko, 2003.

Thompson, Don, and Dick Lupoff, eds. *The Comic-Book*. New Rochelle, NY: Arlington House, 1973.

Tinsley, Frank. "Air-Power Transport." *Air Trails* 37 (January 1952): 26–27.

———. "A-Powered Trains in Glass Tubes." *Mechanics Illustrated* 52 (December 1956): 62–65.

———. "Atomic Planes Are Closer Than You Think." *Mechanics Illustrated* 51 (August 1955): 71–75.

Titus, A. Constandina. *Bombs in the Backyard: Atomic Testing and American Politics*. Reno: University of Nevada Press, 1986.

———. "The Mushroom Cloud as Kitsch." In *Atomic Culture*, edited by Zeman and Amundson. Boulder: University Press of Colorado, 2006.

Tomoyuki, Omote. "Gen's Place in the History of Comics." In *Hadashi no gen ga ita fukai fukei* [Barefoot Gen and Its Social Landscape], edited by Yoshiaki Fukuma and Kazuma Yoshimura. Tokyo: Azusa Shuppansha, 2006.

Uery, Harold C. "How Does It All Add Up?" In *One World or None*, edited by Dexter Masters and Katherine Way. New York: McGraw-Hill, 1946.

US Congress. *Hearings Before the Subcommittee on Research and Development of the Joint Committee on Atomic Energy . . .*, June 2, 3, and 4, 1954. Washington, DC: GPO, 1954.

US Department of State. *The International Control of Atomic Energy*. Washington, DC: GPO, 1946.

Vanderbilt, Tom. *Survival City: Adventures Among the Ruins of Atomic America*. New York: Princeton Architectural Press, 2002.

Walker, Brian. *The Comics Before 1945*. New York: Abrams, 2004.

———. *The Comics Since 1945*. New York: Abrams, 2002.

Walker, J. Samuel. *Prompt and Utter Destruction: Truman and the Use of Atomic Bombs Against Japan*. Chapel Hill: University of North Carolina Press, 1997.

Walker, Mort. *Beetle Bailey: The First Years, 1950–1952*. New York: Checker, 2008.

Walt Disney, Mickey Mouse. New York: Abbeville Press, 1978.

Warren, Stafford L. "Conclusions." *Life* 23 (August 11, 1947): 86–88.

Wasserman, Harvey, and Norman Soloman, with Robert Alvarez and Eleanor Walters. *Killing Our Own: The Disaster of America's Experience with Atomic Radiation*. New York: Dell, 1982.

Weart, Spencer R. *Nuclear Fear: A History of Images*. Cambridge: Harvard University Press, 1968.

Weinstein, Simcha. *Up, Up, and Oy Vay! How Jewish History, Culture, and Values Shaped the Comic Book Superheroes*. Baltimore: Leviathan, 2006.

Wendt, Gerald, and Donald Porter Geddes, eds. *The Atomic Age Opens*. New York: Pocket Books, 1945.

Wertham, Fredric. *Seduction of the Innocent*. New York: Rinehart, 1954.

"What Science Learned at Bikini." *Life* 23 (August 11, 1947): 74–85.

Wiater, Stanley, and Stephen R. Bissette. *Comic Book Rebels: Conversations with the Creators of the New Comics*. New York: Donald I. Fine, 1993.

Williams, Russell R. "The Atomic Age." *Saturday Review*, December 1, 1945.

Winkler, Allan M. *Life Under a Cloud: American Anxiety About the Atom.* New York: Oxford University Press, 1999.

Witek, Joseph. *Comic Books as History: The Narrative Art of Jack Jackson, Art Spiegelman, and Harvey Pekar.* Jackson: University Press of Mississippi, 1989.

Wolfe, Charles. "Nuclear Country: The Atomic Bomb in Country Music." *Journal of Country Music* 6 (January 1978): 4–22.

Wright, Bradford W. *Comic Book Nation: The Transformation of Youth Culture in America.* Baltimore: Johns Hopkins University Press, 2001.

Wright, Nicky. *The Classic Era of American Comics.* Chicago: Contemporary Books, 2000.

Younger, Stephen M. *The Bomb: A New History.* New York: Harpers, 2009.

Zeman, Scott C. "'Taking Hell's Measurements': *Popular Science* and *Popular Mechanics* Magazines and the Atomic Bomb: From Hiroshima to Bikini." *Journal of Popular Culture* 41 (2008): 695–711.

Zeman, Scott C., and Michael Amundson, eds. *Atomic Culture: How We Learned to Stop Worrying and Love the Bomb.* Boulder: University Press of Colorado, 2006.

INDEX